"Jeanne Cooper, aka Mrs. Chancellor, has worked that role to the max. Her book is equally good. Jeanne is still young and restless."

—Aretha Franklin

"I loved my dear friend Jeanne's book so much that I read it in a day and a half! She's one of a kind, and *Not Young, Still Restless* definitely does her justice."

—Lee Phillip Bell, cocreator,
The Young and the Restless and *The Bold and the Beautiful*

"Daytime's undisputed grande dame delivers a no-holds-barred memoir so full of heart, wit, and insight that reading it is like sitting with a glass of fine wine and the great lady herself. Jeanne Cooper's memoir, *Not Young, Still Restless*, is a gift, not only to her millions of fans and admirers, but to anyone interested in how a talented, independent woman thrives and survives eight decades in this brutal business of show without compromising her principles, her work, or her fierce individuality. Ms. Cooper is a treasure, truly one of a kind, and her memoir is a helluva good read!"

—Anthony "Tony" Geary, Luke on *General Hospital*

"Fasten your seatbelt! You are about to fly with Wilma Jeanne Cooper as she is blown up, down, and sideways through eighty-three fabulous years of life! Smashingly funny, heartachingly honest, and loaded with some damn fine dish (yep, she kisses *and* tells!), this is much more than a memoir. It's a handbook for survival. You won't just admire this woman's feisty grace and old-soul wisdom, you will want to be her when you grow up."

—Michael Logan, *TV Guide*

"This amazing woman and I have known each other since we really were 'young and restless.' How wonderful to have a book that shares her life with the world, and how blessed I was to have been part of it all—her incomparable talent when we worked together on movies

and TV shows, including many episodes of Perry Mason, and at-home time with our families, trying to keep our kids (and husbands) out of trouble. I simply adore her. Take her home with you—the book, I mean."

—Barbara Hale, actress, and *Perry Mason*'s iconic Della Street

"Written beautifully, lived beautifully. As spectacular as she is to know, the journey was even more fabulous. So that's how it's done."

—Hillary B. Smith, actress, *The Doctors*,
As the World Turns, *One Life to Live*,
and *The Bold and the Beautiful*

"I love working with Jeanne. She has a great sense of humor and she and I don't hold back with our opinions. I have warm feelings for her because I respect the fact that she has survived in this business for so long and is still standing strong."

—Eric Braeden

"Jeanne Cooper is a wildly interesting woman, and lucky for us, she has written a wildly interesting memoir. Treat yourself."

—Marcia Wallace, actress and author of
Don't Look Back, We're Not Going That Way

"What a great life Jeanne Cooper has had! And here she is, having come full circle. Jeanne started out young and innocent and has ended up *old* and *innocent*."

—Susan Flannery, Golden Globe
and Emmy Award–winning actress

Not Young, Still Restless

A Memoir

JEANNE COOPER

with Lindsay Harrison

itbooks

AN IMPRINT OF HARPERCOLLINS PUBLISHERS

*it***books**

All photographs courtesy of the author except:

Page 6, top: Courtesy of Universal Pictures Company, Inc.

Page 8, top: Courtesy of *The Young and the Restless*

Page 15, bottom: © 1973, 2012 CPT Holdings, Inc.

Page 16, top: Courtesy of Charles W. Bush, photographer, and *CBS Soaps in Depth*

Page 16, bottom: © 1973, 2012 CPT Holdings, Inc.

A hardcover edition of this book was published in 2012 by It Books, an imprint of HarperCollins Publishers.

HarperCollins books may be purchased for educational, business, or sales promotional use. For information please write: Special Markets Department, HarperCollins Publishers, 10 East 53rd Street, New York, NY 10022.

First It Books paperback published 2013.

Designed by Renato Stanisic

Library of Congress Cataloging-in-Publication Data is available upon request.

ISBN 978-0-06-211775-5

13 14 15 16 17 ov/rrd 10 9 8 7 6 5 4 3

To Corbin, Collin, and Caren,
my three greatest accomplishments

Contents

Not Young, Still Restless

The Obligatory Beginning

I think Bill Cosby put it perfectly many years ago when he said, "I started out as a child." And so naturally, that is where my story begins.

It never occurred to me at the time that there was anything unique about my childhood. Like most people, with nothing to compare it to, I assumed it was normal to move too often to make lasting friendships, to have a cow as your closest confidante for a while, to be molested a couple of times, and to know with absolute certainty by the end of eighth grade what you wanted to be when you grew up.

But since one of life's great lessons is that there's no such thing as "normal," I'll go all the way back to the beginning, into some places I haven't explored in decades, and tell you all about it, even the parts that make me cringe. (Don't you hate those autobiographies in which you know you're being lied to? I always find myself wondering why the authors bothered. I intend on sharing it all, even those moments I would prefer to forget.)

~ ~ ~

I MADE MY FIRST entrance on October 25, 1928, in the beautiful little oil town of Taft, California. True to family tradition, my mother's mother, Grandma Moore, delivered me at home, with a doctor standing by. There was no great rejoicing, no congratulatory cigars being passed around to all the menfolk, just a subdued resignation that Wilma Jeanne—the unplanned third child in the family, the one my mother occasionally referred to as "the night the diaphragm didn't work"—had arrived, healthy, loud, and eager to live whether they liked it or not.

My father, Albert Troy Cooper, was English and Cherokee Indian. My mother, Sildeth Evelyn Moore, was Irish and Cherokee Indian. They met in Oklahoma, where both families worked in the oil fields, and they were married after a fairly brief courtship. (I used to wonder if Mother was already pregnant with my brother, Jack, on her wedding day. But by the time I got married, I had no stones to throw on that subject.)

Tragically, in Oklahoma in the early 1900s, full-blooded Native Americans, many of whom worked side by side with my father and grandfather, were targets of cruel discrimination and the shameful epithet "red niggers" by too many ignorant bigots and bullies. My very proud, very regal, very "color"-blind grandma Moore wasn't about to have her grandchildren raised in such an intolerant atmosphere, so at her insistence, the Moores and the newlywed Coopers moved to Taft, where the men could pursue their oil careers and the family could thrive in the open-minded, harmoniously integrated West.

It was such a great idea on paper. In practice, though, it was occasionally rough and scary and even life-threatening. I was too young to understand much of what was going on, but I know that

my father and his business partner enraged some powerful people by being very outspoken advocates of equal pay for oil field workers of all races. I know that my father's business partner was murdered. I know that my mother and I hid in a ditch in a cotton field one day, with Mother's hand over my mouth to keep me quiet, while some angry men looked for my father, and that my older sister, Evelyn, and I were rushed to the school basement when I was in second grade because someone was trying to scare my father by threatening to harm us. And I know that my father and my grandpa Moore were good, brave, hardworking men who never backed down from or apologized for their beliefs, and I was proud of them.

I wish I'd known my father better. He traveled for work much more than he was home, and when he was around he seemed larger than life to me. Family vacations with him were adventures to such magnificent places as Yosemite, Sequoia, and Kings Canyon National Parks, where we hiked and explored and learned to share his ancestral reverence for the land and wildlife around us, which more than made up for his complete disinterest in organized religion as far as I was concerned. He believed, and taught us to believe, that we weren't entitled citizens of this planet, that instead we were its privileged custodians who owe it our most vigilant care and gratitude. In fact, to this day, thanks in large part to my father, I'm as diligent about feeding the birds and squirrels around my house as I am about feeding my three dogs.

I remember his free-spirited playfulness.

I remember how dapper he looked when he got dressed up.

I remember being sound asleep early one morning and feeling something wet and silly on my cheeks, and opening my eyes to see that my face was being covered with kisses by a tiny Pekingese puppy my father brought me as a surprise.

I remember discovering when I was very, very young that I could

be funny, that being funny was an almost guaranteed way to get his attention, and that I loved making him laugh.

And I especially remember the one week of my life when my father and I spent time alone together. I was in high school, still recovering from my mother's death from uterine cancer. My brother and sister had both left home with their respective spouses. I walked into the kitchen one morning to find Dad sitting alone at the table crying. It was the first and only time I ever saw him cry. If we'd been closer he might have known he could talk to me about whatever was wrong, and I might have known how to comfort him. As it was, there was nothing but silence between us while he turned away to hide his tears and collect himself. Then, out of nowhere, he said, "Let's go visit Aunt Ellen."

Aunt Ellen was one of Dad's many cousins, and they'd been the best of friends since childhood. She lived in Memphis, where I'd never been before, and it took me no time at all to reply, "Okay, let's go visit Aunt Ellen."

We took the train to Memphis and back, drinking in every mile of this beautiful country along the way. Aunt Ellen was warm and loving, a peaceful, comforting presence I probably needed as much as Dad did. She had a car she only drove in two gears—third and reverse—and I remember she couldn't honk the horn because honking was illegal in Memphis at the time. Most memorable of all, though, was how proud and special it made me feel that my father invited me—just me—to spend a week with him. I would have been too shy with him to tell him how much it meant to me, but I do hope I said thank you.

And then there was Mother, who was so different from Dad in so many ways. But their marriage never seemed to me like the old cliché about how opposites attract. Even as a child I never felt that they had a particularly close, loving relationship. There was a

lack of chemistry between them, no intimate unspoken connection when they looked at each other. My best guess is that they hadn't necessarily fallen in love when they met, but that they satisfied each other's ideas of "good marriage material," and they weren't wrong. He was a hard worker and a responsible man who would always provide for his wife and children as best as he could, and she was a devoted mother, homemaker, and schoolteacher who never complained about her husband's long, frequent absences.

Despite marrying a man who simply refused to set foot inside a church, she was a devoutly religious woman. I was never quite sure which denomination she embraced; I just knew it included a long list of sins that included dancing, wearing makeup, and a lot of other things that frankly matched my list of things I was looking forward to. I never understood it, and I certainly never related to it—it seemed dogmatic, arbitrary, and fear-based to me, as opposed to the joy, comfort, peace, and acceptance I believe our Creator offers. I still remember a huge family Thanksgiving dinner in Taft when I was four years old. For no reason at all other than being playful little girls who loved attention, a cousin and I decided to entertain our relatives by performing a brief, enthusiastic hula. Mother put an immediate, shrieking stop to the dance, horrified at the sight of two innocent four-year-old children "moving their hips back and forth like that!" Not for a moment did I or do I believe we'd done anything wrong, and if I'd been an adult in the room at the time, I would have loudly joined the chorus of relatives who were quick to point out, "They're kids, for God's sake! They're just playing!"

Also unlike Dad, Mother was an introvert without his sense of adventure, which, through a child's eyes, made her look just plain not as much fun as he was when he was around. A particular pet peeve of mine was that on family vacations, when Dad and Jack and

Evelyn would take off to climb a mountain together, or go canoe-
ing down a river, I was expected to stay behind and keep Mother
company, because she was too afraid and/or too disinterested to try.

Come to think of it, those occasions seem to magnify a kind of
running theme throughout my childhood. I know that sometimes
the third-born and last child is pampered and spoiled and treated
like the perpetual baby of the family. In my case, it felt more as
if I'd arrived late to a dance at which everyone had already paired
up. I was very different from my brother and my sister, and from
my mother and my father, for that matter, and I never quite found
a place among them where I felt as if I could relax, be myself, and
just belong.

Dissimilarities and mutual frustrations aside, I remember
Mother with love, gratitude, and respect for being the prototypi-
cal Good Woman. She was, after all, a working mother of three
whose husband was gone most of the time, and she took great care
of her children and her household no matter how many times Dad
relocated us. We were never neglected, and we never doubted for a
moment that we were loved. And during two very ugly crises in my
childhood, she was my fearless, unequivocal hero.

The first one occurred when I was five years old. As usual, a
group of relatives had come to visit, including Uncle John, who
was actually someone's cousin. Uncle John was fun and funny,
and we kids invariably competed for his attention, so I felt like a
princess when he invited just me and nobody else on a trip to the
grocery store.

I'm not sure when it was during the ride that I detected a subtle
change in Uncle John's affection toward me, or when I started to
feel in the pit of my stomach that something was wrong. But I have
a very clear memory of my growing, sickening fear, of the car stop-
ping far away from the store, and of Uncle John telling me what

pretty legs I had while he reached over and slid his hands up my skirt and into my underpants.

I had two immediate, involuntary reactions, the second of which was a guaranteed mood breaker for Uncle John—I began to cry, and I defecated all over the front passenger seat of his car.

Needless to say, he suddenly couldn't get me home and out of his car fast enough, and I couldn't race into the house and find my mother fast enough. I was sobbing so hard in Mother's arms that I barely got out the words "Uncle John tried to stick his hands up my legs where I poop."

She didn't question it. She didn't accuse me of exaggerating or making it up. She didn't make me feel as if I'd done anything wrong. She simply held me, dried my tears, and promised she would take care of it. Next thing I knew, the group of relatives, including Uncle John, was being escorted out the door, and I heard my mother say to Uncle John's wife, in a tone that was more a promise than a threat, "Get him help or one of us is going to kill him." I have no idea whatever happened to him, but I hope his karma was swift.

Mother was every bit as fiercely heroic when I was twelve. We were in Taft, no longer living there, just visiting still more relatives while Dad was off working God knows where. A woman who lived at the end of the block with her sixteen-year-old son earned her living by taking in laundry, and my relatives had been patrons of hers for years. So no one, including me, thought a thing about it when, one lazy, sweltering summer afternoon, her son offered to take me out for a chocolate malt.

Next thing I knew he took a wrong turn—away from the nearby malt shop, away from town—and drove into a dusty, desolate oil field in the middle of nowhere, and all the while that knot of icy fear began forming in my stomach again.

He was on top of me the instant he stopped the car, his mouth

and hands everywhere. I kicked, I fought, and I screamed, know-
ing no one could hear me. I was so terrified that a huge rush of
adrenaline flooded into me and somehow, despite the fact that he
was more than twice my size, I managed to slide out from under
him and jump out of the car.

Unfortunately, I had nowhere to go. There wasn't a person or
building in sight to run to, so I simply ran away from him as hard
and as fast as I could. He had no trouble catching me, and his voice
was calm and almost apologetic when he grabbed me. "Get in the
car, Jeanne," he said so sweetly. "I'll take you home." I refused,
tried to pull away, and kept on fighting him while he repeated over
and over again, "I'll take you home, I promise, just get back in the
car." Finally, still scared to death, physically outmatched, and fresh
out of options, I slid back into the passenger's seat, pressed myself
against the door, and gripped the handle, fully prepared to leap out
of the car again if it came to that, no matter how fast it was going.
But to my profound relief, he really did drive straight home without
trying another thing or saying another word until he stopped in
front of my relatives' house.

"You're not going to tell anyone about this, right?" he asked
quietly.

"Of course not," I lied. "I won't say a word."

I promptly flew out of that car and safely indoors, where I told
my mother everything. Again, she didn't doubt me for a moment,
or make me feel one bit responsible; she just comforted me and
made sure I was okay. Then she and one of my aunts marched up
the street to have a talk with the boy's mother. By the time they
came home again, the entire neighborhood could hear the mother
giving her son the beating he deserved.

(I should add that I owe a debt of gratitude to that ice-cold knot
of fear in my stomach. I learned to listen to it, and it served me

well when I got to Hollywood, saving me from a few producers, directors, and casting agents who probably thought of themselves as "ladies' men" but who, as far as I'm concerned, were no better than those two predators who molested me as a child and made me ask myself that sadly disturbing, unanswerable question: "Why me?")

I've always wondered if Mother just decided one day to loosen up a little because she damn well felt like it or if this was the result of a subconscious premonition, but when I was about to enter my teenage years, she suddenly started wearing makeup and letting her nails grow long, painting them bright, immodest shades of red. It didn't shock me as much as it intrigued me, and I remember thinking, "Good for you." I wish I'd said it out loud.

A few short months later Mother's health started to decline and we first heard the ugly words "uterine cancer." Today she would have stood a great chance of beating it. Back then it was a cruel, hopeless series of trips back and forth from home to the hospital, a three-year war that she finally lost on August 21, 1945. I was sixteen years old.

In a way, her death meant the end of any security and stability I'd found in my family. Jack had long since started a family of his own and then marched off to fight in World War II. Evelyn had married Everett, an army man she'd known throughout her high school years. Now my mother was gone, and because she had no health insurance, her medical bills left us virtually penniless. When Dad got a job offer from an oil company in Edmonton, Canada, he wasn't about to turn it down, and I wasn't about to move yet again and spend my senior year in high school surrounded by yet another group of strangers. So I waved good-bye to the last remaining member of my immediate family, spent my senior year living with my friend Faye Krause and her family, graduated from Bakersfield High School in the top third of my class, and never looked back.

~ ~ ~

IT PROBABLY SHOULD HAVE been harder for me than it was to let my father move to Canada without me when, in a way, he was all I had left. But very early in my life, because we never seemed to stop relocating, I developed a very effective defense mechanism for coping with the "saying good-bye" process to keep it from being too painful—I learned to avoid getting all that attached to begin with.

In the first eighteen years of my life I lived in Taft, Fellows, Pumpkin Center, Pixley, Porterville, Tupman, Panama, Redondo Beach, Bakersfield, and Pasadena, not necessarily in that order. At one point Dad even moved us to a five-acre farm so that Jack, Evelyn, and I could learn to truly appreciate animals and the land. Jack was given a cow named Rose, Evelyn had chickens, and I raised rabbits, with whom I won more than one blue ribbon at the California State Fair, thank you very much.

I had a special bond with Jack's cow. Rose had beautiful eyes and was such a calm, gentle, reliable presence that for a few years she was my best friend and closest confidante—I could tell her anything without having to worry about her judging me or betraying my confidence, and she always let me do all the talking.

When it came to human friends, I gravitated more toward my teachers and other adults than I did toward children my age. Dolls and tea parties with teddy bears and playing dress-up were never my idea of a good time, and when there were no adults around to hang out with, I was lucky enough, for as long as I can remember, to enjoy my own company and not rely on anyone else to make me happy.

Not for one minute, though, did I let that deprive me of the sweet joy and the heartbreaking anguish of falling in love.

~~~

CHARLES CLARK AND I were eleven years old when we met as classmates. He was a gifted athlete and a good student, with a smile that sent a thrill through me from the first moment I saw it, and we were the poster children for every book, song, movie, and poem ever written about first loves. I adored him, and I adored how it felt to love him and be loved by him. In fact, it was Charles who inspired my lifelong belief that those of us whose first loves were significant and lasted awhile spend the rest of our lives trying to re-create that same intensity, that sweet sense of purpose and focus and completeness, that perpetual excitement of always having something to look forward to, because just being together, or talking on the phone, or seeing each other in the hall between classes, felt like special occasions. I'm sure I spent the rest of my love life trying to re-create the "high" of Charles Clark, and at the risk of ruining the suspense, I'll tell you right now it never happened.

Charles and I mutually agreed on two conditions when we officially started our relationship. The first was that if either of us found ourselves wanting to be with someone else, we would tell the other immediately. The second was that no matter how tempted we might be, he would respect my insistence on being a virgin when I got married. That wasn't some hysterical reaction to the two molestation experiences I'd had, or a blind acceptance of one of Mother's religious rules whether it made sense to me or not. It was my idea, my belief that my virginity was too valuable to forfeit for anything less than a lifelong commitment. Charles, hormones and all, respected that without question or complaint, which, of course, only deepened my faith in him and made me love him more.

To add to the perfection, our parents approved, so there was no sneaking around or lying or other family drama to complicate

things. We spent a lot of time at each other's houses, and Charles's mother even drove us to Bakersfield one night to see the premiere of an impossibly romantic movie called *Gone with the Wind*. (I still remember how shocked I was to hear the word "damn" come out of someone's mouth on-screen, let alone Clark Gable's.) And when Charles's father was transferred to another town and his family moved away, I loved going there to spend weekends with my boyfriend and with the people I was sure were my future in-laws.

So when he called one day and said he had something to tell me and it had to be in person, I was so excited about seeing him for the first time in almost a month that I conveniently ignored the weight in his voice and simply started deciding what to wear.

He didn't kiss me hello when he got there. He barely looked at me as he stepped past me into the house and stood in the living room like a stranger, studying the floor. And when I finally broke the silence between us and asked what was wrong, he took a few long, deep breaths before he answered me.

He told me her name, but I was too stunned to hear it. He may have told me everything about her, and how long they'd been seeing each other, for all I know. All I heard was a steady, deafening, horrible buzzing noise in my ears until he got around to the two words I heard loud and clear: "She's pregnant."

I was sure the ground was falling away beneath my feet, and I felt sick from the pain and rage that instantly welled up in me. But I guess I instinctively refused to give him the satisfaction of knowing that, because all I said, in the calmest, steadiest voice you've ever heard, was, "I understand." Not bad for a sixteen-year-old girl whose world had just exploded, don't you think?

And then I completely outdid myself by accepting his invitation for me to meet her. No, not someday, not even later that day. What luck, she was sitting outside in his car at that very moment.

Shock is an amazing phenomenon, isn't it? Without a single beat of hesitation, I walked out of the house with him, head held high, and marched up to the car and looked right at her when he introduced us, although I couldn't tell you a thing about her. She probably had hair, and a face. She probably said something, and I probably said something back. Maybe we shook hands, maybe not. The one thing I'm sure of is that I gave her my best smile for that two- or three-minute encounter, a smile I hoped said, "If you think you're the winner in this situation, guess again."

Then I waved good-bye to both of them, walked back into the house, closed the door behind me, and cried until there were no more tears left in me.

From what I heard, they got married soon after that, a marriage that lasted until shortly after the baby was born.

He tried several times to get in touch with me, but I never saw or spoke to him again.

It became a lifelong pattern, personally and professionally: I don't care who you are, you don't get more than one chance to betray me, and as this book should make apparent, I have a very long memory.

~~~

I'M NOT SURE HOW I would have made it through the end of Charles and me, or Mother's death, if it hadn't been for another great love of my life, one that started when I was thirteen and continues to sustain me to this day: the love affair between me and an audience.

I was in eighth grade, and I was chosen for a small part in the class play. I think it was called *Annabel Steps In*, or something equally compelling. I've had several colleagues over the years who

knew from the day they were born that they were destined, even driven, to be actors. That wasn't the case with me. Acting had never occurred to me. I thought no more of learning my lines and rehearsing for *Annabel Steps In* than I thought of doing the rest of my homework and, because I'm an overachiever, doing it well. But then, on opening night, I stepped onstage in front of an audience and it changed my life. It changed me.

It wasn't just the novelty of being the center of a whole lot of attention that felt so utterly joyful. From those very first moments, it felt like an unspoken agreement between me and the audience: the more pleased they were with whatever it was I was doing and saying, the more I wanted to please them, so that we fed off each other and created a unique experience together that neither of us could have created on our own. It was uncomplicated, reciprocal, and unconditional, a real connection and an exchange of energy I never saw coming and that I continue to treasure to this day. It fulfilled me, it made sense to me, it impelled me, and it gave me something I'd yearned for and wasn't sure I would ever find—I finally had a place to point to and say from the heart, "I belong here."

I immediately became addicted to learning everything there was to know about the theater, from performance skills to the material itself. I voraciously read and wrote reports on every play in the library. I especially fell in love with the works of Noël Coward and had the pleasure of performing in a Bakersfield Community Theatre production of his wonderful play *Blithe Spirit* during my high school years. In fact, I leapt at every opportunity to appear onstage, and by the time I graduated, I'd decided with absolute certainty on the course my future would take: I would study and prepare and work hard to save money, and at the first opportunity I would move to New York and spend the rest of my life as a deliriously happy, utterly fulfilled stage actress. That never happened, of

course, which should teach us all a good lesson about the words "absolute certainty."

I headed straight from Bakersfield to the Pasadena Playhouse College of Theatre Arts, which my father could never have afforded without the help of my mother's only sister, my aunt Della. She lived in Los Angeles and was kind enough to offer me a free place to stay. I'd also been active enough in theater to earn a lifetime membership in the International Thespian Society, so I hit the ground running in Pasadena and loved every minute of it, soaking up every bit of knowledge, education, and experience that came my way. It was a joyful time—I was in my element and growing more confident with every class, every performance, every new friend who shared my dream—and I was devastated when, at the end of my first year, Aunt Della announced that she was moving away, and Dad informed me that without the room and board she provided, he couldn't afford for me to stay at Pasadena Playhouse College any longer.

There's a wonderful old saying that goes, "When God closes a door, somewhere He opens a window." I doubt if whoever coined that saying was thinking of Stockton, California, at the time. But just as I was mourning the loss of my education, and possibly my theatrical career in New York, my sister, Evelyn, and her husband, Everett, invited me to stay with them in Stockton. There I could take extension courses through the theater department of College of the Pacific, get credits for performances, and explore the incredible array of theater, ballet, opera, and other creative arts that Stockton had to offer.

I sadly waved good-bye to Pasadena, and was still drying my tears when I arrived with my luggage on Evelyn and Everett's doorstep and embarked on four of the happiest, most stimulating years of my life.

Eager to start supporting myself, I got a job in an appliance store and scheduled my theater and improv classes around my shifts.

I did play after play after play, particularly such light opera classics as *Naughty Marietta* and *Song of Norway*. Randy Fitz, a College of the Pacific professor, also wrote several plays and cast me in every one of them.

I wrote and cohosted a radio show about campus life with my friend Jerry DeBono, cleverly called *Jeanne & Jerry*.

Jerry and I teamed up with our friends Donny Dollarhyde and Pat McFarland to perform sketches for visiting conventioneers.

I wrote and performed in the Stockton centennial show.

I became part of a wonderful, talented, informal group of theatrical performers, directors, and playwrights who made occasional trips to Los Angeles to check out the theater world there, while similar groups regularly made the trip from Los Angeles to Stockton to see what was going on with us. It wasn't long before strong, lasting friendships evolved between the two groups—in my case, such great pals from L.A. as Tony Kent, Jerry Lawrence, Janet Stewart, Clarence Stemler, and Billy Lundmark would change my life whether I wanted them to or not.

And oh, yes, I almost forgot, I got engaged. His name was Owen Chain. He was a smart, exciting, talented man from a very influential family, and we met one night when he came to say hello to the director of a play I was rehearsing. He quickly became a part of our inseparable theater circle and a part of my life as well, so supportive and well connected that he got me admitted to the Royal Academy of Dramatic Art in London. I passed, having no desire to leave the comfort, friendships, and success I'd worked hard to achieve in Stockton. After a whirlwind two-month engagement, I also passed on marrying Owen, having no desire to

tie myself down with a marriage to him or anyone else. Two more things I then knew with "absolute certainty": I would happily stay in Stockton for the rest of my life, and I would never get married. (Are we sensing a pattern here?)

~ ~ ~

OWEN WASN'T THE ONLY person trying to persuade me to leave Stockton. My L.A. friends had begun trying to convince me to move there. "You can do so much more," they would say. "You're a big fish in a small pond. In Hollywood you can be seen by people who can open up a whole new world of opportunities." Even Randy Fitz, my College of the Pacific professor, had been telling me that four years in Stockton was quite enough and it was time for me to spread my wings.

I was having none of it. I was well known right where I was, and I had my choice of roles in a wide variety of nonstop, challenging theatrical productions. I'd moved to an apartment I loved and furnished it exactly the way I wanted, and I still had the security of my job at the appliance store. As far as I was concerned, that was about as good as life could get.

So my friends decided to take matters, and my future, into their own hands.

I never did find out who all was involved in this, or how long it took for them to plan and choreograph it behind my back, and I swear to you, I'm not making this up, because I couldn't.

I woke up one morning on what seemed like a perfectly normal day, got dressed, and headed off to work. I arrived to discover that Tony Kent and Janet Stewart had arrived before I did and given my boss notice that I was quitting, effective immediately. My boss and

I had a great relationship, and he took this news so well that when I walked in the door that morning he greeted me with a sweet, supportive, "I know it's time for you to move on, and I understand completely." I obviously had no idea what he was talking about, but before I could ask, Tony and Janet came bursting in, grabbed me, and walked me right back out the door.

"Come on, Jeanne, let's go," Tony ordered, thoroughly enjoying himself.

"Go where?" I sputtered.

"Your new home."

We arrived at Tony's car, which was packed with all my clothing, and over the next several hours on the road, they filled me in on the whole astonishing story.

The minute I left for work, where Tony and Janet had already resigned on my behalf, a second team of friends had raced into my apartment, completely cleaned it out, loaded all my furniture into someone's truck, and delivered it to its new owner in Stockton, my friend Millie.

And that night I was delivered to the partially furnished apartment above a garage they'd already rented for me in Los Angeles.

So there you have it, my answer to the age-old question: "How does an aspiring actor get to Hollywood?"

Get yourself kidnapped by the best and sneakiest friends anyone could ask for (and even when you're in your eighties, never, ever forget them).

CHAPTER TWO

Hollywood and I Discover Each Other

So there I was, waking up that first morning in Los Angeles in my new apartment, complete with a space-saving bed that rolled into the wall when it wasn't being used. My head was spinning from the day before, a day that had started with a routine drive to my job at an appliance store in Stockton and ended in a whole new world with a whole new life. I was overwhelmed, scared, and more than a little excited as I assessed the situation. I'd grown up being relocated whether I liked it or not, so I had plenty of experience adjusting to that. I'd proven to myself that I could hold down a steady day job and do it well, which meant I wouldn't let myself starve, and no one had studied harder or worked with more dedication to learn and love the art of performing, which meant I still had a long way to go but nothing to apologize for. This might work, I decided. And even if it didn't, it wouldn't matter, since I'd be moving on to New York City theaters before long anyway.

Armed with that confidence, the dear friends who'd brought me here, and more than a little false bravado, I hit the ground running.

Through one of those dear friends, Paul Davis, I got a job at Ball Scripts, a company that typed and mimeographed scripts for the studios and routinely employed struggling actors in need of rent and grocery money. What it lacked in glamour it more than made up for in inside information—we got to see firsthand and ahead of the rest what projects were being done in town and what parts would be available.

At the same time, another of those dear friends, a choreographer named Jack Pierce, decided to open a theater-in-the-round called the Gallery Stage at the corner of Crescent Heights and Santa Monica Boulevards, in the heart of Hollywood. It was a wonderful ninety-nine-seat space, perfect for the production of *On the Town* with which it opened its doors for the first time. I was privileged to be part of the cast, and in this case being part of the cast also meant being part of the crew. Between rehearsals and our day jobs, we hammered, we painted, we hauled, we scrubbed, and we fell in love with that theater. I mean it literally when I say that we were still pounding the last few nails into the floorboards on opening night and changing from our coveralls into our wardrobes with only minutes to spare.

I threw my first official Hollywood party during those insane weeks of rehearsals. I have no idea how that many people managed to wedge themselves into my small apartment. I also have no idea when or why I fell asleep on the couch. But first thing the next morning I woke up yearning for my magical disappearing wall bed.

I still remember the shock of rolling the bed out from its hiding place in the wall and discovering that it was already occupied. There, peacefully and soundly asleep, was Pat Morrison, a fabulous singer and dancer in the *On the Town* cast. Having never entertained an

overnight guest before whom I didn't know was there, let alone one who was hidden in my wall, I was debating the etiquette of the situation (i.e., whether to wake her up or let her sleep) when my doorbell rang. I answered it to find Don Gazzanaga, aka Pat's husband, standing there.

"Good morning, Jeanne," he greeted me cheerfully. "Thanks again for last night. Great party. Really, just great. I was wondering, though, did I happen to leave my wife here?"

Before I could say a word, Pat came scuffing up behind me and said sleepily, "Right here, honey." She turned to me for a hug and promised to see me later at the theater, then scuffed on out the door and disappeared with her husband.

"Interesting marriage," I thought as I watched them drive away. "Interesting town."

(Pat and Don and I became close friends over the years, by the way, and it turned out that they had a strong, happy, totally committed marriage. They apparently just misplaced each other every once in a while.)

DESPITE ITS ALMOST LEISURELY sprawling layout, Hollywood is a very small town, and word spread quickly among the acting community that a new theater called the Gallery Stage was opening. Our first audience was graced with the likes of Elizabeth Taylor, Debbie Reynolds, Betty Garrett, Norma Shearer, Barbara Eden and her husband, Michael Ansara, and more than a few other show business movers and shakers. We were a hit, we were ecstatic, we got great reviews, and we were suddenly in demand.

The studios immediately started calling, wanting to meet me. I had no agent and not enough experience to know which calls to

return and which to ignore. Paul Davis came through again—his cousin Jerry Herdan was an agent, half of the successful Herdan-Sherrill Agency, and next thing I knew, he was officially representing me. Jerry had several clients at Universal Studios and arranged a meeting for me there.

Another "next thing I knew" thanks to yet another wonderful pal: Bill Lundmark, one of the elves who'd participated in my surprise move from Stockton, was a good friend of an actor named Raymond Burr, who was fresh from a prestigious performance in a hit film called *A Place in the Sun* with Elizabeth Taylor and Montgomery Clift. As a favor to Bill, Raymond agreed to do a screen test with me for Universal Studios, a scene from another recent movie called *Detective Story*.

Universal promptly offered me a contract, and believe me, $250 a week was far too generous a salary for me to pass up. Suddenly I found myself surrounded by such esteemed colleagues as Shelley Winters, Lee Marvin, Tyrone Power, Rock Hudson, Julie Adams, Dennis Weaver, and Beverly Garland, to name just a few.

There was a lot to be said about the legendary "studio system" in those days. Publicity departments worked hard to create and perpetuate images for its contract actors that we were expected to maintain (in public), while the studios provided a mandatory series of classes, teaching us everything from acting to dancing to horseback riding to wardrobe and makeup skills. We visited soundstages and postproduction houses to learn about filmmaking both in front of and behind the cameras and to see with our own eyes that we actors were only one part of the process. Our "den mother" at Universal was a drama coach named Sophie Rosenstein, and I've never forgotten the speech she gave her new students on our first day of "school," which still resonates to this day:

"Some of you are here because of your looks," she said. "Some of you are here because of your talent. And some of you . . . I have no idea why you're here. But whatever you're doing here, never forget that this is first and foremost *a business*. The studio is investing money in you, and if they don't get a return on their investment, count on it, you will be excused."

It was an exhilarating time. I loved everything I was learning both inside and outside those classes at Universal. It became apparent, for example, that, to paraphrase Sophie's speech, some of us were aspiring to be famous and others of us aspired to be skilled, legitimate actors. In my case I quickly realized that my passion was acting, and whether it led to fame or anonymity was beside the point. I also discovered that while there were, and are, some truly great people in this town, people of real worth and substance, Hollywood was, and is, a place where far too often qualities like depth, talent, and integrity are valued less than skin-deep appearances, a place where many fail to remember that genuine success has nothing to do with wealth. In fact, some of the creepiest, most despicable people I've ever met happened to be rich, proving that the old adage really is true: money doesn't care who owns it.

My mandatory presence at the studio made it impossible to keep my job at Ball Scripts, but I kept right on performing in and loving *On the Town*. And then, one fateful day, casting director Millie Gussie called me to her office at Universal and informed me that I would have to give notice at the theater, because I'd be too busy shooting my first movie, *The Redhead from Wyoming*, with Maureen O'Hara.

I know. You'd think I would have been yelling "Thank you!" at the top of my lungs and turning cartwheels around the room. Instead, I was about to be taught a lesson in what could be called Contract Signing 101.

"I'm sorry," I told her, "but I've only got one week to go on the play, and then I'll be moving to New York. Thank you for thinking of me, though."

She smiled a little and patiently let me finish making a fool of myself before she replied, "*I'm* sorry, but that won't be happening. You signed a contract. Universal made a six-month commitment to pay you $250 a week, and you made a six-month commitment to earn it."

And that's the story of how my film career officially began.

The Redhead from Wyoming, a story of a cattle war in Wyoming Territory, confirmed everything I'd been hearing from other actors on the lot: nothing's more fun to do than a Western. (For the record, I would leap at the chance to do another one today. How about Jeanne Cooper and Eric Braeden in *The Life and Legend of Wyatt AARP*? Anyone . . . ?) In addition to Maureen O'Hara, the cast included Alex Nicol, Jack Kelly (the future Bart Maverick in the *Maverick* TV series), and Dennis Weaver, who was cast as Chester in the iconic series *Gunsmoke* not long after *The Redhead from Wyoming* was released.

I played the role of a showgirl named Myra, and from the very beginning I couldn't help but notice that Maureen O'Hara, the saloon proprietress, was repeatedly cutting more and more of our scenes together. I didn't appreciate it, but even more than that, I didn't understand it, especially since she wasn't cutting anyone else's scenes but mine. Approaching Miss O'Hara about it was out of the question—I wasn't shy, but I knew my place on the set—so I asked our director, Lee Sholem, about it instead, wondering if I'd done something to offend our star, and if I had, what on earth it could have been, since I thought I'd been nothing but respectful and professional.

"It's nothing you've done," Lee assured me. "It's who you are."

"Who I am? What does that mean?" I asked, incredulous. "I'm

a newcomer. She's Maureen O'Hara. What does who I am have to do with it?"

He put his hand on my shoulder and led me off the set until we were out of everyone's earshot, and he kept his voice discreetly quiet and compassionate. "Exactly," he said. "You're a newcomer, and she's Maureen O'Hara. Or, to put it another way, you're a fresh, dynamic, talented young actress with your whole career ahead of you. She's an established star who's been around awhile, and standing next to you on-camera makes her look and feel older. Please don't take it personally."

I'll always appreciate how graciously he handled it. That simple, honest explanation erased any possible resentment I might be harboring and made me want to reach out to her. Later that morning, at the first opportunity, I sat down with her and said, partly because I meant it and partly to defuse any resentment *she* might be harboring, "Miss O'Hara, I just wanted to tell you how honored I am that I'm doing my first film with you. I'm new at this, I don't know what I'm doing, and I can't imagine working with a more patient, more generous teacher."

She'd clearly been feeling guilty—she immediately thanked me and started making excuses for cutting so many of my scenes, while I kept on complimenting her, hoping the ice between us had finally been broken.

That afternoon we were shooting a crowded dance hall scene. I was standing in the background among several other actors, where I'd been told to stand, when I felt an arm slide around my waist to subtly move me a little to my right. It was Maureen O'Hara, who whispered before she left me there, "Always remember, Jeanne, if you can't see the camera, the camera can't see you." She made sure I could be seen; I've never forgotten that bit of advice, and I've most definitely never forgotten her.

I was happy to go directly from that film to another Western, *The Man from the Alamo*, starring Glenn Ford, Julie Adams, and the very handsome Hugh O'Brian, television's future Wyatt Earp. It was during the shooting of that movie that one conversation with a good friend convinced me to give up my New York dreams once and for all and made me realize that I was actually right where I belonged.

David Janssen was that good friend. He and I were Universal contract players together, and he was still relatively unknown, a decade away from his megasuccess in the television series *The Fugitive*. One day he kidnapped me from the *Man from the Alamo* set for lunch, arranging with a studio wrangler for us to ride two of the horses far into the vast back lot where we could have a picnic in peace and, as usual, confide in each other about our dreams for the future of our careers.

There wasn't a building or another person in sight while we relaxed there together. The only signs of civilization were several reflectors on tripods at the top of a hill. David looked up at them during a long, thoughtful moment of silence and then pointed at them and said, "I'll tell you where the future is—it's right up there. Get in on the ground floor of that and you'll have a career you can count on."

I didn't have a clue what he was talking about, and told him so.

"That's a television show they're shooting on that hill. Take my word for it, television is going to be the most exciting thing to happen to actors since motion pictures were invented."

I know it's hard to believe, but there actually was a time when television didn't exist, and in the early 1950s television sets were just beginning to appear in living rooms across the country. Its potential seemed limitless, as did its need for programs, which meant

a whole new world of employment possibilities for us actors. You know how sometimes you hear something and you know it's true? You're not even sure why you know, you just do. And that's the way it was with that prediction of David's.

Apparently the timing of the truth counts for something too. As David daydreamed about the magic that TV would perform on the entertainment industry someday, I flashed back to an evening at the Pasadena Playhouse when a small herd of executives in expensive suits gathered us acting and theater majors for a rah-rah session about a new phenomenon called television. It was going to sweep the country, the execs said, and there would be a time when no home in America would seem complete without one. Its potential was beyond our wildest imaginations, they said, but it couldn't happen without those of us in the creative community. Come join us when you graduate, they said, and we will guarantee each of you a CEO position in the television industry.

They asked for a show of hands of everyone who'd be interested. Not one hand went up. Give up our prestigious futures in the theater and in motion pictures for what would so obviously turn out to be nothing more than a short-lived, ridiculous fad? Yeah, that'll happen. As a proud, hardworking, theater-trained student of the esteemed Pasadena Playhouse, there was one thing of which I was "absolutely certain": my future did not lie in some mythical box in people's living rooms.

But on that day years later, on that picnic on the back lot of Universal Studios, I decided I didn't want to be a New York stage actress after all. I wanted to stay right here in Hollywood, not to be a film actor but to take David Janssen's advice and get in on the ground floor of television. Almost sixty years later I'm proud and grateful to still be working in this extraordinary medium.

IT'S MY EDUCATED GUESS that no matter what business you're in and how proficient you are at it, there's always something or someone around to make sure you're humbled from time to time. Being a busy contract actress at Universal Studios was no exception.

In 1952 Ann Blyth, Gregory Peck, and Anthony Quinn made a film for Universal called *The World in His Arms*. When the film was released, six of us actresses were sent off to Alaska with Ann Blyth and some other contract players to promote the movie and to entertain the troops who were stationed there during the Korean War. We were honored and excited, until we found out what was really going on.

It seems that while we were gone, Universal, in constant search of new faces whether they had a shred of talent or not, quickly brought several gorgeous Miss Universe contestants to the studio, put them under contract, and cast them in any roles for which they might be even remotely appropriate—roles that would have been given to us contract actresses if we hadn't been so conveniently out of town. So we returned from a long, exciting, exhausting trip to discover that not only had we been duped, but we'd also been temporarily and unceremoniously replaced by a group of international beauties who had no training and no acting experience whatsoever. It wasn't the fault of the Miss Universe contestants, needless to say. We had no one else to thank but the studio executives who "adored" us but were only too happy to shove us aside at their convenience.

It shouldn't have surprised us. Sophie Rosenstein had warned us from the very beginning that, in the end, "this is a business." But even she seemed a little sheepish at the insult she had to add to our injuries. She called us into her office one day to inform us that we'd each been assigned our very own contestant to treat as a kind

of "little sister," to take under our wings and befriend—in other words, we were to be helpful, darling tour guides, chauffeurs, and confidantes to our potential replacements. Klass with a capital *K* or what? A contract is a contract, though, and Universal had one with my signature on it, so I wasn't about to shoot myself in the foot by being uncooperative.

My new BFF was the very beautiful and oddly unhappy Miss Germany. I would have asked what she was so unhappy about, but it wouldn't have been enlightening, since she didn't speak a word of English and Universal provided interpreters only at publicity events. I promise you, I more than fulfilled my obligation. I showed her around the studio. I took her shopping. I took her to lunches and dinners with my friends. I posed with her for countless photos. And not once, no matter how much she seemed to be enjoying herself at any given time, did her undercurrent of unhappiness disappear.

I learned the sad, simple reason for it one day when I offered to drive her somewhere. I don't remember where I thought we were going; I just knew that I was relying on her for directions. There was a lot of pointing and gesturing on the long drive to wherever, and only when we were almost there did I realize that she was directing me right toward the entrance of Los Angeles International Airport. I gave her a shocked "What are you doing?" look, to which she responded in the few words of English she'd managed to pick up: "I want to go home."

Believe me, I sympathized, but in the end, I'm a survivor. I had no interest in finding out what fate awaited me if Sophie Rosenstein asked me if I happened to know where Miss Germany might be and I replied, "I put her on a plane back to Munich." Ignoring the wails and racking sobs of my passenger, I did an immediate U-turn, drove straight to Universal, personally escorted one very unhappy fräulein into Sophie's office, and hugged her good-bye. From what

I was told, she was released from her contract and flown home the following day. For someone I barely knew, whose name I don't even remember, I've thought of her often and imagined what it must have been like for her to be thrust into a town and a business that are overwhelming enough when they've been part of your dreams. Against your will, they could be a living nightmare. I hope she went on to have a wonderful life.

One of the Miss Universe contestants who was put under contract by Universal Studios and decided to stay was a stunning blond Miss Sweden named Anita Ekberg. She and I didn't know each other well, but we were certainly friendly acquaintances, and we ran into each other on the lot several times a week. She took me by surprise one day when she pulled me aside in the commissary and asked for my help in her very thick Swedish accent that I won't even try to re-create on paper.

"I'm doing a film with Tyrone Power," she whispered, "and I think he's so beautiful, but I can't seem to get his attention. We're shooting a big dance scene this afternoon, and I'll be dancing in the background of a scene with him and Julie. What can I do? How can I get him to notice me?"

The film, it turned out, was *The Mississippi Gambler*, with Tyrone Power and Julie Adams. Anita was playing the uncredited role of the maid of honor. I had no idea what to tell her, so I just offered the only advice that came to mind.

"I don't know, Anita, maybe just have your partner dance you right into Tyrone a few times. Sooner or later he's bound to notice you, even if it's just to ask you and your partner to knock it off."

She actually seemed to think this might work and went skipping off to her wardrobe and makeup call. And I admit it, my curiosity got the best of me—I couldn't resist strolling over to the set of *The Mississippi Gambler* that afternoon to watch Anita in action.

Sure enough, there were Tyrone and Julie, both of them gorgeous, dancing away in front of the cameras on a crowded dance floor, surrounded by twenty or thirty couples dancing away in the background, Anita and her partner among them.

I would have advocated more subtlety than this, but before long Anita initiated a series of minor collisions with Tyrone and Julie that kind of escalated in intensity until finally Anita Ekberg virtually slammed into Tyrone Power and a romance was born. They became the darlings of the tabloids, with the help of the Universal publicity department, and there's no doubt about it, they looked breathtaking together. It made me smile.

It was about five years later, I think, that I ran into Anita at a party with an escort who was most decidedly not Tyrone Power. In the brief private conversation between us, I found a gentle way to ask her if she and Tyrone were still together.

"Oh, no," she said emphatically. "I'm not with him anymore, and I almost wish I'd never met him."

It was the last thing I expected to hear after her almost frantic desperation to get his attention. "Why would you say that, Anita?" I asked her.

She began shaking her head with some mixture of regret and disbelief. "Terrible, Jeanne. Terrible in bed. You would not believe it, just terrible."

Definitely the last thing I expected to hear and almost too much information. But for those of you who've always wondered, there you have it, from a woman who seemed to know what she was talking about.

Not long after Miss Germany presumably landed in Munich and Anita Ekberg had collided her way into Tyrone Powers's heart, it was time for Universal and me to negotiate a new contract. My agent and I were convinced that I deserved a raise. Universal was

convinced I didn't, and that $250 a week was really very generous of them. Both sides refused to give an inch, and in the end I left, excited to freelance and find out if I might have a future in television. For about a minute and a half I was offended that Universal didn't appreciate me enough to give me the reasonable raise I demanded. But I quickly got a grip on two things I knew beyond a doubt: first, and yet again, that Sophie Rosenstein was exactly right, they don't call it show *business* for nothing, and second, that I'd never let anyone define my worth, and I wasn't about to start with Universal Studios.

I've always considered myself lucky, and it may be part of my longevity, that I grew up with my own sense of self and my own identity, rather than relying on other people's opinions of me to form the foundation on which I've built my life. I've had my share of awards and great reviews. I've also had my share of comments similar to producer Hal Wallis's assessment of me: "Jeanne Cooper just doesn't do anything for me." At the end of the day, no one is more of an authority on my strengths and my weaknesses than I am, or more responsible for the choices I've made, both good and bad.

~~~

MY FIRST GUEST-STARRING ROLE on a television series, *The Adventures of Kit Carson* in 1953, changed my life in so many ways. Not only did I instantly realize that television was where I belonged, but I also met a woman who was to become a lifelong friend. Barbara Hale was an actress whose star was on the rise, and she also happened to be the wife of "Kit Carson" himself, the handsome and very talented Bill Williams. Barbara and Bill met while they were both under contract at RKO Radio Pictures in the 1940s, and when they married in 1946 they became the darlings of the RKO

studio, both of them wonderful, great-looking people with whom audiences were beginning to fall in love.

Barbara and I clicked immediately. We liked each other, we had our careers in common, and we both loved a good game of poker and nothing more than a long, loud, convulsive laugh at any given opportunity. And one of those opportunities came along one night when Barbara was visiting the set.

We worked six days a week back then, and each of those days lasted as long as it took to complete that day's schedule. So there we all were one dark midnight shooting a "night for day" outdoor scene—i.e., with the help of a whole lot of very bright lights, scenes shot during the night look as if they were taking place during the day. There was nothing unusual about shooting night for day. We'd all done it a million times.

But what set this particular night apart was that, just as the director yelled, "Action!" a hard, steady rain began to fall. Without backlighting, the rain was invisible. So was the black tarp that was quickly secured above our heads to keep us dry, high enough that it was off-camera . . . and, unfortunately, high enough that it couldn't possibly accomplish its purpose. We gamely launched into a lengthy, rather emotional scene, professional enough that we acted as if there were no rain falling at all. My hair, though, didn't care about professionalism and behaved exactly as hair behaves in the rain, getting wetter and flatter with every line of dialogue. We all did our best to ignore it, but the more I watched my scene mates trying desperately to keep a straight face as they looked at me, the more impossible it was for me not to fall apart, so that take after take after take was destroyed as we actors were reduced to a group of giggling, howling kindergartners. And no one laughed harder than I did, with the possible exception of our star's wife, Barbara Hale.

Parenthetically, it's worth mentioning that I rank the ability

to laugh, and a sense of humor in general, as one of life's greatest survival skills. If I couldn't sit down from time to time and laugh myself senseless at things that could just as easily enrage me or destroy me, I'm sure I would have gone stark raving mad by the age of two. (Okay, occasionally laughter isn't my first reaction to a situation, but I do get there sooner or later.)

Another great source of hilarity on *The Adventures of Kit Carson* was my trial-by-fire introduction to the brand-new world of series television. I didn't think a thing about it because I simply assumed this was the way it was done. Looking back, I have no idea how we survived it.

My three episodes of *Kit Carson* were shot simultaneously, and I played three different characters. We were all slaves to maximum location efficiency, particularly when it came to outdoor scenes on the main street—we shot every one of them for all three episodes before moving on to another location. This left me galloping out of town on a pinto as, let's say, Sally, the kindhearted saloon girl, and, with a change of wardrobe and hairstyle, riding back into town on a stagecoach as Janet, the hardware store owner's wife. At some point Janet would take the stagecoach out of town again, only to return on a palomino with yet another wardrobe and hairstyle change appropriate to Amanda, the shy librarian. It was exactly as frenetic, confusing, and hilarious as it sounds, but it certainly made the rest of my television work seem like a walk in the park. One episode at a time? Seriously? After *The Adventures of Kit Carson*, I could handle that with my eyes closed.

~ ~ ~

IN ADDITION TO LIVING just blocks away from each other, and sharing the challenges of balancing our personal lives and our careers, my dear new friend Barbara Hale and I had the luxury

of working together many times, starting with a film called *The Houston Story*, which was almost more dramatic behind the scenes than it was on-screen. It originally starred the magnificent Lee J. Cobb, fresh from his unforgettable performance in *On the Waterfront*, but unfortunately, much of it was shot on location in the oil fields of Texas. In August. Enough said? One day during the rehearsal of an especially physical scene, the director, William Castle, noticed that Lee was looking like a man in serious physical trouble—gray skin, shortness of breath, dizziness, barely able to stand. A few hours later, Lee was in the hospital, suffering from a near-fatal heart attack. He was replaced by the suave, dark-haired Gene Barry, who looked about as much like Lee J. Cobb as I did, and somehow the film was completed without any actual casualties.

And then, of course, Barbara and I worked together for five episodes on a project in which she costarred as the inimitable Della Street with my beloved friend Raymond Burr in the title role of a series called *Perry Mason*.

~~~

RAYMOND BURR AND I had stayed very much a part of each other's lives ever since he was kind enough to do the screen test with me that inspired Universal to offer me a contract. You wouldn't guess it from looking at him, but he was a fun, funny, playful man who loved to laugh and loved a good practical joke even more.

I'm not sure this is common knowledge about Ray, but it should be: he served in the navy in World War II, was honorably discharged when a piece of shrapnel lodged itself in his stomach during the Battle of Okinawa, and was awarded the Purple Heart. He expressed his lifelong loyalty to our armed forces by traveling

anywhere in the world he was needed and whenever he could to entertain the troops.

One night after filming on a *Perry Mason* episode, and shortly before he left to visit the troops at an army base in Japan, Ray was surprised with a beautiful trophy, a thank-you from one of the many charities he generously supported. He was very proud of that trophy, as he deserved to be. He was also very aware of the fact that I was on the set. He'd played more practical jokes on me than I could count, and he knew it was a guarantee that sooner or later, I would retaliate. So when I walked over to give him a congratulatory hug, he immediately hid the trophy behind his back and refused to show it to me.

"Why won't you let me see it?" I asked with all the innocence in the world.

"You don't want to see it, you want to steal it," he answered.

To be honest, I'm not sure that thought had occurred to me until he suggested it. But once he planted the idea in my head, it became an obsession as the celebration on the set progressed. Ray kept an eye on me, I kept an eye on that trophy, and finally, just for an instant, the opportunity presented itself. I grabbed the trophy, slipped it to one of the stagehands, and told him to hang on to it for me and keep it hidden from Ray. Getting a huge kick out of being part of whatever the joke was, the stagehand promptly disappeared with the trophy until I retrieved it from him at the end of the evening. In the meantime, of course, Ray was beside himself when he discovered that his brand-new trophy was missing, and he marched straight over to me and demanded that I give it back. I was able to tell him in all honesty that I didn't have it, opening my purse and turning my jacket pockets inside out to prove it. He didn't believe for an instant that I didn't have something to do with the disappearance of his award, and he watched me like a hawk

until he finally gave up and headed home. A few minutes later I headed home too, trophy safely in hand, plotting the most effective way to return it to him. By the time I pulled into my driveway, I knew exactly what to do.

Everett, my brother-in-law, was in the army. Since Ray was visiting an army base in Japan in three days, it was too perfect a situation to pass up. I called Everett and told him what I was up to, and he was delighted to help. After a half hour on the phone discussing the details, we hung up and Everett began making all the arrangements.

First thing the next morning, a courier picked up the trophy and delivered it to the nearest army base, where it was put on a transport plane that left a few hours later for Japan.

Once it arrived in Japan, the trophy was taken straight to the base commander, who sent it out to be engraved with an inscription I'd personally requested, a sentiment I knew Ray would have chosen if the situation had been reversed: the Japanese translation of the simple words "Fuck you."

Ray's plane landed the next day. He was driven straight to the base, where the commander and a huge, enthusiastic audience of soldiers were waiting to greet him, all of them in on the joke. Ray came striding onstage to be presented to the troops, and after shaking his hand, the commander gave a brief, stirring speech about how deeply the soldiers appreciated his traveling such a long distance to entertain them and assure them that they were loved and appreciated back home.

"And as our way of saying thank you," he concluded, "it's my honor to give you this heartfelt token of our esteem."

With which he withdrew the trophy from behind his back and extended it to Ray, who gaped at it in stunned silence while the troops gave him a standing ovation.

When he was finally able to form words again, he turned to the commander and asked, "Where the hell did you get this?!"

The commander had memorized his lines perfectly. "It was flown in especially for you by someone you know, who also composed the inscription." He ceremoniously read the engraved inscription, first in Japanese as printed, and then in English, while the troops cheered and applauded again and Ray began laughing so hard he could hardly breathe.

He remembered and treasured that practical joke until the day he died. I still cherish it too, not just because of the thought and effort that went into it but also because of the great love and friendship that inspired it in the first place.

At the risk of transforming this book into *The Raymond Burr Story*, I do want to add a tale that illustrates what a loyal, generous man he was for those of us he thought of as family.

There was a time during the *Perry Mason* years when Bill Williams and Barbara Hale's marriage hit a rough patch, as all marriages do. (Look up "rough patch" in the dictionary and you'll see a picture of me and my ex-husband. But let's not get ahead of ourselves.) Barbara's career was thriving, while Bill's career seemed to be on the decline through no fault of his own—executives in this town don't always have the most vivid imaginations, and too many of them couldn't get past Bill's Kit Carson persona and rediscover what a wonderful actor he was. It's not only among actors that an imbalance of success can cause stress in a marriage, particularly when both people are in the same business. So it's understandable, maybe even inevitable, that Bill was resenting Barbara for many things, including not being home enough, and Barbara was resenting Bill for many things, including his resentment of her commitment to a job that brought her so much joy and a steady paycheck.

Barbara wasn't in the habit of bringing her problems to work.

She was never anything less than a true professional. But the cast and crew started noticing that she wasn't her usual outgoing, funny, bawdy self on the set and instead was spending most of her time alone in her dressing room. She told everyone, including me, that she was "fine," but none of us were buying it and all of us were concerned.

It was Ray who guessed what was wrong and did something about it. Without prying or insinuating himself into his dear friends' marriage, he quietly pulled a considerable number of strings and used some of his considerable clout to see to it that Bill Williams began working both in front of and behind the camera and feeling like a success again.

Barbara and Bill's marriage lasted and thrived for forty-six years, from 1946 until his death in 1992. Obviously most of the credit for that goes to them, but when trouble hit, Ray was right there quietly helping them through it.

So next time you happen across one of my five *Perry Mason* episodes, or, for that matter, one of my three episodes of Raymond Burr's later hit series *Ironside*, I hope you'll enjoy them even more knowing that you're watching close friends who loved working together and loved playing together even more.

The 1950s were busy, exciting, stimulating years. I shot more than forty TV episodes, on such classic series as *The Twilight Zone*, *Wanted: Dead or Alive*, *Maverick*, and *The Millionaire*. I guest-starred in more than a dozen films. (One of them, *Plunder Road*, was recently featured in a film noir festival in Palm Springs, which I was honored to attend. As any actor will tell you, it's always impossible, while you're in the middle of making a movie, to predict whether you're working on a hit or a complete flop. For *Plunder Road* to reemerge more than fifty years after it was shot and be considered a classic in its genre couldn't have been a more pleasant surprise.)

~ ~ ~

ACTING WAS MY PRIORITY, my joy, and my nourishment. My personal life was a lovely bonus—I had more than my share of fun, and that was all I was looking for. Between being fiercely independent and not having the slightest interest in compromising a career I'd worked so hard to establish, I didn't consider myself a viable candidate for the demands of a serious relationship. I still knew with "absolute certainty" that I would never get married and I would never have children (I know, I know, let's not talk it to death). But I wasn't about to let those self-imposed conditions stand in the way of a good time, and what luck, I happened to be surrounded by exciting, talented, available people who were as ready to have a good time as I was.

You might remember my nonnegotiable rule with Charles Clark that I was going to be a virgin when I got married. Well, at some point I realized what an impractical rule that was for a normal, healthy woman who had no intention of ever getting married. So what can I say, one night some combination of opportunity, curiosity, trust, and hormones inspired me to lose my virginity to Lyle Smith, director of the Stockton productions of *Naughty Marietta* and *Song of Norway*. It was sweet and natural and enjoyable but not earth-moving—I wasn't disappointed, and I certainly didn't regret it, but I did wonder afterward why I'd been so adamant about "saving myself" for something that turned out to be not that big a deal after all.

It seemed logical to leave myself open to sexual possibilities in Hollywood, which was, to understate it, rich with opportunities for a successful, confident, extroverted woman in her twenties. I wouldn't say I had an active "love" life. It was more of a "genuine fondness"

life, and sometimes something as simple as a "wow, do I find you attractive" life—exactly right for what I did and didn't want.

I never considered these encounters as affairs, even when they happened with some regularity. "Affairs" implied "entanglements" and/or "expectations" as far as I was concerned, and most of the men involved were friends I had no intention of losing just because our emotional intimacy occasionally expressed itself physically. In fact, some of them, in that uncomplicated long-ago pre-AIDS era, were friends who happened to be gay. (And yes, they were gay *before* I slept with them—and to the best of my knowledge I never inspired anyone to switch sexual preferences.)

Some of them you've never heard of, which I know doesn't make for interesting reading. Some of them you have heard of, and I feel a little sophomoric and name-droppy listing them like this. But you'd feel cheated if I held out on you, and I can't say I'd blame you. So . . .

David Janssen. Dennis Weaver. Robert Taylor (didn't see that one coming, did you?). Hugh O'Brian, almost (we'll just leave it at that). And, maybe predictably, all things considered, Raymond Burr.

～～～

ONE OF THE GREAT luxuries when you live in Los Angeles is when you happen to have friends who live at the beach and love to throw dinner parties. The beach at night, with the moon reflecting off a calm ocean, is like a long, gorgeous exhale. Add good food and good company and it's about as perfect as an evening can get.

I was lucky enough to have one of those friends. When he invited me to his beach house one night for a dinner party, I said yes in spite of the fact that he had an agenda—he wanted to fix me up

with someone, and he was sure we'd like each other. I was never a
fan of blind dates, but I would have said yes if he'd asked me to come
clean up after his dogs if it meant dinner overlooking the ocean.

I arrived fashionably late and was happy to be greeted by a
roomful of people I knew and liked. The only exception was a man
so impossibly handsome he took my breath away. He was tastefully
and impeccably dressed; he exuded confidence and charm. I closed
my eyes for a quick, silent prayer: "Please, God, if he's not my blind
date, at least let him be here alone."

My prayer was answered moments later when our host took the
impossibly handsome man's arm and led him straight to me. It was
immediately apparent that the attraction was mutual.

"Jeanne Cooper," our host said with an enthusiastic smile,
"Harry Bernsen."

Just Wild about Harry

Here's my theory about what happens when we women meet someone to whom we're too attracted for our own good: I don't think it's a matter of not noticing the red flags that signify this relationship is *not* a good idea. I think we notice them and, because those red flags don't mesh with what we think we want, we come up with euphemisms for them, to trick ourselves into believing they're part of what makes him interesting.

There was one red flag after another with Harry. It took me years to stop renaming them and start getting honest with myself about this man I thought I wanted.

And as superficial as it sounds, the truth is, there wouldn't have even been a second date if he just hadn't been so damned handsome.

~ ~ ~

HARRY BERNSEN WAS BORN and raised in Chicago, one of four very competitive brothers. Their father was a successful real estate

investor who owned several properties on the Loop until he lost
everything in the 1929 stock market crash. Their mother would
hang a framed portrait on the wall of whichever son had given her
the most money that week. It was usually Harry, who lived with
her well into his twenties. (Red flag: a mama's boy who should have
been out of the house and on his own long before then. The eu-
phemism: how sweet that he gets along so well with and takes such
good care of his mother.) He served in the armed forces as a marine
before moving to Los Angeles, drawn to show business like a moth
to a flame.

His mother had converted from Catholicism to Christian Sci-
ence, some of which Harry adhered to with remarkable commit-
ment—he didn't drink coffee, tea, or alcohol, he didn't smoke, he
didn't gamble, and he couldn't have been less interested in drugs.
(Red flag: a long list of principles that fails to include anything re-
sembling a faith-based moral compass. The euphemism: what a
clean-living, disciplined man!)

He spent a lot of time traveling as a kind of road manager and
merchandiser for such popular acts as Martin and Lewis (star-
ring Dean Martin and Jerry Lewis), Guy Lombardo, and Burl Ives
before becoming an incredibly gifted agent with the Jaffe Agency. I
so admired his talent and found his gift of gab so addictively stimu-
lating that I bragged to anyone who would listen that Harry Bern-
sen could sell ice to an Eskimo. It took me longer than it should
have to realize that I was one of the Eskimos.

He was charming, he was funny, and he had an audacious self-
confidence that I found wildly attractive until the novelty wore off
and I discovered that "audacious self-confidence" was my euphe-
mism for "massive ego."

From the very beginning, my family disliked him. My predict-
able take on that: "They just don't know him like I do." Besides, his

mother and I couldn't stand the sight of each other, so how much did family opinions really count anyway? (There were actually family members of Harry's whom I adored, but we'll get around to them later.)

The bottom line is, I'm the first to admit that I fell into a trap to which we women are vulnerable much too often: I found (or imagined) enough good qualities in him that I was convinced I could nurture them into the spotlight and drive the less admirable ones into the darkness forever and ever. I'll never understand why it seemed like such a good idea at the time, but it was my choice and my responsibility. Or, as one of my favorite wise women, Judge Judy, puts it so inarguably, "You picked him."

I did mention that he was incredibly handsome, though, right?

<hr />

IT WAS A WILD, exciting ride at the beginning. My career was going beautifully, I had a loyal and gifted group of friends, and there was a new man in my life who not only seemed to respect but also even to understand and encourage what I did for a living. And when his love of gamesmanship revealed itself very early on, I didn't think that much of it. I'd been around the block a time or two myself by then, so I'd learned how to play my part in a few of those games myself.

"Call me," he whispered as we ended our first night of passion at my apartment.

"I will," I promised as I kissed him one more time and watched him walk away, already looking forward to seeing him again.

I waited a day or two before I called—never a good idea to look too eager or too available, after all. Finally I picked up the phone and dialed.

A woman answered. His mother, it turned out. Harry wasn't in, she told me, as terse and unfriendly as she could be. She wasn't sure when he'd be back, and yes (with a thoroughly inconvenienced sigh), she would tell him I called.

Twenty-four hours later, when I hadn't heard from him, I called again. Same icy woman, same result, and I'd officially reached my phone call quota.

A couple of weeks went by. I was a little disappointed, but I didn't have that much invested either, and I had work to focus on, so it was easy to shrug and move along. I also had another dinner party to look forward to, with my pal Patrick Clement, at that same beach house where Harry and I met, so it wasn't as if my social life was suffering either.

There were a lot of people at that party, but I spotted Harry across the room as soon as we walked in the door. He was with a date. He probably thought I was too, although Pat and I were just good friends, nothing more. It didn't take Harry long to slip away from his date and catch me alone on the deck while Pat was inside getting our drinks.

He greeted me with a simple, "I thought you were going to call me."

"I did," I said. "Twice. You weren't there."

"Call again."

"You call me." I smiled and left him there on the deck by himself, and it was no accident that I left the party that night without giving Harry my phone number.

Game, set, and match.

I won't even pretend it surprised me that he got my number from our host and called first thing the next morning. And there it is, the touching story of how Harry Bernsen and I became a couple.

～ ～ ～

WE ACTUALLY HAD A lot going for us when we started out to-
gether. We both loved to laugh and had very similar senses of
humor. We both loved going to parties, drive-in movies, and the
theater. We were both committed to our careers and both spoke
fluent "show business," so we were genuinely interested in each oth-
er's answers to the question "How was your day, dear?" He admired
my work, and I admired his, especially when he became an agent,
and a brilliant one, at the Jaffe Agency with the highly respected
Phil Gersh. He thought I looked gorgeous in an evening gown, and
I thought he looked gorgeous in a tuxedo.

A year after we started seeing each other, Harry moved in
with me.

His mother never forgave me for taking her darling twenty-
eight-year-old baby boy away from her. But she didn't like Harry's
three sisters-in-law either, all of whom I loved, so I took her disdain
as a compliment and happily avoided her like the plague.

～ ～ ～

LIVING WITH HARRY MEANT that I was now deeply invested in
believing he was fabulous, and because I hate to be wrong, I didn't
pay nearly enough attention to any evidence to the contrary. It's
that red flag thing I was talking about earlier. Facing those warning
signs meant admitting that I couldn't trust my own judgment, and
somehow that felt more threatening to my sense of security than
anything Harry could do to me . . . or so I thought.

I was really eager for my sister, Evelyn, my brother, Jack, and
their respective spouses to meet him now that we'd officially set up
housekeeping. They met him. They didn't like him one bit. In fact,

from that first meeting on, they were only interested in coming to visit when Harry was out of town.

He didn't seem to care much for them either, or anyone else I was close to whose status didn't impress him, for that matter. That gregarious life of the party I'd spent a year dating was suddenly likely to turn sullen and pout his way through any social gathering that wasn't his idea and/or his guest list. Of course, it became easier to let him have his way than to run the risk of his being rude to my friends and family, so I cooperated more than I should have. Unbeknownst to me until much, much later, he was also screening my phone calls, only passing along messages from people of whom he approved.

And then there was my beloved woody convertible. I had that car when Harry and I met, and I adored it so much that I'd probably still have it to this day if it weren't for him. But Harry, image-conscious to a fault, felt strongly that as a successful Hollywood actress, I should always be seen in nothing less than a chauffeur-driven town car instead. I put up a halfhearted fight, but again, to keep peace, and because it didn't occur to me that he was up to something, I finally agreed to it . . . after which Harry promptly sold my woody convertible and used the money to pay off a debt to his brother.

So there I was, without my own car anymore, seeing less and less of my close friends and family, and having my phone calls and messages carefully screened without even knowing it. Or, to put it another way, becoming more isolated and less independent but still grimly determined to prove that my investment in Harry Bernsen was worth the time and effort I'd put into him.

And no one was more surprised than I was when it turned out to be worth all that and more. (Didn't see that coming, did you?)

～～～

THERE'S NOTHING QUITE LIKE the words "you're pregnant" when you're not expecting them to shock you into an instant re-evaluation of your life.

To be honest, I had no business being as shocked as I was. I'd been sexually active and irresponsible about it for years, apparently assuming that not intending to have children was all the birth control I needed. I'd honestly started to think that maybe I couldn't get pregnant. And after a year and a half with Harry, neither of us using any protection at all, I believed his claim that he'd been told he would never be able to father a child.

Of course, my single actress friends and I had talked many times about whether we wanted children. We were almost unanimous in our position that children could and should wait until later in our lives, when our careers were either well established or over. Our theory was that a combination of a career and children meant that inevitably, sooner or later, one or the other would have to come first, and none of us would have put our careers ahead of our children. So the idea of children was always coupled with another abstract idea: someday.

All of which was blown right out of the water with the news that I was pregnant (as was that theory that career women can't be good, attentive mothers, needless to say). And to my amazement, I found pregnancy to be one of the warmest, fuzziest, most fulfilling experiences I'd ever had. By sheer instinct, decades before there was such a wealth of information available, I became the most health-conscious pregnant woman you've ever seen. I maintained a very strict diet, helped considerably by the fact that while I'd had several pregnant friends whose cravings consisted of things like hot fudge

sundaes and angel food cake, I lucked out—all I craved throughout that pregnancy and the two that followed were tomatoes. I gained so little weight that I never even had to invest in maternity clothes, and I was able to work until two weeks before I delivered.

Corbin Dean Bernsen was born on September 7, 1954. It was such an easy delivery that the nurses had to wake me up to tell me he'd arrived. At the time, it was common practice for nurses to whisk newborns away after birth. However, baby Corbin was inexplicably kept from me for a few hours after he first entered this world.

I couldn't understand for the life of me, nor could I get anyone to explain, why the nurses were so obviously avoiding bringing my son to me. I wanted to see him, and I wanted to see him *now*, or someone had better damned well give me a good reason why not.

Finally, trying to calm me down and reassure me that Corbin was a fine, healthy baby and there was nothing to worry about, a nurse told me that Harry had asked them not to show him to me because he was "deformed."

I predictably went berserk, offered a few thinly veiled threats if there were any further delays in my holding my child, and informed the nurses (along with probably most of the hospital and a few low-flying planes) that they had no right to let Harry's orders override mine.

They brought Corbin to me. Even before I first laid eyes on him, I knew that whoever it was who said there's no love like a mother's love for her child knew what they were talking about. He was breathtaking. Obviously Harry was too busy and too mystified by babies in general to experience the same overwhelming joy. Baby Corbin couldn't have seemed more alien to his father than if he'd been born with antennae. The "deformity" that had so horrified Harry was nothing but a hematoma on his head, presumably from a collision with my pelvic bone and not all that uncommon. It went away in

a couple of months, but until it did, Harry actually wanted me to either postpone letting people meet our firstborn son or keep a blanket over his head when showing him off. I would have preferred a more devoted, adoring reaction, but not for a moment was I about to let Harry Bernsen diminish my awe of this little six-pound miracle. Needless to say, I proudly introduced Corbin to everyone I knew, without a blanket on his head, and dared Harry to try to stop me.

I think that was the first time I became aware of what turned out to be one of Harry's most insidious modus operandi. He supposedly didn't want me to see my baby because his so-called deformity would upset me. On a much broader scale, unbeknownst to me for far too long, "Don't tell Jeanne. It will upset her" was almost a mantra when he was trying to manipulate someone, seduce someone, or borrow money.

A typical money-borrowing scheme went a little something like this: when hitting up a friend for a $25,000 loan, rather than be truthful about why he wanted the money, he would and did say, "Please don't tell Jeanne I confided in you about this—it would upset her—but I'm afraid she had a mental breakdown and blew $25,000 on an insane shopping spree without telling me . . ." Many years later he even borrowed money to bail our daughter out of jail. But to keep the lender from finding out that our daughter didn't need bail money because she'd never been in jail or ever in trouble in her life, he added, "Don't tell Jeanne. She doesn't know anything about this, and she'd be devastated."

～～～

OF FAR MORE IMPORTANCE, though: so much for my old concern about having to choose between my child and my career. I went back to work as soon as possible, but with even more passion than before.

I'd always worked for my own benefit—for rent money, for groceries, for a car, for a respectable wardrobe. Working for the benefit of my brand-new little boy made it so much more worthwhile. I couldn't wait to get to a soundstage or location first thing in the morning to earn my paycheck and earn it well, and I couldn't wait to get home to spend every second with my son. I did start a tradition with Corbin that I continued with my next two children as well, though—I took six months off when they were about to start walking, because I didn't want to miss all the "firsts" that go along with that incredible phase of a baby's life. And not a day went by when I didn't appreciate being able to afford that luxury, believe me.

Harry, in the meantime, was proving to be a really extraordinary agent, natural-born salesman that he was. He also loved the doors my success opened for him in a business where it really does often boil down to who you know, while at the same time resenting the fact that I was outearning him. It put me in the impossible position of feeling as if I was supposed to apologize for one of his favorite things about me. But I don't play when I know it's impossible for me to win, and I had a beautiful baby who needed me as much as I probably needed him, so I let Harry go about his business without paying as much attention as I should have. He was gone a lot, which was frankly easier than having him around. At least when he was gone I didn't have to make excuses for his inattentiveness toward the precious new life in our home.

We'd moved to an apartment on the Sunset Strip in Hollywood next door to Ciro's, one of the most popular nightclubs in the city. The Ciro's parking lot was essentially Corbin's playground for the first couple of years, and he took maximum advantage of it—he was as outgoing and personable as any child I've ever seen and especially loved being in the company of adults. Artists who were

booked to perform at Ciro's could count on a very friendly greeting from the tiny Mr. Corbin Bernsen when they arrived for rehearsals, particularly Sammy Davis Jr., who would actually look for Corbin (escorted by his mother, of course) if he wasn't on hand for an exuberant hello and a hug before Sammy disappeared through the stage door. My friend Sylvia Browne has always said that because all our souls are the same age, created at exactly the same time an eternity ago, the term "old soul" refers to one who's been on earth for several incarnations. Corbin was definitely an old soul, running into far more pals than strangers from the moment he was (re)born.

~~~

IT WAS AT CORBIN's first birthday party that Harry, almost in passing, said, "Let's get married."

I replied, "Yeah, okay."

And if you think that's romantic, wait till you hear about the wedding.

Of course, people had been asking since Harry and I started living together when we were getting married, and I always responded with some vague, joking answer, because the truth was I was in no hurry to get married, or to get married at all, for that matter. But now there were three of us, one of whom hadn't asked to be born and deserved the very best we could give him, and parents who'd legalized their commitment to each other didn't seem like that much to ask. Looking back, I can see with crystal clarity that I wasn't in love with Harry when I married him. If we hadn't had a child together I wouldn't have even considered it. But at the time, it seemed like the right thing to do, and I still had a tenuous grip on the belief that I could somehow be so supportive and

so encouraging of Harry's best qualities that he'd become a man I could admire in spite of himself.

And so it was that we left our year-old son with his beloved babysitter and headed off on the four-hour drive to Tijuana to get married, sparing ourselves the time, energy, and expense of a full-blown wedding in Los Angeles that neither of us cared about to begin with. We'd been to Tijuana for occasional long weekends, and we liked the Palace Hotel there, so it seemed like a reasonable "why not?" destination.

The wedding itself went like this: we arrived at the courthouse, walked up a couple of flights of stairs, signed some paperwork, and left the courthouse legally married. No music, no flowers, no photographer, no vows, no exchange of rings, no cake. I can't even begin to tell you what I wore, other than definitely not a gown. Our witnesses were two total strangers who happened to work there and may or may not have spoken a word of English. Harry, who clearly didn't understand the "civil ceremony" concept, was some-how shocked at the lack of guests, decor, and opportunity to be the center of attention.

"That's it?" he said as we waved adios to our witnesses, Senor and Senora Whoever-They-Were, and left the cramped, cluttered office.

To the best of my recollection, I just gaped at him, for neither the first nor the last time in my life.

The honeymoon complemented the wedding—in that there wasn't one. Harry had to be back in Los Angeles for a meeting on Monday. After a night in the presidential suite at the Palace Hotel, we were back in the car, paperwork in hand, for the four-hour drive home.

To answer the question I know you're asking yourself right now, yes, it really was exactly as glamorous as I've made it sound.

~~~

M Y B A B Y B O Y A N D my career were thriving in the mid- to late 1950s. Corbin was enthralling and funny and the light of my life, and I had the stimulating pleasure of working on a couple of feature films and a wide variety of television series, including classics like *Playhouse 90*, *The Ford Television Theatre*, and *The George Sanders Mystery Theater*. Harry, in the meantime, began making regular trips to Europe, especially Rome, where he was supposedly looking into setting up a branch office of the agency. Unfortunately, like many of his colleagues, he also decided that, instead of focusing all his energy on being a successful, very gifted agent, he wanted to be a producer. And frankly, he had no talent for that at all, primarily because he couldn't let the crews he hired do their jobs—his ego was so enormous by then that he was mistakenly convinced he was better at those jobs than they were. But he loved the title and its unearned prestige far too much to give it up and commit himself to the agency business where he belonged.

He was home from time to time, though, as evidenced by the fact that, in the summer of 1957, we got the joyful news that I was pregnant again. My second pregnancy was as perfect as my first—same strict diet, same rabid cravings for tomatoes, same lack of need for maternity clothes, and same ability to work until two weeks before I gave birth. In fact, I distinctly remember a rehearsal for *Zane Grey Theater* in which Dick Powell (one of the nicest people I ever met, by the way) pulled me into his arms so tightly that my baby gave him a swift kick from the womb, prompting Dick to ad-lib, "Alone at last, just the three of us."

Collin Bernsen was born on March 30, 1958. He was a breech baby, so by definition it was a more difficult delivery than Corbin's. And according to Harry, poor Collin was "deformed" as well, with

a few marks on his face from the obstetrician's forceps and one eye that didn't open as soon as Harry thought it should have. But by then the hospital staff knew better than to withhold Collin from me, and sure enough, he was gorgeous, just like his brother.

Collin's arrival made it apparent that our family had outgrown our apartment, so it was off to a beautiful new home in Beverly Hills, complete with a guest house and pool, that Harry bought for us (I thought). As an added bonus, our guest house was going to be occupied by Harry's two aunts, Mamie and Elsie.

I know. You wouldn't necessarily expect that to be good news, would you? But they were two fabulous women. I don't know what we would have done without them. (Actually, I do—we would still have been living in a cramped apartment, for one thing. It seems that Harry, after his usual "don't tell Jeanne" warm-up speech, had convinced his aunts to loan him the down payment on our house in exchange for his promise that Auntie Mamie and Aunt Elsie would have a place to live rent-free for the rest of their lives.) I adored them, and my children, whom they helped raise, adored them every bit as much. Elsie had worked as a grocery store clerk and loved her beer. Mamie and her late husband had owned a bar in Chicago and she could have been cast as a gangster's wife. She was a strict disciplinarian with the children and was also fiercely protective of them. Both women were fun and funny and just plain Good People, and we were blessed to have them with us for many years.

I was quickly back to work after Collin's birth, happily going from episode to episode of one television series after another, including *State Trooper*, *Tales of Wells Fargo*, and the iconic *Twilight Zone*. And speaking of *The Twilight Zone*, I do have a confession to make: I didn't cheat on my husband when I shot that episode, but I most definitely thought about it.

It was the first time I'd ever worked with Dan Duryea. I knew he was a wonderful actor, but I had no idea I would find myself so attracted to him. He had the most irresistible puppy-dog eyes, and an aura that was both intensely masculine and romantic. And he made absolutely no secret of the fact that the attraction was mutual—we hadn't finished our first day of filming before he became openly flirtatious and asked me to dinner.

I was tempted, what can I say? I was excited by him and by being wanted by him, and frankly, the thought of being naughty was suddenly very appealing. I'm sure it took longer than it should have for me to say, "I'd love to, but I'm married."

Imagine my surprise when he replied, "Okay, so bring your husband."

As we say in scripts, cut to Harry, me, and Dan Duryea in a quiet, elegant restaurant, Dan shamelessly ignoring Harry and draping himself all over me, making comments like "Where were you when I was ready to get married?"

I would have been a little embarrassed and put a stop to it if it had been making Harry angry or uncomfortable. But no—he thought it was great and thoroughly enjoyed every minute of it. I don't understand a thing about that. Dan must have thought I was married to a complete wuss, and I was beginning to wonder myself. The only possible explanation I could come up with was that maybe it was exciting to Harry to see how desirable his wife was to another man. But if some woman sat right in front of me and threw herself at my husband like that, I promise you, she and I would go off together for a little talk, and only one of us would come back.

In the end, nothing ever happened between me and Dan Duryea, and I guess I'm glad that I did the Right Thing. I don't mind admitting, though, that I was sad when we finished filming and we went our separate ways, and I'll always wonder . . .

~ ~ ~ ~

I TOOK MY USUAL six months off when it was almost time for Collin to take his first steps. Just as so much of Corbin's personality was apparent from the beginning, it was obvious even then that my second son was highly charged, very funny, and utterly determined—no matter how many times he fell while he learned to walk, he doggedly got back up again. With apologies for getting ahead of myself, it still makes me laugh to remember him at the age of five, emptying out his closet every morning during the week to study his options and put together exactly the right outfit for that day at kindergarten.

I wouldn't trade my two boys for anything in this world. I was in love with both of them while they were still in my womb, and I would lay down my life for them with a smile on my face. And I must say, even though he had no idea how to interact with them, let alone feed them, change their diapers, or rock them to sleep, I never doubted for a moment that Harry loved his sons too.

But I'd begun to yearn for the one thing that seemed to be missing from my life: a daughter. I dreamed of a little girl to fuss over and dress up and have pretend tea parties with, another feminine presence in a house full of testosterone.

That dream came true on August 17, 1960, with the birth of my sweet, gorgeous Caren Bernsen, after another easy pregnancy that allowed me to keep working almost until it was time to head for the delivery room. It was no secret that I was hoping for a daughter, and my hospital room was so filled to the brim with congratulatory flowers from friends and family that I finally asked the nurses to start delivering them to other patients.

There's no doubt about it, Harry loved her. But he still had no clue what to do with babies, and the fact that she was a girl made

her even more mystifying to him, so he rarely interacted with her on the rare occasions when he was around. More often than not, though, he was away—on business trips, he said—for weeks at a time. As independent as Caren was from the moment she was born, she was also more sensitive than her two rowdy big brothers and more of an introvert, and I know it hurt her when she was a child that her father was absent so often and so seemingly disinterested in her.

Let's see . . . a little girl with two older siblings and a father who always seemed to be off somewhere working instead of home with his family. I admit it, it took me years to figure out why, in addition to adoring her, I always felt a special connection to her—as different as our personalities have always been, raising her was like watching my own childhood repeat itself right before my eyes.

I can't begin to count the number of times I begged Harry to spend time with his children, especially Corbin and Collin as they got old enough to start really wanting and needing their dad. Play with them, I said. Get to know them. They're fabulous, funny, wonderful boys. I know you love them, but you'll also enjoy them if you'd give yourself a chance to find out who they are.

And so it was that when Corbin was about eight years old and Collin was four, Harry decided that on Saturday mornings when he was home, he would go on outings with his boys. What that translated to on the Planet Harry was that he would take his sons with him to do what he always did on Saturdays anyway—drop off and pick up his laundry (which for some reason he loved and wouldn't dream of letting anyone else do for him), get a haircut, and go to the car wash. After the third or fourth Saturday of this, Collin finally asked his father if they could please not play with him anymore because it wasn't any fun. To the best of my recollection, that about wrapped up the father-son bonding between

Harry and the boys until they were old enough to play Little League baseball, which Harry did enjoy, especially when he discovered what gifted athletes our sons were.

～～～

FOR THE MOST PART, life was filled with blessings when the 1960s began. I had three beautiful, healthy children, plenty of adoring help from Auntie Mamie and Aunt Elsie, and a steady stream of work I loved, from more episodic television work to the role of a "hooker with a heart of gold" in a wonderful film called *Let No Man Write My Epitaph* with my old friend Shelley Winters. Harry, in the meantime, was spending a lot of time in Rome, partly to set up an Italian branch of the Jaffe Agency and partly to take care of a client, Dolores Hart, who was there filming *Francis of Assisi* with Bradford Dillman and Stuart Whitman, and directed by the great Michael Curtiz.

I don't remember which one of us suggested it, but somehow, Harry and I headed off to Rome together, a business trip for him and a much-needed vacation for me. I was looking forward to going to the *Francis of Assisi* set and meeting Dolores Hart, who was a beautiful, young up-and-coming star at the time, but Harry informed me when we arrived that it was a closed set—no visitors allowed. (I know. If it was a closed set, what was Harry doing there? But I didn't push it.) My friend Ethel Levin was living in Rome at the time, and over lunch one day, when I explained that Harry couldn't join us because he was on the set with Dolores, she gave me a very intense look and said, "Jeanne, I'm telling you this as someone who cares about you—keep an eye on those two."

It felt like a punch in the stomach. For one thing, it caught me completely off guard. For another thing, while I can't claim that

the thought of Harry being unfaithful had never entered my mind, I'd never had anyone strongly suggest it to my face before. For still another thing, nothing I'd heard about Dolores Hart implied that she would have anything to do with a married man. I didn't ask Ethel what prompted that warning. I probably wasn't ready to hear it from anyone but Harry, if at all. It ate at me, especially in my hours alone in our hotel room while he was "working" and "running late," but I wasn't about to confront him about it based on nothing more than a comment from a friend.

The coup de grâce of that trip actually didn't involve Dolores Hart at all. It involved another of Harry's clients, a handsome actor named Guy Madison, television's "Wild Bill Hickok," who also happened to be the former husband of a stunningly beautiful actress named Gail Russell. Guy was in Rome for some reason or other, and Harry and I met him for drinks one night. We were chatting away, having a perfectly enjoyable time, when Guy mentioned that he was looking forward to a trip to Majorca that weekend.

"Majorca, huh?" Harry piped up. "It's beautiful there. Jeanne, why don't you go with him?"

It was awkward, it was embarrassing; Guy and I both stared at him with our jaws hanging open. We knew he wasn't kidding, and since neither Harry nor I drank in those days, we couldn't use too much alcohol as an excuse. No, stone-cold sober he had just tried to send his wife away for the weekend with another man—and not just any man, but another man who was also a client, for God's sake. It disgusted me. It also made me think that my friend Ethel probably knew what she was talking about.

"No, Harry, I won't be going to Majorca this weekend, but thank you for inviting me on Guy's behalf." I turned to Guy and added as I stood up, "Guy, I apologize for this. It was lovely seeing you again. Now, if you'll excuse me . . ."

I went straight to our suite, packed my bags in record time, headed to the airport before Harry got back to the hotel, and flew to Madrid for the second leg of this alleged "vacation." He arrived two days later, begging and pleading for me to forgive him and please, please not to leave him over a stupid mistake, just under so much stress, will never happen again, loves me and our children so much, blah, blah.

In the end, we flew home together. I don't know if this is an explanation or an excuse, but I still had my heart, or head, set on admiring him, despite all evidence to the contrary, and I was more determined to be right about him than I was to do the healthy thing and walk away. Someone put it perfectly once in something I read somewhere: "I think I loved you first and knew you later. I wonder if love is strong enough to overcome dislike."

It took years for me to find out the whole story, and of course not from him. Nothing sexual had ever gone on between Dolores and Harry, it turns out. He tried his damnedest, but she wouldn't have anything to do with a married man. He assured her that his marriage was over—he was taking me on this one last trip to Rome, and then as soon as we got home, I was well aware that he'd be filing for divorce. He had to handle things delicately, you see, because of my mental problems. If I became too upset, I might become dangerous, either to myself or to him or to our children. Unfortunately for Harry, Dolores considered "almost divorced" to mean "still married," so while they spent a great deal of time together and seemed fond of each other, their relationship was purely platonic. And to keep the cast and crew of *Francis of Assisi* from passing stories from the set along to me, Harry told them, "Jeanne is giving up her career for the sake of our children, and she resents all the time and attention my work requires, so please don't upset her by saying a word about my clients or show business in general."

Dolores Hart, by the way, made four more films and then, in 1963, at the age of twenty-four, she abandoned both show business and secular life to become a nun. She eventually became prioress of the Benedictine Abbey of Regina Laudis in Bethlehem, Connecticut. I like to believe Harry Bernsen inspired her decision—if he was any indication of the men she had to look forward to, she would rather run, not walk, to the nearest convent. It's not remotely true; I just like to believe it.

~ ~ ~

THROUGH THE 1960s AND early 1970s, between my healthy, thriving children and my healthy, thriving career, I was so busy and had so much to be grateful for that I chose to assume my marriage was intact. Harry was adamant that he didn't want to lose our children and me. It never occurred to me to ask him why.

It's hard to describe the embarrassment of riches in the world of television back then, decades before "reality" TV convinced network executives that actors and writers are foolish wastes of time and money. I had the good fortune to shoot more than seventy prime-time series episodes and a few feature films, and to work with some of the most fascinating actors in the business. There was the incredibly suave Roger Moore (Beau Maverick of the *Maverick* series), who went on to superstardom in seven James Bond movies. (I loved Sean Connery as much as the next person, but let's face it, Roger Moore wasn't exactly chopped liver.) There was the wonderful Richard Boone in *Have Gun—Will Travel*, as brilliant an acting teacher as he was a performer. There was the theatrically trained Robert Vaughn in *The Man from U.N.C.L.E.*, whose flawless diction was a joy to these theatrically trained ears. There was *The Boston Strangler* star Tony Curtis, whom I so admired for

never letting his extraordinary success give him amnesia about his tough, humble childhood in the Bronx. There was the wildly play-ful Leslie Nielsen in *Bracken's World*, who was rarely seen without a homemade "fart machine" hidden in the palm of his hand for those inevitably stressful moments on the set. And there was Jack Lord, the original "Book 'em, Danno" man of *Hawaii Five-0*, thanks to whom I inadvertently came to believe that one of the most funda-mental doctrines of show business is nothing but a myth.

Jack and I were doing some publicity shots during an episode of his series *Stoney Burke* that involved the two of us in equestrian out-fits playing around on top of barrels used in horse shows. The short version of the story (trust me, the long version isn't especially inter-esting) is that I fell off one of the barrels and landed on my elbow. I was in a lot of pain but ignored it as best I could to finish that day's work. The pain didn't ease up during the night. I finally went to the doctor for X-rays, and what do you know, my elbow was broken. I walked out of my doctor's office in a cast, still in quite a bit of pain, and, with the help of some wardrobe adjustments involving long puffy sleeves, made it through whatever it was we were shooting. My performance was commendable, all things considered.

It was that "all things considered" part that bothered me and ended up making me a nonbeliever in the timeworn premise "The show must go on." Every audience member, whether he's watching television, a stage play, a concert, or a movie, deserves nothing less than 100 percent for the time, effort, and/or money he's invested. If a performer isn't capable of offering 100 percent because of illness, injury, personal problems, or just plain irritability, that performer needs to step aside, temporarily or permanently, or the audience is going to be shortchanged. It's that simple. "The show must go on"? Not *ever* at the expense of the audience, and that I'll believe until the day I deliver my last line.

By the time the early 1970s rolled around, I realized that the one thing I needed more than anything else in this world was a couple of weeks off, as far away from wardrobe and makeup and as close to my kids and lazy mornings on a beach as I could possibly get.

Isn't it funny how, even in those hours right before your life changes forever, you rarely if ever see it coming?

CHAPTER FOUR

Becoming Young and Restless

I
t was early in 1973 when I headed off for a Hawaiian vacation
with the kids, each of whom brought a friend. Me and six teen-
agers. Okay, maybe I needed to rethink my idea of a vacation.

Harry wasn't with us. Somehow he could always dash off to
Europe or anywhere else in the world on a moment's notice "to
take care of a client," but he couldn't seem to make time for family
vacations that were planned weeks in advance. It irritated me on
principle. When I took a long, hard, honest look at it, though,
based on our previous trips together—the glamorous wedding
junket in Tijuana, for example, or our thrill-packed days in Rome
when he tried to unload me on a client so that he could pursue his
potential new girlfriend—I had to admit it was a lot more relaxing
without him.

One day there was a message waiting for me at our hotel from
a man named John Conboy. I knew he was a producer, I knew I'd
auditioned for him before, and I knew he'd been very complimen-
tary about my work in several prime-time projects. What I couldn't

imagine was what would possess him to track me down in Oahu. Rather than return his call, I let my agent fill me in.

It seems that John Conboy and a woman named Patricia Wenig were producing a CBS soap opera called *The Young and the Restless*, and John was convinced I'd be perfect for the role of a new character named Katherine Chancellor, the wealthy, powerful, alcoholic, adulterous pillar of Genoa City, Wisconsin, society. Five days a week, one live-to-tape half-hour show per day. They had a three-year contract ready for me to sign, and they needed an answer ASAP.

I can count on less than one hand the number of times in my life when I've found myself speechless. This was one of those times. I may have told my agent I'd call him back. I may have just hung up the phone without saying a word. What I definitely didn't do was give him an answer, since I didn't have the first clue what that answer was going to be. Suddenly the only thing I could come up with that sounded like a really good idea was to get out of there and give myself time to think before John Conboy had a chance to call again.

"Okay, kids, pack your bags! We're going to Maui!" I announced, trying to make it sound like a fun surprise rather than the avoidance tactic it really was. I got a few very brief confused looks in response, but in the end I knew I wouldn't exactly have to drag a group of teenagers kicking and screaming to Maui.

Nor did I have to drag them kicking and screaming when we fled to Kauai a couple of days later after a few messages from John Conboy at our hotel in Maui. (Some of you may be too young to believe this, let alone remember, but there was a time on this planet when cell phones didn't exist. And frankly—especially when I'm trying to rehearse or have dinner with the top of someone's head because they're too busy texting to pay attention—I often yearn for those days.)

I wasn't as resistant to this soap opera offer as I was simply torn. It was a huge decision for a lot of reasons.

I'd never seen a soap opera before, including this new half-hour daytime drama called *The Young and the Restless*, and I certainly had nothing against them. In fact, I'd even auditioned for one a few years earlier. It was called *Days of Our Lives*, and I read for the role of Julie Olson Williams. (Apparently I wasn't right for it. A beautiful young actress named Susan Seaforth was. She and her costar Bill Hayes met on the set, fell in love, and are still happily married to this day. Isn't it refreshing when things work out exactly the way they're supposed to?)

Still, five days a week, with no hiatus, playing the same character every single day for three years sounded as if it might get very old very quickly. I'd spent the first twenty years of my career successfully going from one project to another, loving the freedom and variety it allowed me. I wasn't a "name" as far as the American public was concerned, but I'd established a good reputation among producers, directors, and fellow actors, and I worked virtually nonstop while doing my damnedest to make time for my children. The closest I'd come to a steady, long-term job was the role of Grace Douglas for fifteen episodes of *Bracken's World* from 1969 to 1970. I loved it, and I loved moving on from it to whatever came next. Locking myself in for three years to a brand-new daytime show whose ratings were teetering somewhere between mediocre and poor . . . ? Would anyone in their right mind consider that a wise career move?

On the other hand, there was a lot to be said for steady income, which any actor will tell you is hard to come by, and while Harry's successful career as an agent seemed to be balancing out his utterly inept career as a producer, he had an uncanny ability, particularly for a man with no apparent vices, to blow through money as

quickly as he could earn it and then turn to me to cover the deficit. I couldn't imagine where all his money was going and why he was perpetually robbing Peter to pay Paul. Or maybe I could imagine, I just wasn't ready to. Yet.

And maybe three years of investing in this Katherine Chancellor character, who actually sounded kind of interesting, might be a beautifully timed chance to reevaluate my life: where I'd been, where I was at that point in time, where I wanted to go and with whom, if anyone, besides Corbin, Collin, and Caren, who were the core of my life and my heart. It was finally dawning on me that my marriage wasn't slowly disintegrating—it was the same marriage it had always been. I was just starting to acknowledge the fact that what it had always been wasn't good enough. In the back of my mind I'm sure I was already anticipating a life without Harry, and what better way to prepare for that than with a full-time job? Besides, these people were asking for only three years. It wasn't as if I'd still find myself working there when I was eighty or something.

In the end, it was in our hotel room in Kauai that I picked up the phone when John Conboy called and heard myself say, "When do you need me there?"

My jaw hit the floor when he replied, "Eight o'clock tomorrow morning. You'll tape your first show the next day."

I started stammering about logistics, reservations, the organizational challenges of getting myself and six teenagers on a plane on such short notice . . .

"Just pack them up and get to the airport," he said, cutting me off in mid-hysteria, which, trust me, isn't easy. "I'll take care of everything else."

It wasn't pretty, but the seven of us caught the midnight flight to L.A. We dropped off the kids' friends at their respective houses and got home at six A.M. I showered, dressed, sprinted to my car, and,

propelled by no sleep and an overload of adrenaline, arrived at the CBS artists' entrance with minutes to spare. Rushed and wild-eyed as I was, I remember to this day that as I stepped through those artists' entrance doors and headed up the endless hallway to the elevator, I genuinely sensed that something important was happening to me and that my life would never be the same as it was just the day before.

Next thing I knew I was sitting with producers John Conboy and Patricia Wenig, reading with my on-screen husband, Phillip Chancellor II, played by John Considine, who was promptly replaced by Donnelly Rhodes. (I never knew why. My current co-workers won't believe this, but I didn't consider it my place to ask at the time.) Any concerns I might have had about finding common ground between me and Katherine Chancellor vanished with my very first monologue, a beautifully crafted explanation from Katherine to Phillip that what she wants—*all* she wants—is someone to love her just for who she is, nothing more, nothing less; someone to be a shoulder not for her to lean on from time to time but for her to *count* on . . . Which is to say that, no matter what soap opera craziness the writers had in store for her, I loved and understood the essence of Katherine Chancellor from the moment I stepped into her designer pumps.

Then it was on to the rehearsal hall, where my new castmates gave me a warm, respectful welcome. And let me tell you, even when they're not in makeup, there's nothing like facing a roomful of soap actors. As you look from one face to the next, you quickly realize that all the women are beautiful and all the men are handsome, and for a moment or two, no matter what you're wearing, you wish you'd worn something else and spent more time on your hair. They were all a blur at first—I do remember a sexy, confident little piece of work named Brenda Dickson (aka Jill Foster Abbott) and

the warmly gorgeous face of my future best friend, Julianna McCarthy (aka Liz Foster Brooks, and if you think I didn't make noise when they killed off her character in 2010, you can guess again). Even our director, Bill Glenn, was a knockout. And there were so many of them. I was just starting to wonder if a three-year contract would give me enough time to memorize all their names when a male voice called out from across the room: "Jeanne! Jeanne Cooper!"

I looked to see William Gray Espy running toward me. (He played Snapper Foster then, before he was replaced by David Hasselhoff.) I was so ecstatic to see a familiar face that I met him halfway across the room, and we hugged for what seemed like about a half hour. We'd worked together and become pals a year before, on a Raquel Welch film called *Kansas City Bomber*, and I'll always be grateful to him for going out of his way to make "the new kid on the block" feel at home on my first overwhelming day at *Y&R*.

It's hard for actors who are just entering the soap world today to fathom this, but way back when we had several luxuries that have eroded away over the years as budgets have become more of a priority than creativity. We had several rehearsals before scenes were put on tape, and if something went wrong during a scene we actually reshot it until we got it right. Today, short of knocking over a piece of scenery or falling facedown in the middle of an important line of dialogue, we get one take, like it or not, and then it's on to the next scene. Sets were beautiful back then, exquisitely decorated and appropriate—houses and apartments had bedrooms and dining rooms, businesspeople had well-appointed offices, and formal events were held in breathtaking ballrooms. The Chancellor living room alone cost $175,000, which was a fortune in 1973. These days, on the rare occasions when you see Katherine's bedroom, you'll notice it bears an uncanny resemblance to one of the rooms at the

Genoa City Athletic Club with the exception of a few pieces of furniture and a change of drapes. The scrambled eggs we used to be served during breakfast scenes might have been cold by the time we got them, but at least they weren't the plates of crumbled corn bread we're given now.

All of which is to say that, from the very beginning, it was the hardest work I'd ever done, and I loved it. I loved the process, even the necessity of spending my evenings memorizing pages and pages of dialogue for the next day. I loved being part of a team of actors, writers, directors, producers, hair and makeup and wardrobe artists, and extraordinary crewmen who were unanimously committed to doing it well and doing it right, and part of a network that supported us. (A widespread rumor had it that our big boss, creator and head writer Bill Bell, whom I hadn't met yet, wanted to pull *Y&R* off the air due to poor ratings. CBS insisted on sticking with us, urging Bill to give the show time and help it build by bringing in this new Katherine character for added edge and controversy, and God bless them for that.)

And perhaps above all, I loved Katherine Chancellor and spending many hours a week giving life to her. She was flawed, no doubt about it. She was desperately fighting to save her marriage to Phillip Chancellor, whom she'd married on the rebound after her first husband, Gary Reynolds, died. Her marriage to Phillip was strained because of the alcohol and the stableboys she turned to for consolation, and before she knew it Phillip had fallen in love and even conceived a child with her younger, ambitious, and all-too-willing paid companion and manicurist Jill Foster, played by that sexy little force field Brenda Dickson I'd noticed on my first day at work.

Those wacky, zany soaps, huh? Where *do* they get such outlandish storylines?

~ ~ ~

EVERY VALENTINE'S DAY FOR the past seventeen years, Harry had sent me two dozen long-stemmed red roses with a card that read, "I love you more and more every year." I might have been more touched by the gesture if red roses had been my favorite flower, or if I hadn't known it was his secretary, not him, who made all the arrangements with the florist to make sure I felt special on such a special day. But I always went through the motions of acting surprised.

On Valentine's Day 1974, I didn't have to act surprised. I genuinely was surprised, to the point of feeling a knot forming in the pit of my stomach, when, instead of the usual red roses, two dozen long-stemmed pink roses arrived, with a card that read, "Thank you for all the wonderful time we spend together." Needless to say, it didn't sit right with me, and the knot in my stomach continued to grow as I put the roses in a vase. I had a sinking suspicion that I knew exactly what had happened, but on the off chance it was an innocent mix-up at the florist, I picked up the phone, dialed Harry's secretary, and told her about the pink roses and card that had just been delivered.

I'm sure if she'd had a minute or two to think about it, she would have covered it beautifully. But since I caught her off guard, she told me all I needed to know without saying a word—she just gasped. I thanked her for her help and hung up, sadder, angrier, and much more shocked than I should have been. I stumbled and seethed my way through the rest of the day and said nothing to Harry. Not yet. I didn't want to start that conversation until I was confident about what I intended the outcome to be, especially when the outcome was likely to have a huge impact on my children's and my lives. As it turned out, I didn't have to wait long for that confidence to hit me right between the eyes.

I was in the rehearsal hall first thing the next morning, so grateful to be in a place that had come to feel like my refuge, a place where I was stimulated and challenged and busy and respected and appreciated and surrounded by friends, a place that had nothing at all to do with Harry. With the rare exception of one of my kids, no one ever called me there, let alone at 7:30 A.M., until that day.

A woman's voice responded when I answered.

"Jeanne Cooper? This is Michelle," she said.

"Who?" I didn't have a clue who she was, but she cleared it right up for me.

"Michelle," she repeated. "I've been seeing your husband for the past six or seven months, and . . ."

I had no idea where she planned on taking this conversation, but I wasn't about to hold up my end of it with a roomful of coworkers staring at me. I cut her off and gave her my dressing room phone number. "Call me there in five minutes." It wasn't an invitation; it was an order.

I hung up, grabbed the closest inanimate object, which happened to be a coffeepot, and hurled it across the rehearsal hall, where it shattered against the far wall. A lot of sympathetic onlookers quickly moved to clean it up, but I waved them away and did it myself, then headed off to my dressing room, gratefully accepting Julianna McCarthy's offer to come with me and listen in.

The phone was already ringing by the time we got there. Even I was surprised at how calm and flat my voice was when I answered. "Yes, Michelle, you were saying . . . ?"

"Well, this is a little awkward, but as I mentioned, Harry and I have been seeing each other for the past six months or so . . ."

"And I hope you enjoyed your red Valentine roses," I said. "Although the note about his loving you more every year must have confused you. But since you've tracked me down at work, I assume you didn't just call to chat, so what is it you want?"

"Like I said, it's awkward, and I'm sorry to bother you with this while you're dealing with your illness."

"My illness?!"

She actually took a stab at sounding compassionate. "Harry told me all about it, and believe me, he's made it very clear that he'll never leave you until you've made a full recovery." Julianna and I pulled our ears away from the receiver to give each other a "Do you believe this?" look. Incredibly, she was getting even angrier than I was. "But the thing is," Michelle rushed on, "he's a month behind on the rent, and we bought all this furniture, but I just found out they won't deliver it until they get a check."

What do you know, I'd been wrong all these years. Harry hadn't been robbing Peter to pay Paul. He'd been robbing Jeanne to pay Michelle and God only knows who else. As for this conversation, I'd finally had quite enough.

"Michelle," I said, "I have good news for you, and I have bad news. The good news is whatever illness I was suffering from, a miracle happened and I don't have it anymore, so Harry's all yours, with my blessing. In fact, marry him if you want, even though he doesn't have a pot to piss in or a window to throw it out of. Really, I mean this, be my guest. But just so you know, here's the bad news—the bank is closed."

I'm proud to say I made it through work that day without a glitch. And then I drove home, packed up everything Harry owned in that house, and had it delivered to Harry's office—or, to be more precise, the office I was renting for him in my agent's suite of offices.

Harry called a few hours later in a panic. "I just got back to my office and all my things are here. I guess you don't want me to come home tonight."

"Not unless you promise to bring me two dozen pink roses," I shot back in a sickeningly sweet voice that quickly switched to a low

growl. "I'm sure you've heard by now that Michelle called me, and I just want you to know that as thoroughly disgusted as I am with you, I'm even more disgusted with myself. Good-bye, Harry."

None of our children was living at home by then. Corbin and Collin had started college, and Caren was thriving at the Idyllwild Arts Academy, a private school near Palm Springs. My plan was to sit down with each of them face-to-face and explain, without going into too many details, that their father and I had separated. Harry, just when I thought I couldn't despise him more, trumped me by calling them instead, even reaching and devastating Caren at school the next morning with the news that "your mother kicked me out." I immediately called the headmaster, told him to please keep her in the building until I got there, and made the two-hour drive in just under ninety minutes.

I wish I could say I felt relieved and glad to be rid of a man with such an obvious lack of integrity. But the truth is, the pain and anger were excruciating, compounded by the fact that as the next days and weeks passed, I discovered that Harry's serial infidelities were the worst-kept secret in town. It seemed as if everyone knew but me, including my agent, who'd been sharing office space with Harry at my expense. Needless to say, I fired him immediately. A well-known soap columnist admitted in private that he'd spotted Harry several times at a restaurant called Jack's at the Beach, not with Michelle but with Michelle's best friend, and Harry had been seen by many of our mutual friends with several different girlfriends at screenings all over town while I was home studying the next day's script. No wonder he'd been so adamant about not wanting to lose me and the children. We were the perfect defense against his having to make any long-term commitments to the many mistresses on whom he was also cheating. Using me was bad enough. Using my children? Really? The word "unforgivable" doesn't begin

to cover it. I've been told there are references on the Internet to the fact that Harry and I remained close friends after our separation and divorce. There you have it—absolute proof that you can't believe everything you read online.

It was an awful, painful, deeply insecure time in my life when there were very few places I could turn where I didn't sense betrayal, secrets at my expense, and astonishing stupidity on my part. One of the places I could turn to was the *Y&R* studio, where I was valued and where Harry Bernsen meant nothing, and not a day went by when I wasn't grateful for the safety net my coworkers, and Katherine Chancellor, for that matter, provided me when I needed it most.

~~~~~

THINGS WEREN'T GOING ALL that smoothly for Katherine either, by the way. When her husband, Phillip, learned that his mistress, Jill, was carrying his child, he was ecstatic and asked Katherine for a divorce. Katherine, drunk as a skunk, signed the divorce papers and Phillip flew to the Dominican Republic to put a quick end to his marriage so that he could marry Jill.

Katherine met his plane when he returned to Genoa City and offered to drive him home, during which she tried to convince him to give their marriage another try. When he refused, Katherine pushed the gas pedal to the floor while going around a curve, and the car flew off a cliff. Both Katherine and Phillip were critically injured. Shortly before he died, Phillip had the hospital chaplain marry him and Jill, a marriage Katherine had annulled by successfully alleging that because she'd been drunk when she signed the divorce papers, the divorce wasn't legal and neither was Phillip and Jill's marriage.

One day Katherine's beloved son, Brock (by her first husband, Gary Reynolds), arrived at her door and begged her to let him take

her to an Alcoholics Anonymous meeting. The "Friday cliffhanger" that week was a very shaky, hesitant, frightened Katherine stepping through the door of a meeting with Brock by her side. We had no idea if she was going to stay or run away . . . but Monday's show opened with Katherine taking a deep breath and stepping forward to announce, "My name is Katherine, and I'm an alcoholic."

I was genuinely honored and humbled by the response to Katherine Chancellor's rehab. For years afterward, I received thousands of letters from fans telling me that it was Katherine's battle for sobriety that inspired them to overcome their own alcohol addiction, and at countless personal appearances people not only thanked me for the inspiration Katherine provided but also gave me their AA chips as a token of their gratitude. One woman in particular touched me deeply—she'd kept a note that I'd written to congratulate her on her first month of sobriety that was so old there was a three-cent stamp on the envelope. Katherine's obvious impact on the *Y&R* audience, and the responsibility that impact carried with it, made such an impression on me that whenever I heard about an upcoming storyline in which Katherine was going to fall off the wagon, I wrote literally hundreds of letters to warn those very special fans what was coming and to remind them that it was only a fictionalized version of what could happen. "Don't do it yourself," I told them. "Let Katherine do it for you, and you'll see, she'll beat it again."

I hope each and every one of you knows what your stories continue to mean to me. I've never forgotten you, and I never will.

~ ~ ~

MEANWHILE, BACK IN BEVERLY Hills, I filed for a legal separation as soon as I kicked Harry out of the house, but it took almost a year to get the actual divorce under way. During that year I worked

hard, trying to regroup and getting invaluable emotional support from such *real* friends as Doris Day, who'd gone through her own marital nightmare with her late husband, Martin Melcher; Barbara Stanwyck, who lived up the street; and my darling Barbara Hale, whose friendship I continue to cherish to this day.

Inevitably, all that emotional pain began to manifest itself physically, including an onset of severe stomach spasms. I was at lunch with a dear friend one day about six months into the legal separation when a particularly nasty spasm hit—suddenly I couldn't breathe, and my stomach distended so horribly that I looked as if I were about eighteen months pregnant. My friend ordered two shots of brandy and told me not to sip them but to belt them down as fast as I could. And what do you know, a few moments later my muscles relaxed, I could breathe freely, and my stomach returned to its normal size. I'd never had any relationship with alcohol at that point in my life, for the simple reason that I just plain didn't like the taste of it. But if it could calm these stomach spasms, and even my nerves, and make all this not hurt quite so much? Sure, hell, why not start keeping some brandy, or whatever, around the house just in case? It worked too, at first to get rid of the stomach spasms and, before long, to prevent them in the first place. Not only that, but it was also socially acceptable, legal, and readily accessible, and it helped me sleep. Even the taste wasn't so bad once I got used to it. What had I been thinking, rejecting alcohol for all these years when it had so much to offer?

The divorce proceeding itself was as predictable as the sun coming up. Harry showed up in court with a team of attorneys and a stack of falsified documents. I showed up with one lawyer and the truth. Harry thought he should receive alimony. The judge and I thought he shouldn't. He thought I should continue living in our Beverly Hills house and pay him $5,000 a month rent. The judge

and I thought the house should be sold and I should pay Harry $0 a month rent. The house went on the market the same day the divorce was finalized, and frankly, at that point, I didn't really care where I went from there or what, if anything, I took with me. I just wanted *out*.

Fortunately, my children did care, and Corbin found a wonderful house for me on Coldwater Canyon in the Hollywood Hills. It was beautiful, secluded, and peaceful but still an easy drive to work, and I loved it there. I spent countless hours decompressing in that house and thinking (maybe even obsessing) about how I got there. The truth, I came to realize, was that while Harry was happy to take every possible advantage of my success, he also resented me for it, and I promised myself I would never again put myself in the position of feeling apologetic for any achievement I damn well knew I'd earned. Nor would I ever again ignore for the sake of convenience what my heart was telling me—in this case, that I'd stayed far too long in a marriage to a man I no longer loved and had honestly come to dislike.

I would and will always give him credit for two things: being one of the most brilliant agents I'd ever seen before his greed and amorality ruined his career, and being the one and only man who could have given me these three magnificent children I wouldn't trade for any other children on this earth.

And while I thought, and regrouped, and relaxed, and faced facts, I drank. I tricked myself into thinking it helped, that it gave me added clarity—in vino veritas and all that. I became an enthusiastic social drinker, telling myself the lie that it didn't affect my behavior in the least except to possibly make me more fun at parties, and I drank alone, which did make me privately wonder from time to time if I might be developing a problem. In general, though, having clearly learned nothing at all on this subject from Katherine

Chancellor, by the time she'd become clean and sober, I'd become a full-blown alcoholic, and I stayed that way for a good—or frankly not so good—three or four years.

Any illusion I might have had that I was a productive, high-functioning, discreet alcoholic (if there is any such thing) was shattered one day when my son Collin knocked at the door.

"Pack a bag, Mom," he said as he came striding into the house. "I'm taking you to St. John's hospital."

"Why would you do that?" I asked him.

He stood facing me, and to this day I remember and admire how neither his voice nor his eyes wavered for an instant. "Bill Bell called. He has a big storyline coming up for you, and he needs you in rehab."

I took that in for a long time. Finally I managed to ask, "Is this mandatory?"

"Yes, it is," he answered, quiet but firm.

My response was as big a surprise to me as it was to him—I blurted out a truly joyful, "Thank God!" and hurried to my room to pack.

I loved rehab. Even during its hardest moments, I was aware that a team of people who'd been trained to help was leading me along an escape route from the prison of alcohol addiction I'd wandered into. I couldn't have become clean and sober without the entire staff and the ongoing support of Alcoholics Anonymous. (Yes, I'm proud to say I'm a "Friend of Bill.") Parenthetically, it was an ongoing source of fascination to me that during my stay at St. John's, I was constantly greeted, even by my therapist, with a cheerful, familiar "How's it going, Mrs. Chancellor?"

I have no idea what the "big storyline" was that inspired Bill Bell to send me to rehab. I'm not even sure there was one; I think it was just his excuse to demand I get the help I needed. And believe me,

I'm convinced that if I had refused, he would have fired me, and good for him. Good for him for caring enough about his show, and about me, to see to it that both of us had the best possible chance to succeed, no matter what it took. There are some network executives and producers today who could learn a valuable lesson from his example and probably save some lives in the process, just like, in so many ways, Bill Bell and *The Young and the Restless* saved mine.

I'D BEEN AT *Y&R* for three or four months before I met Bill and Lee Phillip Bell. I knew the Bells lived in Chicago, where Lee Phillip was a star in her own right with her own daytime talk show. I knew they cocreated the show and that Bill was our head writer. I knew Bill was also a consultant on *Days of Our Lives*. And I knew he'd had another actress in mind for the role of Katherine Chancellor until John Conboy convinced him to give me a try. So it was a huge confidence boost when I glanced over one morning to see Bill and Lee standing discreetly offstage watching rehearsal, grinning from ear to ear. Bill's blue eyes were literally twinkling, although his dubious pair of plaid pants caught my attention more. Lee exuded a warm, graceful charisma that made me look forward to getting to know her.

We quickly became good friends. We genuinely liked and respected each other, and we became almost quasi-godparents to each other's children—like me, Bill and Lee had two boys and a girl: Bill Jr., Bradley, and Lauralee. I still remember dancing with eleven-year-old Bill Jr. one night at the Beverly Hills Hotel and how fiercely protective I was of Lauralee when she joined the *Y&R* cast as Christine "Cricket" Blair and had to deal with the double-edged sword of being the boss's daughter. And when my daughter,

Caren, headed to Chicago for college, Bill and Lee made a heartfelt offer of "anything she needs, no matter what it is, all she has to do is pick up the phone." She never took advantage of their generosity, but it meant the world to her, and to me, that she had someone close by who'd be there for her in a heartbeat.

The Bell family eventually moved to Los Angeles, into a beautiful estate in Beverly Hills. They were staying at the Beverly Wilshire Hotel while their home was being renovated when I took the family to dinner one night and then ordered them to follow me to a kind of surprise party I'd arranged. Halfway there, they waved me over to the side of the road, and Bradley came running over to my car to explain that it was already past his father's bedtime (at nine P.M.) and to ask if it would be all right if they just headed home and called it a night instead.

"No, that would not be all right," I told him. "A dear friend of mine is expecting us. If your father wants to leave and go home to bed after we get there, that's fine with me, but we *are* showing up."

Our two-car procession pushed on, I'm sure with a lot of grumbling and whining in the rear car, until we finally arrived at our destination: a club in Hollywood called La Cage aux Folles, renowned for its spectacular, hilarious drag shows. I'd been there before to see my dear friend, a drag queen named James Haake, perform, and I loved every minute of it. (By the way, James, you once told me that, no matter what was going on in my life, I should devote two hours a day, every day, strictly to myself, because it would reduce my stress level and because I deserved it. I've been gratefully taking your advice ever since.)

The Bell family looked understandably tentative as they followed me to our table in the crowded club, Bill cursing me under his breath and yearning for his pajamas, I'm sure. I ordered a round of drinks, which arrived just as the show began—a fabulous show

that, thanks to James, was played directly to the Bells for the most part, with many of the standard songs slightly revised to include the name "Bill" ("It Had to Be Bill," for example, and "Can't Help Lovin' That Bill of Mine").

It was one of those magical nights I even knew at the time I'd never forget. We all had fun, but none of us more than Bill, who started laughing and singing shortly after the show began and kept right on going until the Bells got back to their hotel at one A.M. In fact, Lee had to retrieve Bill from the middle of the street an hour later, where he'd decided to serenade the heart of Beverly Hills at the top of his lungs, and by all accounts that was the first and last time in his life Bill stayed up until three A.M. and loved every minute of it, whether he remembered it the next day or not.

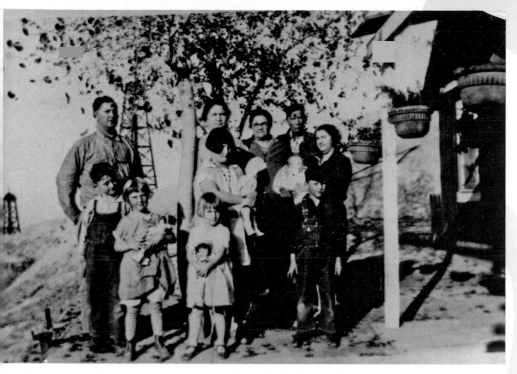

My parents and grandparents at the Taft oil fields (mother, in black, holding me), looking like a group audition for *The Grapes of Wrath*.

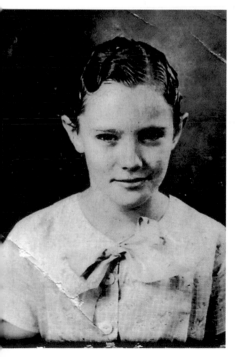

Even at eight years old I knew—it's all about the hair.

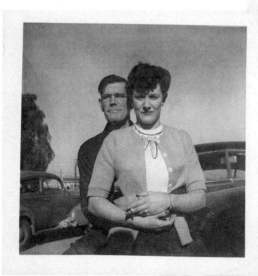

A rare shot of just me and Daddy.

Eighteen and surviving my first bro-
ken heart.

Good-bye, Taft . . . look out,
Pasadena.

Daddy, Evelyn, Jack, and me—one of our
last moments together.

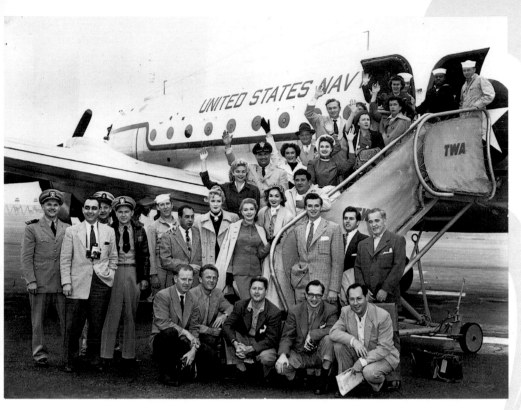

Off to Alaska with Ann Blythe, while Universal flew in our replacements behind our backs.

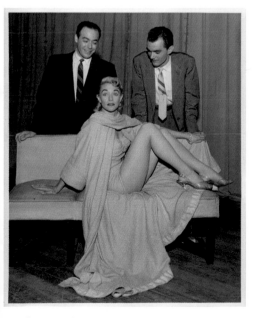

The good news: starring in *Best Foot Forward* on stage. The bad news: having to sit like this to promote it.

Adding "sultry" to my repertoire for $250 a week.

Harry and me, straining for happiness in Venice while I shot *The Vikings*.

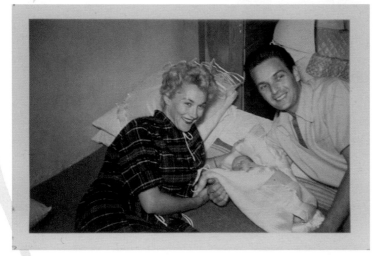

Harry, baby Corbin and me—Harry smiling longingly over at my checkbook.

One thing I'll say about Harry and me: we did make three spectacular children (from left to right, that's Corbin, Collin, and Caren).

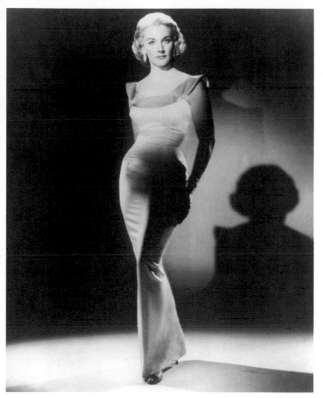

You thought Angelina Jolie invented this move?

A "candid" shot of me shopping in Beverly Hills with two Russian wolfhounds and a studio photographer.

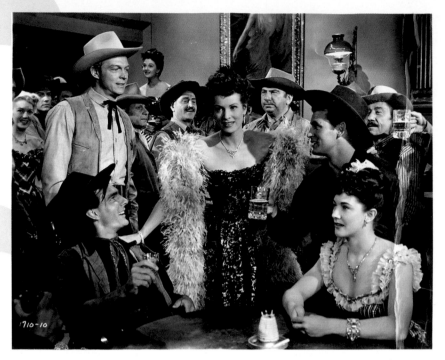

Maureen O'Hara, in *The Redhead from Wyoming* (center), taught me well: "If you can't see the camera, the camera can't see you."

From *The Big Valley*, on which I guest-starred with my great pal Barbara Stanwyck.

Happily upstaged by the chimpanzees in *Black Zoo*—not the first or last time I'd fall in love with my costars.

With Paul Winchell and Jerry Mahoney—or, as I came to see them, Harry's idea of the perfect relationship.

"What's that, Harry? Another business trip? Really?" (Actually, just a press photo for *The Man from U.N.C.L.E.*)

In *Kansas City Bomber* with Raquel Welch, one of Hollywood's most underrated actresses.

My first *Y&R* cast photo in 1973, me (top row) wondering how I'd last all the way through a three-year contract.

Onscreen and off, I found Quinn Redeker irresistible.

My televised face-lift—I'm in this for the glamour.

One of my greatest thrills—playing Corbin's on-screen mom on *L.A. Law* and both of us being honored with Emmy nominations.

My alter-alter-ego, Marge Catrooke, whom I adored. May she rest in peace—and come back soon.

My friend Diane Sawyer, a beauty inside and out.

My son Collin and my boss Bill Bell literally saved my life.

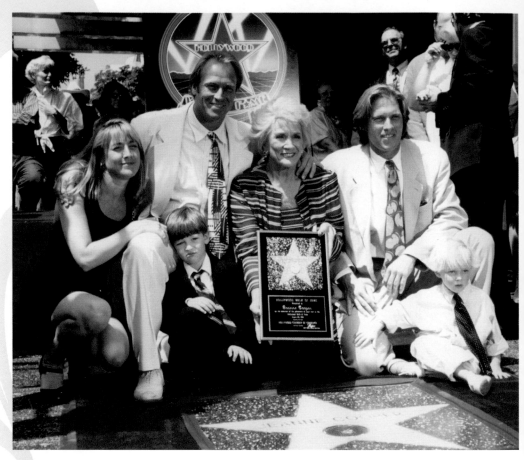

An embarrassment of riches: my three children, my first two grandchildren (Oliver and Weston), and a star on the Hollywood Walk of Fame.

The big boss, Leslie Moonves, President and CEO of CBS, at whom I shamelessly throw myself every chance I get.

What I won't do for charity—that's me, singing with my two great pals Shirley Jones and Beverly Garland at the Ritz Carlton Hotel in La Jolla.

Doug Davidson (*Y&R*'s Paul Williams), whom I've been trying to adopt since the day we met.

The class act of the group: my dear friend Lee Philip Bell, cocreator of *Y&R*.

Never let it be said that Planet Hollywood doesn't know how to throw a cast party: that's most of us in New York for the Daytime Entertainment Emmy Awards.

The man who started it all: my friend, my boss, my savior, and my favorite sparring partner, the late, great Bill Bell.

Beau Kayser: my son Brock on *Y&R*—so no, it most certainly wasn't incest.

*died 2014*

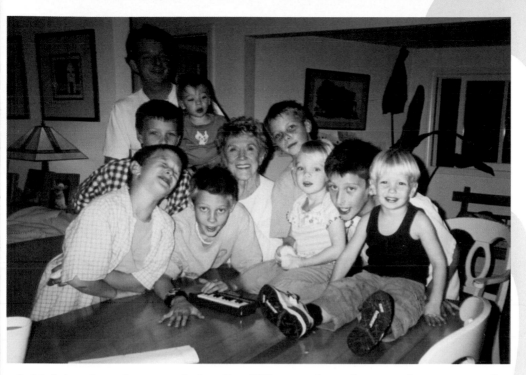

I think it only took my son-in-law, Jon Wilson, and me about two hours to get all eight of my grandchildren to sit still for one of their first photos together.

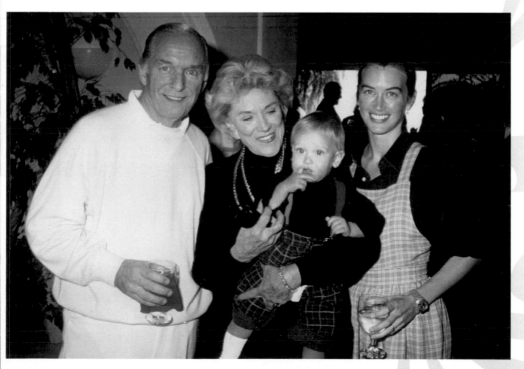

My sons have always had great taste in women: that's Corbin's wife, the spectacular Amanda Pays, with Bill Bell, me, and their oldest son, Oliver.

Later
ve an
ways u
and Ev
ontinue
miliar
Jennif
rprised
an exc
t be er

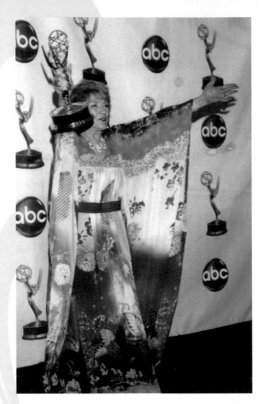

My first daytime Emmy, and well worth waiting for. In case you can't tell: I was ecstatic.

If and when my cherished friend Barbara Hale writes her memoirs, let me just say in advance that I deny everything.

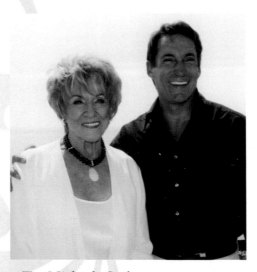

To Michael Corbett: you were a fabulous David Kimble on *Y&R*, and you're fabulous on *Extra*. Congratulations on your success, my friend!

With my beloved Jess Walton (*Y&R*'s Jill Foster Reynolds Chancellor Thurston Brooks Sterling Atkinson and, apparently, Fenmore) on a brief break between cake-fights.

My former costar Shemar Moore (*Malcolm*, *Y&R*)—actually, just an excuse to include this photo, because . . . well, look at him!

Personally and professionally, I love Anthony Geary and finally got to work with him on Corbin's film *Carpool Guy*.

Dressed as Queen Elizabeth I for *Y&R* . . . or an ill-conceived fashion risk.

I proudly and humbly present my real-life family.

I proudly and humbly present my daytime family.

*All photographs courtesy of the author unless otherwise indicated.*

CHAPTER FIVE

## The Face-Lift Heard 'Round the World

Not enough can be said about the genius of Bill Bell. The characters he created to populate Genoa City were bigger than life but always based in reality, and they never made an appearance until Bill had meticulously thought through their purpose, their impact, and their past, present, and potential future in the tapestry of Genoa City society. When a character didn't work, usually because either the actor or the storyline wasn't developing as he'd hoped, he was the first to erase the part from the canvas, sometimes unceremoniously—one character, for example, whose name I can't recall, went upstairs in the Abbott house one day to wash her hair and was never seen or mentioned again. Bill's core characters were part of his family, and even when they were written out of the show for some reason, he never killed them off. The main reason, of course, was that he always wanted to keep the option open to bring them back someday. But I always suspected

a little superstition under the surface too: Bill wasn't about to run the off-chance risk that ending the life of a fictional family member might compromise the safety of his nonfictional family.

Bill lived and breathed *The Young and the Restless*. He was a workaholic who took his show and everyone involved very seriously, and he never expected more of any of us than he expected of himself. He also had a short fuse when he detected laziness, disloyalty, or a lack of commitment, and since I'm not exactly known for having the world's longest fuse myself, he and I had our share of yelling, screaming, shouting matches, as only two people can who are passionate about what they're doing, know each other very well, and love each other as dear, dear friends.

Bill had no use for people who complained about trivia, or, even worse, for the sheer attention of complaining. He was not the man to whine to if someone had a bigger dressing room than yours, or if you thought your parking space was an inconvenient distance from the artists' entrance, or if you didn't have as many lines as some other actor in any given script. And if you went to him to complain about a problem, you had better have a "fix" in mind, so that it would be a "Here's what I'm unhappy about and here's what could be done instead" conversation, rather than a simple, annoying "Here's what I'm unhappy about."

What Bill and I fought about most often involved our occasional differences of opinion about Katherine Chancellor—not how her character was being developed, because it was hard to find fault with that, but how she expressed herself. And ninety-nine times out of a hundred it was some idiomatic word or phrase in a line of dialogue that drove me crazy enough to take on the boss.

No one, I sometimes believed, knew Katherine Chancellor better than I did. But of course in the days of Bill Bell, that simply

wasn't true. He originated her on paper, and like every other character on the *Y&R* canvas, there was nothing imaginary about her as far as he was concerned—she was a real person and she was an essential part of his intellectual and emotional family. He never ceased to appreciate that he and I were Katherine's "co-parents," so to speak, but in a knock-down, drag-out fight about what she would or wouldn't say, he always won.

I would come across some word or phrase in Katherine's dialogue that seemed completely foreign to me, and if it became too awkward for me to shrug off, I wouldn't hesitate to march upstairs into Bill's face.

"What the hell is this line supposed to mean?" I would roar. "I've never heard this word [or phrase] in my life, and I would certainly never use it."

"This isn't *The Jeanne Cooper Story*," he would roar back. "I don't care what you would or wouldn't say, I care what Katherine Chancellor would or wouldn't say." He would then point out the countless differences between Katherine's history and mine, including the fact that she was a Midwestern woman, remind me that he knew Midwestern idiomatic speech infinitely better than I did, and end with a firm, usually loud "The line stays as written."

On rare occasions he might be a little flexible, particularly if the alternate dialogue an actor suggested was an improvement and was clearly thought through. But Bill had one unconditional rule: his "tag lines," the lines that ended a scene, were never to be tampered with, as Jess Walton once found out despite my warning that she'd be fighting a losing battle if she spoke up about it.

For some reason, she dug in her heels about a tag line in which Jill was supposed to say, "And now, if you'll excuse me, I have a distended bladder." Jess didn't want to say it. She thought saying

something about excusing herself to go to the ladies' room, or to powder her nose, would be much more natural, and she felt strongly enough about it that she insisted on confronting Bill.

"Forget it. It's a tag line," I told her. "He'll never let you change it."

"We'll just see about that," she said, and she marched upstairs to his office.

She was back a few minutes later, and, while I'm sure it was under protest, delivered the line as written. That was probably in the late 1980s. And as recently as the Y&R fan event in 2011, viewers from all over the world were still taking delight in quoting what's become known as "the distended bladder line."

As fiercely as Bill could take one of us on at any given moment, his ferocity multiplied when he was fighting with CBS for the success and integrity of his beloved show. He knew *The Young and the Restless* was making a fortune, and he knew it earned every dime it made for the network thanks to the blood, sweat, and tears he and his cast and crew were investing in it. We were no fluke, no passing stroke of luck, and he wasn't about to let us be treated as if we were. He and his creation changed the face of daytime. If CBS didn't care to give us the support and respect we deserved, he left no doubt in executives' minds that he was fully prepared to go elsewhere. Having been on the losing end of more arguments with Bill than I can count, I've never been surprised that we started on CBS in 1973 and we're still there almost forty years later.

Bill and his "real life" family were also among the most generous people I've ever met, and we lucky recipients of that generosity were treated to some truly memorable parties. The annual Christmas festivities at the Bell house were as spectacular as the house itself: five-course sit-down dinners for the cast and our guests. The show's anniversary celebrations invariably took place at the stunning Bel-Air Bay Club overlooking the ocean. There were so many

cake parties on the set that I think we stopped just short of celebrating someone's successful trip to the mailroom, and in every case, no expense was ever spared. I wish to this day that the "suits" would learn from Bill's example and recognize what a difference gestures like those can make when it comes to cast and crew morale. The issue isn't how much money is being spent to show us a good time. It's our bosses simply understanding that everyone who works for them would appreciate a thank-you here and there in the midst of the current, much more frequent "There's no room in the budget."

In my educated opinion, the soap opera world has never known a more dedicated, more gifted head writer than Bill Bell. He was an artist with uncanny instincts and a brilliance for weaving several carefully constructed storylines together into a balanced, compelling tapestry. He and I had our disagreements, some of which you'll read about, and I often accused him, as did many of my castmates, of spying on us when our fictional storylines hit a little too close to home in our personal lives. But we all owe the last thirty-eight years on the air, and our twenty-three years as the number-one daytime drama, to him. I thank you, I miss you, and God bless you, Bill.

~~~

ALONG WITH MY DEEP feelings for Bill, I fell in love with Katherine Chancellor and the cast and crew of *The Young and the Restless* the instant I met them. In so many ways, they saved my life, challenging me and stimulating me and becoming a ready-made group of friends to look forward to seeing four or five days a week . . . even if a couple of those friendships got off to a rocky start.

The role of Katherine Chancellor's nemesis, Jill Foster, was originally played by a sexy, feisty actress named Brenda Dickson. In our first scene together, Katherine, in a full-length mink coat,

swept grandly into the salon where Jill was working as a manicur-
ist. During rehearsal I accidentally dropped the coat on the floor at
Brenda's feet and asked her to please pick it up and hand it to me.
You would have thought I'd asked her to please wash and kiss my
ass. I picked the coat up myself and walked away without saying
a word—which, as those who know me will tell you, took every
ounce of restraint I could muster. But she was interesting to work
with, full of surprises, with an offbeat delivery unlike anything I'd
ever seen before, so at least, I decided, there was something to be
said for her.

Unfortunately, our next encounter was no warmer or fuzzier. We
had a very important, difficult scene to shoot, and Brenda was no-
where to be found. I was getting angrier and more anxious by the
moment as the search for Brenda spread throughout the building, so
that finally, when she came flying in at the last possible instant, I blew.

"How you treat your other castmates is none of my business," I
snarled in her face. "But when you have a scene with me, don't you
ever pull this shit again."

She took a step toward me, glared into my eyes, and said un-
apologetically, "I've never been spoken to like that in my life. How
dare you?"

I wasn't done yet, stepping even closer to her without losing eye
contact. "I don't know what your background is," I said, "but mine
is theater. I'm a very disciplined actress, and I don't appreciate
being panicked right before a scene begins. It shows in the per-
formance, which means the audience gets less than they deserve.
That may be okay with you, but it's sure as hell not okay with me,
and I'll be damned if I'm going to let you get away with it when
we're onstage together."

In my very early days on *Y&R*, Brenda mentioned that she'd
seen and loved *Let No Man Write My Epitaph*, a dark, gritty movie

costarring Shelley Winters as a tough, troubled barmaid who becomes a heroin addict. Brenda was especially taken with Fran, the redheaded prostitute in that film, and she was impressed to hear that I was the actress who'd played Fran.

And so, wanting to be sure I'd made a lasting impression on her, I couldn't resist finishing what I'll politely call our little ground rules discussion with a firm, pointed "Or, to put it another way, pretend I'm Shelley Winters."

Her eyes widened, then she turned and stormed away without saying a word. For the next three days we didn't speak to each other except as Katherine and Jill. She stared menacingly at me at every opportunity, and, depending on my mood, I either stared back or ignored her completely.

Finally, on the morning of the fourth day, there was a knock on my dressing room door. To my surprise, it was Brenda, and she didn't seem to be holding a weapon. After a long moment of silence between us she said, simply and quietly, "You were right. I apologize. It won't happen again."

And thus began a friendship I cherish to this day. I loved working with her, and I love her. I always will. Under all that attitude and bravado, I found her to be tender, generous, and sometimes heartbreakingly fragile. One night I'll never forget because it touched me so deeply: she called in tears and asked if I could please come to her house as soon as possible. I arrived to find her in the midst of a full-blown meltdown over the fact that her fiancé had broken up with her with no warning at all, just a few short weeks before the wedding.

"What am I going to do with these?" she sobbed, pointing to four hundred beautifully engraved wedding invitations.

"You're one of the stars of the number-one show in daytime," I told her. "I'll bet you could sell them for five dollars apiece

minimum." She smiled for the only time during that long, sad night. I ached to see her in that much pain, and watching the tenacity and determination with which she pulled herself out of that darkness made me proud to be her friend.

She left *Y&R* amid a flurry of rumors and tabloid publicity. Her reasons for leaving belong in her book, not mine. Even after all these years, while I don't see her or talk to her as often as I should, I hope she knows how fondly I remember her and wish her the best.

~ ~ ~

THE ROLE OF JILL Foster Abbott passed from Brenda Dickson to Jess Walton in 1987, and I'm not sure any two actresses could have been more different. As intriguing and professional as Jess was from the very beginning, with a great track record from her days on the CBS daytime soap *Capitol*, it wasn't the world's smoothest adjustment for me, a little like making the transition from working with a Vegas showgirl to acting opposite a classical ballerina. In an earnest effort to be helpful, I gave Jess several hours of Brenda-as-Jill tapes, for backstory and some idea of the stilettos she'd been hired to fill. She never watched them. She wasn't interested in portraying Brenda Dickson playing Jill Foster Abbott. She was interested in playing Jill Foster Abbott, and doing it her way. At first I was annoyed at her for ignoring what I thought was a very generous, embracing gesture on my part. Looking back, and being brutally honest with myself, I doubt if I would have appreciated being handed a pile of tapes of someone else playing Katherine Chancellor with an implied subtext of "Here's how to portray this character." I came on board to make Katherine Chancellor mine, as surely as Jess came on board to make Jill Foster Abbott hers, and I respect

her enormously for that despite my initial reaction to the contrary.

The relationship between Katherine and Jill has always been a fascinating one: brilliantly conceived by Bill Bell, a great rivalry between two strong-willed, passionate women who have every reason to despise each other but, underneath it all, might take a bullet for each other under the right circumstances. The only period in which it was less than a joy for Jess and me to play the roles was that bizarre, and thankfully temporary, twist that had Katherine and Jill believing they were mother and daughter, news that sent Katherine into an instantaneous, cataclysmic stroke. It was one thing for Jill to use her favorite term of endearment—"you old bat"—on her nemesis. It was quite another, as far as the audience, Jess, and I were concerned, for Jill to say such a thing to her mother. A cake fight between two women who've spent decades torturing and loving each other is understandable if not downright entertaining. But a cake fight between a mother and daughter? Really? It was a tough emotional tightrope for us to play, and we did our damnedest to make it work, but we couldn't have been happier or more relieved when the writers saw fit to let that notoriously unreliable Genoa City DNA lab discover yet another of its mistakes and announce that Katherine and Jill weren't really related after all.

There are times when I think, "Bill Bell would be spinning in his grave." That was one of those times.

~~~

As far as I was concerned, from that moment in 1974, when I packed up Harry's belongings and had them delivered to his office, I was a single woman and fully intending to stay that way. I was ready to enjoy my life, heal my eroded self-confidence, and rediscover what

it was like to live without that constant dull, sad ache of mistrust in my soul. If never fully trusting anyone again was the best way to guard against a repeat performance of all those years with a man whose motto was "Don't tell Jeanne," that was fine with me. But it didn't have to stop me from having a good time, both onstage and off.

There was, for example, the broodingly handsome Donnelly Rhodes, aka Phillip Chancellor II, Katherine's husband when *Y&R* began. This was around the time when Phillip's affair with Jill led to their marriage, and Katherine, attempting to win him back, caused a car accident that inevitably resulted in his death. The short version of that story: somewhere in there, Donnelly and I spent a couple of perfectly lovely afternoons together at a friend's apartment. It was far too brief and uncomplicated to be called an affair, but it was memorable enough for me to still be smiling about it almost forty years later.

Come to think of it, that storyline inspired one of my more amusing moments at an airport too. I was waiting for my luggage at the baggage claim carousel when a woman who was clearly a *Young and the Restless* fan stepped over to me and said in a rather loud voice, "Admit it, you deliberately killed your husband, didn't you?" I smiled and gave her a noncommittal shrug. As my bag arrived and I started toward the exit, I noticed a couple and their child gaping at me with more than a little concern—clearly not *Young and the Restless* fans, clearly not having a clue who I was, and clearly having overheard the woman's question. Rather than disappoint them, I passed them quickly and quietly said, "Of course I deliberately killed him, and I'd do it again." To this day I wonder how many news broadcasts they watched trying to get a glimpse of that strange lady at the airport so that they could alert the authorities that I'd confessed to them on my way to the exit.

～ ～ ～

MANY YEARS LATER THERE was the divinely fun, brilliant, multitalented Quinn Redeker, who played Brian Romalotti (father of Danny and Gina), a con man Jill hired in yet another plot against Katherine. Brian underwent a makeover, funded by Jill, and was introduced to Katherine as the fabulously wealthy Rex Sterling. To Jill's profound chagrin, Katherine and Rex ended up sincerely falling in love. They probably would have lived happily ever after if Katherine hadn't been kidnapped and replaced by a diner waitress named Marge Catrooke, who bore an uncanny resemblance to Katherine Chancellor. (Don't you hate it when that happens?) Rex, unaware of the switch, found his beloved "Katherine" to be increasingly obnoxious and not nearly as appealing as the woman he married, and he ultimately divorced her and married, of all people, Jill.

Quinn Redeker and I spent a hilariously fun weekend in San Diego together, just the two of us. It was romantic and silly and I wouldn't have missed it for anything, nor would either Quinn or I have wanted to take it one bit more seriously than we did.

One thing that always bothered me about that storyline, by the way, and about similar storylines on *Y&R* and other soaps in which an imposter has infiltrated a relationship, is the apparent inability of a character to tell that the person with whom they're being intimate isn't the same person with whom they were being intimate just hours or days before. I don't care how identical the imposter is to the person they're pretending to be—I will never believe that, when bedtime rolls around, the differences wouldn't be immediately apparent. Wouldn't you think at some point pretty early in the proceedings the words "Wait a minute, who are you?!" would enter the picture? I know. Soap operas, suspension of disbelief, blah,

blah, but still, wouldn't you love for the writers, just once, to either acknowledge that problem or find a way to explain it?

I've said it a thousand times in interviews, and I'll say it again: I loved playing the dual roles of Katherine and Marge. And the greatest acting challenge of my career was playing the blue-collar, plainspoken Marge pretending to be the insanely wealthy, grammatically precise Katherine Chancellor. I always made it a point to keep Marge's impersonation of Katherine slightly, subtly imperfect but still close enough to fool Katherine's family and friends. I was and am proud of those performances, and it's the one Emmy I didn't win that I truly felt I deserved. I've never forgotten Crystal Chappell, who was on *Days of Our Lives* at the time, making a point of telling me at a pre-Emmy gathering that year (1990, I believe), "If you don't win this year, you got robbed—you more than earned it." When I finally did win my first Emmy, in 2008, I made it a point to find Crystal in the crowd and wink at her on my way to the stage. It's not as common as it should be in this insanely competitive business for actors to be generous with their compliments to each other, and I'll always appreciate her for that.

~~~~

I DID HAVE ONE genuine love affair with a castmate on *The Young and the Restless*. It lasted more than a year and ended gently and mutually. To this day I can count on less than one hand the members of the cast and crew who won't be surprised when they read this.

I still remember my first impressions of him—tall and strong, with a handsomely kind face, the sweetest smile, and the gentle heart of a hippie. In the beginning it was just a lot of long, relaxing, pretty dinners at the beach. It evolved into much more. In fact, he, with his guitar perpetually in hand, was the first man I'd brought home to my

children and my bed since Harry moved out, and he and my children loved each other. To this day I can picture him, Corbin, and Collin cutting down a rubber tree in our yard, singing and laughing and having the best time together. I wondered then and I wonder now why I hadn't insisted many years earlier on a house for my sons and my daughter that was filled with more fun than tension.

We talked about marriage. My disinterest in it had nothing to do with him.

I wasn't nearly ready to be his or anyone's wife again. I still had far too much healing to do, and I shudder to think how much misdirected surplus anger and mistrust I might have aimed at him, despite the fact that he'd done absolutely nothing to deserve it. Through no fault of his, it would never have worked. I'm as sure of that as I am grateful for the fact that we still are and will always be good friends.

And while it didn't bother him in the slightest, our age difference bothered me. As I pointed out to him more than once, "When I'm eighty, you'll only be sixty." He meant it when he said it wasn't an issue for him—not long after our romantic relationship ended, he briefly married a woman ten years older than I was.

His name is Beau Kazer. Fans of *The Young and the Restless* probably know him better as Brock Reynolds, Katherine Chancellor's son.

~~~~

OF COURSE, THERE HAVE been many actors on *Y&R* to whom I was wildly attracted but with whom there was never anything more than wonderful platonic friendships and, in one case in particular, a storyline in the late 1970s/early 1980s that made it a joy to go to work every day.

As usual, it all started with the Katherine-Jill rivalry. Jill was a

manicurist at a salon called the Golden Comb, where the irresist-
ible Derek Thurston (originally played by Joe LaDue) was a hair-
dresser, cosmetologist, and manager. Katherine fell in love with
Derek, who wanted Jill. Katherine, never one to let Jill win without
a fight, managed to get Derek drunk and married him before he
could sober up. Despite his feelings for Jill, Derek realized there
were certain advantages to being Mr. Katherine Chancellor, not
the least of which was enough money to open his own salon.

Derek's avowed love for Jill, though, sent Katherine into almost
suicidal despair, particularly when Jill began an affair with Stuart
Brooks and Derek realized he might be losing her. In an effort to
hang on to him any way she could, Katherine convinced him to
stay with her on a purely platonic basis for a year, after which she
would handsomely reward his loyalty. He finally opted to stay with
Katherine, and Jill married Stuart Brooks.

Afterward, there was an unfortunate shooting that left Kath-
erine temporarily paralyzed, but that paled in comparison to the
arrival of Derek's ex-wife, Suzanne Thurston-Lynch (played by
Ellen Weston), who was intent on winning her husband back. So
she did what any romantic rival would do: she offered Katherine
candy laced with drugs. That sent Katherine to a sanitarium, which
her roommate set fire, leading the people of Genoa City to pre-
sume Katherine was dead. Derek, who was still legally married to
Katherine, inherited her fortune and planned to spend every dime
of it on his beloved Jill. But just as they were about to be married,
Katherine appeared at their wedding, alive and well, and reclaimed
both her husband and her money.

To celebrate their reunion, Katherine and Derek went on a
cruise, intended to be a second honeymoon. Unfortunately, it
didn't go well, and after one particularly heated fight, Katherine
leapt overboard in yet another failed suicide attempt.

But what luck—Katherine was found and rescued by a Cuban revolutionary named Felipe Ramirez (played by the stunningly attractive Victor Mohica), who took her to the island on which he was holed up.

They fell madly in love, while Katherine also fell madly in love with the simplicity of Felipe's lifestyle, having nothing to do with luxuries and everything to do with hard work and inventiveness just to survive. Katherine might have vanished forever into the Jill-free jungle with her beloved Felipe had she not severely injured her leg and had the injury not resulted in a life-threatening infection that forced Felipe to risk his own freedom to return her to Genoa City for proper medical treatment. Heartbroken but knowing there was no future for him in Katherine's world and in a country in which he would undoubtedly be arrested, he left her there where she belonged but he didn't.

She recovered, of course, and immediately divorced Derek.

As far as I'm concerned, Katherine has never loved another man, before or since, as much as she loved Felipe Ramirez.

And to this day I smile at the thought that if Harry Bernsen had tried to send me from Rome to Majorca for the weekend with a handsome, uncomplicated hero like Felipe Ramirez, and if I hadn't had my beautiful children waiting for me in Los Angeles, I might have become a Majorcan resident and lived simply and happily ever after.

~~~

ASK MOST ACTORS WHO'VE been on a soap opera for a long time and I believe they'll tell you the same thing: sometimes we can't help but wonder if our bosses have surveillance teams following us around, sneaking their way into our homes and our heads. I've suspected it over and over again about the occasional eerie parallels

between Katherine Chancellor's life and mine, but never did she and I fall into perfect step more literally than in 1984.

I turned fifty-five in October 1983. Even then I didn't think of fifty-five as old, and I wouldn't have minded looking my age. But more and more often, I found myself looking in the mirror and wondering where "I" had gone. Rather than seeing fifty-five-year-old Jeanne Cooper, I kept staring at someone who was wearing every hurt, every moment of stress, every disappointment, every lie, every betrayal, every tear and sleepless night on her face for all to see, and I hated it. On a more practical, less emotional level, I also hated that my time in the makeup chair at work had expanded from thirty or forty minutes to a mind-numbing two hours, which was both boring and intensely discouraging.

As luck would have it, I'd already scheduled my allotted vacation, and the idea evolved with growing excitement that I wanted to spend it under the knife of the best plastic surgeon in town, reclaiming a face that looked as healthy and happy as the rest of me felt. After a lot of research, a lot of referrals, and a lot of consultations, I chose Dr. Harry Glassman, who, among many other accomplishments, has been the chief resident in plastic and reconstructive surgery at the University of California at Los Angeles (UCLA) since 1975. (His name might also be familiar to you as Victoria Principal's husband for many years.) I liked him very much and found him positive, confident, and reassuring, and I also admired his extensive, often pro bono experience with life-altering reconstructive surgery.

Dr. Glassman required full payment in advance. It was a lot of money, more than I could afford, and God bless my agent for lending me what I was unable to come up with on my own.

It's no surprise that I began talking about my upcoming face-lift at work—I was nervous and excited and had no interest in being

secretive about it, and we all spent so much time together that there was very little we didn't know about one another anyway. Among my most supportive *Y&R* teammates were our executive producer Wes Kenney and, most especially, our producer Tom Langan.

Predictably, it came up in our many conversations that my having a face-lift meant Katherine would be having a face-lift at the same time.

Unpredictably, although it felt perfectly logical and even inevitable, the idea took root and grew of letting my/Katherine's face-lift and recovery be filmed and aired as part of Katherine's storyline on *The Young and the Restless*. Bill Bell was ecstatic and readily agreed to my demand that it be shot documentary style—no special effects, no "prettying it up" for the cameras. "If we're going to do this, let's do it right, let's do it 'real,' and let's do it honest," I said. "Let's have Katherine show people who are afraid of plastic surgery exactly what it's like and what a difference it can make." And that unanimous commitment was at the heart of every decision we made from that day forward. Tom Langan was in enthusiastic, capable charge every step of the way, which gave me the luxury of knowing that all I had to do was hold up my end of this storyline—I could trust Tom, without a second thought, to take care of everything else.

As has happened more times than I can count over all these years, Katherine and I had hit simultaneous low periods in our lives. She was feeling as "used up" as I was. Both of us had children who'd grown up and gone out on their own. Katherine was facing the added torture of knowing that Jill's precious growing son had been fathered by Katherine's late husband. (Okay, Katherine switched Jill's baby with someone else's at birth, but I've never claimed she wasn't moody.) To rub further salt in the open wound, Jill had now married Katherine's dear friend and former lover John Abbott. Derek was gone. Felipe was gone. Katherine

was fighting her alcohol addiction again, and there didn't seem to be much left for her to live for.

Bill wrote a gorgeous scene that was as easy to play as it was excruciating, a scene that perfectly expressed what both Katherine and I were struggling with. Katherine and Dina (John Abbott's ex-wife and a confidante of Katherine's, played by the wonderful Marla Adams) were in Katherine's bedroom after some sparkling social occasion or other. (Remember sparkling social occasions in Genoa City, especially at the Colonnade Room? I miss them terribly.) While they talked, Katherine slowly began disassembling herself, removing her glittering gown . . . her makeup . . . her false eyelashes . . . at that moment in time, as far as she was concerned, the whole carefully constructed disguise she wore to trick people into thinking she was still an attractive, vibrant woman. As she looked in the mirror, her façade crumbled, exposing the flawed, fading, empty shell she felt she'd become, and she began baring her soul, first to the much younger, happier Dina and then to herself, in a beautiful monologue of quiet despair that ended with a helpless, hopeless "God, someone help me." It was one of my most memorable performances as far as I'm concerned, probably because it wasn't a performance at all, and I can still feel Terry Lester's arms around me when it was over. Terry originally played the role of Jack Abbott and played him brilliantly for many years. We were very close offscreen; we shared each other's joys and knew each other's demons without judgment, and we understood why that scene had made us both cry and impelled him to run onstage to hold me and let me hold him for a long time the instant the director yelled, "Cut!"

(Terry left the show in 1988 and passed away, far too young, in 2003. I think of him and miss his friendship every day.)

I give Dr. Glassman a lot of credit for agreeing to perform my face-lift "live" on worldwide television and the patience with which

he tolerated the often tedious and cumbersome production preparations. More than his share of colleagues was strongly warning him against it. I think the word "crazy" was even tossed around. Who wanted millions of people watching in the unlikely event that something went wrong, after all? But he stood his ground and had the courage to rise to the occasion, and I'm eternally grateful to him for that.

I'm also grateful to an actor named John Beradino, by the way, who had nothing to do with it whatsoever, other than showing up for his scheduled gall bladder surgery and discovering that he'd been "demoted" from Operating Room 1 to Operating Room 2 because of *Y&R* filming. "My gall bladder is taking a backseat to some soap actress's face-lift?" I'm told he said as they wheeled him into Room 2, and if the situation had been reversed, I'm not sure I would have been as good a sport about it as he reportedly was.

For obvious reasons I don't remember the surgery itself. I have vague memories of spending that night at a first-class surgical recovery center in Beverly Hills. And I certainly remember being surrounded by cameras while Katherine and I had our bandages removed and got our first "live" look at the results. There was some concern that the unveiling might be too graphic for daytime television, but I promised I wouldn't bleed, and sure enough, I didn't. Millions of viewers saw Katherine's new face at the same moment she and I did, and with bruises, swelling, and all, it was too exciting to be scary.

The shows themselves were artfully done. My on-screen surgeon's hands, for example, were intercut perfectly with Dr. Glassman's hands when the bandages came off, and the postoperative instructions were written into the dialogue to make the whole experience as real and informative as possible. Our ratings soared. I think I was on every national and local talk show in the country, and I got literally thousands of letters from people all over the United

States and Europe telling me that watching Katherine Chancellor's face-lift defused their fears of plastic surgery—a big accomplishment in the 1980s, when it wasn't nearly as common a procedure as it is today. It was even more gratifying that, as I'd hoped, the vast majority of mail came from men and women who'd been considering plastic surgery not for the sake of vanity but to correct some birth defect or trauma-induced disfigurement that had created a barrier between themselves and their God-given right to enjoy full, confident lives.

In fact, I had the honor of meeting one of those people, and she holds a special place in my heart to this day. A few weeks after the face-lift shows aired, I was in Dr. Glassman's office for a checkup when he asked if I'd mind talking to a woman who'd flown in from San Francisco for a consultation and was in his waiting room, hoping for a chance to talk to me. She was in need of some extensive reconstructive surgery after a terrible car accident. Her face had been so badly damaged that she'd become reclusive, hiding from the world in her small apartment but too afraid of the idea of plastic surgery to explore her options, until she watched *The Young and the Restless* and saw Katherine Chancellor go through it from beginning to end and emerge healthier and happier than ever. The woman and I had a great talk in Dr. Glassman's waiting room, and well beyond my assuring her that it was the nicest, safest present she could possibly give herself, I think seeing me thriving in person, with no TV lighting, makeup, and clever camera angles between us, eased her mind just enough to summon her courage and let Dr. Glassman work his magic on her. She wrote me a gorgeous letter several months later to thank me for giving her back the full, happy life she'd had before the accident. All the credit for that goes to her and Dr. Glassman, of course, but I was humbled to

know that Katherine and I, along with the whole *Y&R* team, played some part in making a difference.

And on that same subject, I must say it made me happy to do something that benefited Katherine Chancellor after all she'd done and continues to do for me.

That televised face-lift was rewarding in countless ways, from the overwhelming fan response to the fact that, without my asking, Tom Langan saw to it that I was given a raise, not only because I initially paid for the surgery (with my agent's help) but also to thank me for the surge in our ratings. Again, isn't it amazing how a voluntary, unexpected gesture of gratitude from your bosses can win your loyalty and respect far more effectively than yelling, threats, and complaining ever could?

So there you have it, the reason I will always proudly maintain that in 1984, *The Young and the Restless* and I cocreated television's very first reality show.

Awards and Other Dramas, Onstage and Off

There's a real sense of community among soap actors that's very unique in the television business. You'll find it within specific prime-time shows and maybe some talk shows and reality shows, for all I know, but you won't find it across the board among, let's say, all sitcom actors, or all one-hour-drama actors. We long-term soap actors, no matter which network we're on, who's producing us, and who's writing for us, have too much in common to not cheer for one another's victories and feel one another's pain when the chips are down, the stakes are high, and we're being told on a sickeningly regular basis that this medium in which many of us have loyally, lovingly dedicated the majority of our adult lives is dying of old age. (We don't happen to believe that, by the way. We really are bright enough to know the difference between "dying" and "being killed.")

Being a soap actor means working your ass off, memorizing vast amounts of dialogue day after day, with no long hiatuses and few, if any, reruns, therefore few, if any, residuals. In fact, a friend of mine, whose career began on a soap before she went on to a distinguished film career and married an insanely wealthy man, once told me that if she had to work for a living again, she'd go back to her waitressing days before she'd audition for another soap, because by comparison being a waitress was so much easier.

Being a soap actor means watching executives and writers come and go, whether or not they seem to have respect for the show, the storylines, or the cast. It can be infuriating, for example, not to mention intensely discouraging, to read interviews in which your newly hired boss is taking pride in never having watched a single episode of the show of which he's now in charge.

Being a soap actor means being asked to take pay cuts every time your contract is up for renewal because of the economy, budget constraints, blah, blah, which would be a bit more palatable if the executives who are so concerned about our budgets were taking pay cuts as well.

Being a soap actor means devoting the majority of your professional energy to shows that are rarely given a fraction of the promotion and publicity prime-time shows enjoy.

Being a soap actor means being given some storylines you adore and some storylines that make absolutely no sense to you at all, and when the latter is the case, knowing your input, even your expertise, about what your character would and would not do, or what might be a really interesting direction for your character to take, is about as welcome among the executives as a swarm of bees at an outdoor wedding.

Being a soap actor means enjoying a theoretical illusion of job security with a constant awareness that at any given moment, you could

be let go or replaced for "budget" or "storyline-dictated" reasons, or, in this new era of disregard for our time-honored legacy, your show could be canceled completely because those in charge have stopped paying attention and/or giving it the support and respect it deserves. And, of course, there's also the inarguable fact that networks can produce a game show or "lifestyle" show for a fraction of the cost of producing a soap, and if it means saving money, who cares that audiences don't have the slightest interest in watching them?

Being a soap actor means working with some of the best professionals in the business, sometimes on more than one soap, so that sooner or later it feels as if you've all worked together somehow, somewhere, and especially in the good old days of the Soap Opera Digest Awards and the more generous Daytime Emmy Awards, you've most certainly partied together.

Being a soap actor means pulling for other shows as surely as you pull for your own, because when one goes, it hurts everyone.

Being a soap actor means having the most extraordinary, loyal, generous, passionate, knowledgeable fans any medium could ever hope for, fans to whom you're enormously grateful and whose frustrations you share when their input is dismissed.

It's no wonder then that soap actors are, in the end, a community, and, for the most part, will close ranks to protect, defend, and support one another in public and try our damnedest to work out our personal problems among ourselves. Unfortunately, on rare occasions, that becomes impossible.

~ ~ ~

ONLY BECAUSE MANY OF us are still asked about it by fans and the press twenty years later, or I wouldn't bother to bring it up at all: probably the most widely publicized battle within the *Y&R* cast

was the backstage physical fight between Eric Braeden and Peter Bergman. It happened in 1991, and Eric, Peter, and the rest of us have long since moved on, but I might as well address it and get it off my mind and out of the way.

I'm not sure exactly what happened or what started it, beyond some ongoing tension between them on the set. Mercifully, I wasn't at the studio that day, and the details are for someone else's book, not mine. My only comment on that truly sad incident was and is my reaction to one of the many solutions that were being thrown around in the executive offices as the suits discussed what to do about it: when the suggestion was made that the easiest way to prevent such a thing from happening again was to fire Peter, I made it clear to anyone who would listen, and even some who didn't want to, that if Peter was fired, I'd walk right out the door with him, and I meant every word of it. It had nothing to do with taking sides and everything to do with my outrage at the inequity of that solution. I didn't want either of them fired, but only one of them? Are you kidding? Where would be the integrity and the fairness in that? And if we don't stand up for what's fair, aren't we basically just taking up space?

The good news, of course, is that cooler heads prevailed in the executive offices, neither Eric nor Peter was fired, appropriate apologies were offered and accepted, and twenty years later *Young and the Restless* viewers are still blessed with the pleasure of watching the classic rivalry between Victor Newman and Jack Abbott as no one else could play it.

～ ～ ～

As FAR AS I'M concerned, though, that fight was just a minor tiff compared to the battle I had with my publicist in 2004, and it all started with what sounded like a perfectly wonderful honor.

I was notified by the *Y&R* office that I was being presented with a Lifetime Achievement Award at that year's Daytime Emmy telecast. I was thrilled, flattered, grateful, and genuinely proud at the thought of sharing a stage with the other 2004 Lifetime Achievement Award winners, all of whom I'd admired so much throughout our long careers: Rachel Ames (Audrey Hardy of *General Hospital*); John Clarke (Mickey Horton of *Days of Our Lives*); Eileen Fulton (Lisa Grimaldi of *As the World Turns*); Don Hastings (Bob Hughes of *As the World Turns*); Anna Lee (Lila Quartermaine of *General Hospital*); Ray MacDonnell (Joe Martin of *All My Children*); Frances Reid (Alice Horton of *Days of Our Lives*); Helen Wagner (Nancy Hughes of *As the World Turns*); and Ruth Warrick (Phoebe Tyler Wallingford of *All My Children*). Who on earth wouldn't be proud to stand side by side with such an esteemed, historic group of professionals, or knock herself out to find the exact right gown, shoes, and jewelry . . . not knowing that she could almost have shown up in her pajamas for all it mattered?

Those were the good old days when the Daytime Emmy Awards were held in New York City, and I was so excited on the trip there, not only because of the Lifetime Achievement Award but also because *The Young and the Restless* was nominated for Outstanding Drama Series, my dear fabulously talented castmate Michelle Stafford was nominated for Outstanding Lead Actress in a Drama Series, and my great pal Anthony Geary, the legendary Luke Spencer of *General Hospital*, was nominated for Outstanding Lead Actor. There was always something energizing about driving into New York, checking into the hotel, and getting ready for the nonstop activities to begin, and it was all I could do not to skip into Radio City Music Hall for the telecast rehearsal. My fellow award winners and I greeted one another with a thousand hugs and kisses, which is my last happy memory of that particular event.

The first indication that I'd let my soaring expectations run away with me was the news that there would be time constraints on the Lifetime Achievement Award presentations because on that same evening, on that same telecast, the National Academy of Television Arts & Sciences had decided to honor *Sesame Street*, with a fairly lengthy appearance by Big Bird and the many stars who'd appeared on that show over the years. Now, let me pause right here to emphasize that I think *Sesame Street* and Big Bird are as good as it gets in children's programming. God bless them all, I love *Sesame Street*, love Big Bird, can't compliment them enough. I didn't take exception for a moment to their being given a well-deserved tribute. I did, however, take exception to the news that our Lifetime Achievement Award segment would be abbreviated so that the television audience could get their fair share of Big Bird, which translated as far as we were concerned, to about three and a half hours (in real life, it was probably six or seven minutes). "So, sorry, Lifetime Achievement people, but there will be no film clips from your vast bodies of work, and there will most definitely be no acceptance speeches. In fact, we'll thank you all to keep your mouths shut and not say a word so we won't run the risk of cutting Big Bird short.

"But wait, there's more—rather than have all of you waste a lot of valuable time walking onstage and off again, we've arranged for a very unique and exciting entrance for you. You'll all gather below the stage, and each of you will stand on one of these clever platforms that will actually lift you up to stage level and then lower you back down again when your segment is over with. Won't that be fun?"

"Fun" in this case was clearly a euphemism for making us feel as if we were there not for an award but for a lube job, and what an especially well-thought-out plan for the one Lifetime Achiever who happened to be in a wheelchair. But not to worry, we were assured,

there would be small bolted-down stool-like devices behind us to hang on to in case we lost our balance during this brief, insipid elevator ride.

I admit it, I was ready to decline the award and walk out on the whole show. But the director took me aside and swore to me that our dignity would not be compromised in any way, and it would be a huge disappointment to our fans if any of us failed to appear. It was the one argument that was guaranteed to work on me. I finally and reluctantly agreed to go through with it. Not happily, but I did agree.

Already feeling quite pushed aside enough as the lead-in act for Big Bird (and one more time, I *love* Big Bird), I headed off to a publicity event at Gracie Mansion with Mayor Michael Bloomberg and several Emmy nominees. I was especially looking forward to meeting Martha Stewart, whom I admire tremendously and who I'd heard wanted to meet me. But it wasn't that kind of day. The event was chaotic. Everyone and everything was running late. Martha Stewart left so soon after I arrived that I didn't even get to introduce myself, and we were all being hastily shoved into a variety of smiling photo clumps by a variety of strangers, all of whom were so busy yelling, "Over here! Hurry!" that none of them remembered to say, "Welcome and congratulations. Would you care for an hors d'oeuvre?"

At some point I was being herded toward Mayor Bloomberg for yet another clump-of-people picture when the mayor made the mistake of reaching out and grabbing my arm to pull me into place. I reflexively yanked my arm away, looked him in the eye, and growled, "Don't touch me." I remember Meredith Vieira finding this hilarious, along with a few others within earshot, and I also remember not feeling a single twinge of remorse about it. If Mayor Bloomberg came away with the impression that I'm a disrespectful, short-tempered bitch, let me just say, "Not always, but I have my limits when it comes to being treated like a prop."

Then, of course, it was back to the hotel to get ready for the Daytime Emmy Awards telecast and off to Radio City Music Hall, where, at the appropriate time, we Lifetime Achievement honorees were ushered into a small green room and then onto our assigned freight lifts to be presented to the audience and to stand there smiling and waving like puppets as each of our names was announced, after which we would magically disappear again into the earth's bowels. Why they didn't just finish us off with water balloons I have no idea.

Incidentally, I found out later that the televised version didn't include our vertical entrances and exits—too time consuming, presumably, or maybe the producers decided it looked as ridiculous as it felt—and that as we were introduced, brief dialogue-free clips were shown of us early in our careers, ending with a freeze-frame of us "way back when" beside a huge photo of us as we looked today. I'm sure it was meant to be an homage to our many, many years in daytime. In practice it looked like a documentary on the aging process.

Once we were gratefully below-stage again we were directed to a young man standing in the wings with a cardboard box, out of which he pulled our actual Lifetime Achievement Awards one by one, read the engraving, and handed them over with an unceremonious (for example) "Okay, Jeanne Cooper? Which one of you is Jeanne Cooper?" It was exactly as touching as I'm making it sound, although it certainly wasn't the young man's fault that I think at that moment each of us would have happily traded our statuettes for cab fare back to our respective hotels.

We were then directed upstairs to the pressroom, which involved about eighty-five escalators. Mind you, I hadn't seen my generously paid publicist in hours, and I thank God to this very day for James Michael Gregory (Clint Radison on *The Young and the Restless*, who

shows up every few years to kidnap Katherine Chancellor again). Michael was my escort that night and had no more of a clue than I did where I was supposed to go, but he kept me from getting lost all by myself and/or heading straight to the airport and catching the first flight to Los Angeles, gown, no luggage, and all.

I finished the requisite interviews, babbling about how honored I was and keeping my mouth shut about everything else, and was heading down one of the eighty-five escalators when I looked over to see my publicist escorting another of his clients, Michelle Stafford, up to the pressroom. Michelle had just won her first and so well-deserved Outstanding Actress Emmy, and I was thrilled for her. I wasn't thrilled with my publicist who, after leaving me to my own confused, head-spinning devices all evening, was taking such attentive care of another of his clients.

"Jeanne!" he yelled over. "Where are you going? They're expecting you in the pressroom!"

"I've already been to the pressroom, thank you!" I yelled back. "The box boy in the basement told me where to go!"

Thanks to the bottleneck of people on escalators number seventy-nine through twelve, I was nowhere near the auditorium when *The Young and the Restless* won its Outstanding Drama Series Emmy and the majority of the cast ran up onstage. I'm sorry I missed it, but being hopelessly trapped on an escalator while my show was being honored on international television was a perfect way to end that particular evening. In fact, by then, as far as I was concerned, I'd decided that my real Lifetime Achievement was making it through the previous twenty-four hours without committing a single homicide.

Incidentally, my publicist called the next day. He used his end of the conversation to tearfully apologize for his neglect the night before. I used mine to explain the meaning of the word "fired."

(See, Charles? I was discreet enough to make it through that whole story without once mentioning your name.)

<center>∼ ∼ ∼</center>

IN SHARP CONTRAST, ONE of the loveliest evenings of my life happened on March 9, 2009, at the Millennium Biltmore Hotel in Los Angeles, when the American Federation of Television and Radio Artists (AFTRA) presented AFTRA Media and Entertainment Excellence Awards (AMEES) to the brilliant singer-songwriter Smokey Robinson, legendary Dodger announcer Vin Scully, the late, great voice-over genius Don LaFontaine, and me. It was a gorgeous dinner party, not televised, at which each of us was surrounded by friends and family, properly introduced, and encouraged to speak for as long as we felt we had something to say. As an added bonus, the event raised a lot of money for charity, and my daughter, Caren, was given a well-deserved, thunderous standing ovation, for reasons you'll read about in the next chapter.

Now, seriously, is that kind of fun, familiar, comfortable, touching award night at which the honorees actually feel as if they're being honored really so much to ask?

Which leads me neatly, I feel, to the Emmy Awards.

<center>∼ ∼ ∼</center>

ONLY TWICE HAVE I been nominated for an Emmy and lost when I genuinely believed I should have won. One I mentioned earlier—my portrayal more than twenty years earlier of Katherine Chancellor, Marge Catrooke, and Marge Catrooke pretending to be Katherine Chancellor. The other goes all the way back to my

first nomination, for a guest-starring role on the Vince Edwards series *Ben Casey*, in 1962.

Mine was the second episode ever shot, entitled "But Linda Only Smiled." I played Linda, a strong-willed woman whose personal beliefs threatened to derail Dr. Casey's treatment of her daughter's potentially fatal illness. It was a great part, powerfully written, and forgive my immodesty, but yes, I'll say it: I nailed it. When word came that I'd been nominated, I honestly thought, "Okay, if I don't win an Emmy for that performance, I'll never win one."

Of course, that was in my more naive days when I knew nothing about bloc voting, an East Coast–West Coast rivalry, and all sorts of other political nonsense that I refuse to rant about here because it's every bit as uninteresting as it is frustrating.

The Emmy Awards were bicoastal in the early 1960s. The primary telecast originated in New York, while we Los Angeles actors, directors, producers, and writers gathered at the then-gorgeous Hollywood Palladium, surrounded by plenty of cameras and microphones on the off chance one of us West Coast people happened to win.

I was gowned, jeweled, and stilettoed to the nines, and the acceptance speech I'd prepared was exactly the right blend of humor and sincerity. My heart was pounding out of my sequined bodice as Walter Brennan appeared on the Palladium's monitors and arrived at the podium to announce the Emmy nominees for Outstanding Performance in a Supporting Role by an Actress in a prime-time drama series: Joan Hackett, Colleen Dewhurst, Mary Wickes, Pamela Brown, and me.

Then, with the traditional "And the winner is . . . ," he opened the envelope. I swear he did a double take when he looked at the card, and there was a subtext of "Am I reading this correctly?" as he announced, "Pamela Brown, *Hallmark Hall of Fame* . . . ?"

There was a gasp in the Palladium, and I sat there stunned, frozen in place, knowing my reaction was being caught on-camera. I meant no disrespect to Pamela Brown, nor had I seen her performance. I've been told that in its entirety, it lasted less than a minute. If that's true, it must have been one hell of a minute.

For the record, I wasn't the only person having trouble grasping this news. My pal Barbara Stanwyck, sitting at a table behind me, whispered, "You were robbed! This is a travesty!" while another pal, Lucille Ball, leaned over from her chair to mutter in her own inimitably delicate way, "What the fuck is wrong with those people?"

All night long friend after friend and colleague after colleague made a point of seeking me out to express their outrage on my behalf, along with their love, support, and respect.

I can honestly say that, in the end, the reactions to my losing my first Emmy were infinitely more rewarding than winning could ever have been. Looking back, disappointment and all, I wouldn't have had it any other way.

BRIGHT AND EARLY ONE morning in 1987 I answered the phone to hear my son Corbin's voice, so excited he was almost yelling into the phone. "Mom! Did you hear? They just announced it—I'm nominated for an Outstanding Lead Actor Emmy! Can you believe it?!"

Of course I could believe it. Since the fall of 1986 Corbin had been playing the swaggering, maverick, womanizing attorney Arnie Becker on NBC's hit series *L.A. Law* and playing him brilliantly, I might add without a shred of objectivity. That his work had earned him an Emmy nomination came as no surprise at all, and I think I may have been more thrilled than he was, if that was possible.

I couldn't wait to get to work that morning to share the news. When I arrived, though, it appeared that everyone already knew—I was getting congratulatory hugs, kisses, and high-fives from the moment I stepped off the elevator and headed toward my dressing room. How wonderful and supportive, I thought, for them to be so excited for Corbin. So it caught me completely off guard when someone finally said, "I saw your episode, and you were fantastic. You couldn't deserve this nomination more."

Before I could ask the obvious—"What the hell are you talking about?"—my dressing room phone rang. It was Corbin again.

"Mom, I'm sorry! I was so blown away when I heard I was nominated that I didn't hear the rest of the nominees. You're nominated too! Outstanding Guest Performer in a Drama Series! Is this unbelievable?! Congratulations! I'm so happy for both of us and so proud of you!"

It was one of the rare moments in my life when I was rendered completely speechless. My incredibly talented, incredibly gorgeous firstborn child and I both nominated for prime-time Emmy Awards, for work we'd done together, playing, of all things, mother and son—it was stunning, it was overwhelming, it was humbling, and it would have been a dream come true if I'd ever had the audacity to dream something as incredible as this.

I'd had so much fun shooting two episodes of *L.A. Law* that I almost felt guilty being paid for it. (Operative word: "almost.") My character, Gladys Becker, was an outspoken, aggressive, take-no-prisoners woman who wanted her son, Arnie (Corbin), to represent her in her divorce proceedings against her husband, Arnie's father. It was neither interesting nor relevant to her that Arnie's father also wanted/expected Arnie to represent him. In one particularly memorable scene, Arnie and Gladys are having lunch at an upscale restaurant. At the suggestion of the director, Janet Greek, Gladys

expresses her displeasure with her steak being undercooked by impaling it on the long bloodred acrylic nail of her forefinger and holding it up for the waiter to see, while Arnie looks around, desperately embarrassed, hoping no one is looking. (In other words, come to think of it, not altogether unlike many of Corbin's and my restaurant meals together.) I was flattered when someone described the brief, pleasant shock of it to that moment in the film *The Public Enemy* when James Cagney smashes a grapefruit into Mae Clarke's face, but I had no idea at the time that it would help to inspire an Emmy nomination.

Meanwhile, back at the *Y&R* set, there was a spontaneous party atmosphere among the cast and crew that day, and I was walking on air, surrounded by a group of people who truly do know how to be happy for one another when the situation demands. I had work to do, though, so I collected myself by midafternoon and was in the midst of shooting a scene when suddenly Corbin strolled right into the Chancellor living room, on-camera, and presented me with a huge, gorgeous bouquet of flowers while everyone around me applauded. It quite literally took my breath away.

(I found out later, by the way, that he'd planned to wait until we'd finished shooting that scene, but Lauralee Bell insisted this was far too big a deal for proper on-set behavior. "Who cares if they're in the middle of a scene? Get out there," she reportedly whispered. "Your father [Bill Bell] will kill me," he whispered back. "I'll deal with my father," she told him. "Walk in there and give your mother those flowers!")

Our whole family was there on Emmy night. The Emmy in Corbin's category went to Bruce Willis, and the Emmy in my category went to Alfre Woodard—both of them well deserved, and who on earth could complain about losing to either one of those spectacular actors?

Of far more importance, September 12, 1987, was one of the most magically unforgettable nights of my life, a night of profound mutual pride between a mother and son, honored not only in a profession they share but also for work they did together. Never in my life will I forget it or stop being grateful.

~~~~~~

By the time the 2008 Daytime Emmy Awards came along, I'd had a total of eight nominations without a single win. I can honestly say I was completely relaxed that night, enjoying myself and not giving a thought to the outcome of the formidable Outstanding Lead Actress competition between Crystal Chappell, Maura West, Michelle Stafford, Nicole Forester, and me. After eight "losses," getting your hopes up has a certain Charlie Brown vs. the football feel to it (i.e., at some point you just feel silly falling for it one more time).

My two sons were with me that night, and Collin clearly wasn't exactly on the edge of his seat about it either—shortly before my category was announced, he headed for the men's room.

Tyra Banks, looking spectacular, stepped to the podium, read the names of the nominees, and said, impossibly, "And the Emmy goes to . . . Jeanne Cooper!"

We've all heard countless people say they weren't expecting to win. I can't stress this enough: I happened to be one of the people who actually meant it. In fact, for a few seconds I was sure I'd misheard her. I don't think it really sank in until, after a kiss from Corbin, I turned to look for Collin and was swept into Doug Davidson's arms for one of the greatest hugs of my life. (For the record, by the way, there are few people on this earth I love more than I love Doug Davidson.) I vaguely remember making it to the stairway and having to be helped up the stairs because my legs had suddenly turned into

well-cooked linguini. I remember spotting Crystal Chappell, who was on her feet cheering at the top of her lungs, and giving her a thumbs-up as I crossed the stage to the podium. I remember Tyra Banks giving me a kiss right on the mouth as she welcomed me and, with a quick glance at my gown, whispering, like a true super-model, "That's Icho! I love Icho!" (Toru Icho is one of my favorite designers, in case anyone's wondering.) And I definitely remember the out-of-body experience of stepping to the microphone knowing millions of people were watching and not having the first clue what I was going to say. So I kicked it off with a simple "I'll bet you all thought I was dead."

Having spent the evening listening to everyone carry on about their wonderful castmates and their fabulous crews and their brilliant writers, producers, and directors, I spontaneously decided it might be time for a change of pace and began thanking our lousy actors, lousy crews, and our lousy writers, producers, and directors. It relaxed me a little to hear everyone laugh, and I almost started enjoying myself.

But then, as indisputable proof that I was still out of my mind with shock, I ended with a special thank-you to my children . . . Corbin and Collin. Yes, it's true, I forgot to even mention that I have a daughter, let alone a daughter I wouldn't trade for any other daughter in the world. I took it much harder than Caren did. She laughed it off. I, on the other hand, saw a clip of it later and literally yelled at the TV at the top of my lungs, "What about Caren, you idiot?!"

There were more congratulatory hugs and kisses that night than I can count, but none of it meant more than the heartfelt ones from my fellow nominees, Crystal, Michelle, Nicole, and Maura. I hope you all know how much I admire you and consider it a privilege to count you among my most treasured colleagues.

To add to the joy that evening, Anthony Geary, one of my favorite actors and people, was the winner of the Outstanding Lead Actor Emmy. I couldn't get to him quickly enough when he came offstage, and when we were finally finished hugging and jumping around in a circle, I said, "Let's do the pressroom together."

"I'd be honored," he replied, and off we went, hand in hand, to try to answer an unanswerable question for the media: "How does it feel to win an Emmy?"

~~~ ~~~ ~~~

I ALSO FIND MYSELF at a loss for words trying to answer the question: "How does it feel to be presented with your own star on the Hollywood Walk of Fame?"

On August 20, 1993, I proudly became the first daytime actor to be given that honor. My JEANNE COOPER star is located at 6801 Hollywood Boulevard, at the corner of Hollywood and North Highland Avenue, a corner that has a special significance to me: five mornings a week in the early 1950s I would leave my apartment in Hollywood, drive east on Hollywood Boulevard, turn left on Highland, and proceed into the Valley to Universal Studios, where I was under contract.

It was Corbin who submitted my name to the Walk of Fame Committee, and I was nothing short of ecstatic when it was announced that I'd been accepted as an honoree. The thought of taking a permanent place in Hollywood history among the likes of Katharine Hepburn, Spencer Tracy, Clark Gable, Bette Davis, and so many others whose work had inspired me and impelled me, and raised the bar for the rest of us, left me in awe and still does to this day.

The presentation ceremony was every bit as much of a dream come true as the star itself. The late, great Johnny Grant,

Hollywood's honorary mayor, presided. My children and their spouses were there. Jeff Sagansky, president of CBS at the time and a man I'll always admire, was there with a full battery of his top executives and offered such flattering words as "She's a true professional," and "She's the backbone of our network's success in daytime." Many of my castmates were there, including Eric Braeden, Melody Thomas Scott, Peter Bergman, Jess Walton, and Kate Linder. Bill and Lee Bell were in Chicago and couldn't attend, but all three of their children, Bill Jr., Lauralee, and Bradley were there. I felt loved and I felt valued, and how much more can any of us hope for in the course of our careers?

In case you've ever wondered if the impact of an honor like that tends to dissipate over the years, I want you to know that, at least for me, it doesn't. Not one bit. I still pass the corner of Hollywood and Highland fairly often, and occasionally I see people stop to acknowledge my star on the Walk of Fame. Every single time that happens, I get the same rush of warmth, privilege, and cherished memories I had on the day it was unveiled in 1993.

~ ~ ~

FOR SHEER, UNMITIGATED GLAMOUR, though, it's impossible to beat the annual Monte-Carlo Television Festival. Cast members from a variety of American television shows that are popular in Monaco, including *The Young and the Restless*, are invited, as they are every year, to a fabulous whirlwind of parties, events, screenings, and press receptions, and in 2005, those invitations were extended to Jess Walton and me.

My longtime hairdresser, makeup artist, stylist, and friend, Gino Colombo, was right by my side every minute of that incredible trip, keeping me from looking wilted and stale in the heat of Monaco in

June, so that all I had to think about was where I was supposed to be next. Jess and I laughed and played and partied and glittered and gambled and enjoyed the endless sights of that tiny, gorgeous principality. We were treated like royalty, up to and including having a battery of security guards with us at all times and practically being carried on a litter through the crowded airport and onto our plane when we flew from Monaco for four spectacular days in Paris.

The only flaw in an otherwise flawless trip, and one that couldn't have been helped, was that Prince Albert II, the reigning monarch, was unable to join us at the festivities. He was observing the traditional year of mourning for his late father, Prince Rainier III, who'd passed away on April 6, 2005. We were all aware and respectful of the fact that he was in mourning, and we were honored that he did choose to attend the formal reception to welcome his country's guests from the United States.

Prince Albert and I were never formally introduced. Our eyes met briefly at that reception, though. I'm not quite sure what brought this on. It may have been because I wanted to acknowledge his having joined us so graciously in spite of his recent loss. It may have been because, early in my career, I knew his mother, Grace Kelly, and felt an almost maternal warmth toward him. It may have been because I saw a glimmer of recognition cross his face when he spotted me.

Whatever the reason, when our eyes met, I winked.

And he smiled so quickly and so subtly that I'm sure no one else noticed but me.

A tiny moment in an otherwise once-in-a-lifetime trip, but one that fondly crossed my mind from time to time after we were all back home, back to work, and back to normal again.

Four years later, in 2009, Prince Albert II was visiting Los Angeles as a part of a US fund-raising tour for the Monaco Foundation,

a charity group dedicated to environmental initiatives. I attended one of the receptions given for him in Beverly Hills.

Again, we were never formally introduced.

Again, at some point, through the crowd, our eyes briefly met.

And undeniably, unmistakably in that brief moment, HSH Prince Albert II of Monaco winked at me.

I smiled back, so touched that he remembered.

I'm still smiling about it today.

All things considered, am I a lucky woman, or what?

Battling the Bad News

It was a warm, sunny Sunday afternoon in October 2005 when Hillary B. Smith of *One Life to Live*, *TV Guide* daytime columnist Michael Logan, and I threw a party for our beautiful friend and colleague Linda Dano, star of *Another World* and *One Life to Live*. Linda had been through a couple of heartbreaking personal tragedies and was moving part-time to Los Angeles, and we wanted to welcome her with open arms and make sure she knew how loved she was and is on the West Coast.

There was plenty of food, love, and laughter among the sixty-five guests—among them, Peter Bergman, Michelle Stafford, Jess Walton, Stuart Damon, Susan Flannery, Ian Buchanan, Finola Hughes, Ty Treadway, John McCook, Constance Towers, Lee Bell, and Corbin Bernsen and his wife, my gorgeous daughter-in-law Amanda Pays. In other words, it was an afternoon of someone wonderful to talk to and enjoy everywhere you turned, one of those special gatherings during which you realize you wouldn't change a

thing; it was everything you'd hoped for and the guest of honor was being properly embraced.

To the best of my knowledge, no one noticed that I felt as if I were watching the party through the wrong end of a telescope.

After a couple of hours I stole a few minutes in private with my close friend Lindsay Harrison, our hostess and, incidentally, my collaborator on this book. The instant we were alone behind her closed guest room door, my smile disappeared and I completely deflated.

"I need to tell you something," I told her, "and you have to swear to me that it will stay strictly between us. I mean that, not a word to *anyone*." She promised with a nod, visibly concerned, and I took the deep breath I knew it would take to get the words out of my mouth.

"I had my annual physical a couple of weeks ago. I've been through double pneumonia four times, so we always do a chest X-ray as well. And the radiologist found a tiny spot on my lung, about the size of a pinhead. It's stage one non-small cell lung cancer, and they want to operate as soon as possible."

Lindsay is nothing if not calm in a crisis, so there were no histrionics, just a long hug and a few tears, after which she asked who else knew.

"No one but you, me, and my doctors," I said.

She agreed to keep the secret on one condition: under no circumstances was I going into surgery without my children and grandchildren knowing what was happening. As she pointed out, and she was right, if the same thing were going on with one of them and they kept it from me, I would hunt them down and kill them. So I assured her that I would wait as long as I could, to give them the least possible amount of time to worry, but yes, I agreed, they needed to know, and they needed to hear it from me.

A few minutes later we rejoined the party, and I found myself

able to feel a little more part of it and to absorb some of that group's warm, positive energy right along with our very special guest of honor.

First thing Monday morning, I scheduled my surgery for two weeks later with the brilliant, innovative surgeon Dr. Clark Fuller, a researcher in video-assisted surgical techniques and thoracic oncology and a highly respected educator at the University of Southern California. I then called the *Y&R* office and arranged for a two-week vacation. It was a routine enough request that they didn't ask for an explanation and I didn't offer one. In fact, the vast majority of my *Young and the Restless* colleagues will be hearing about this for the first time when they read this book.

I want you to know that my intense insistence on secrecy had nothing to do with denial or superstition. It has to do with one of my most basic beliefs when it comes to any kind of insidious, potentially cataclysmic illness: providing it with "air" and energy of any kind gives it life, credibility, and a chance to thrive and grow. I believe in forming a small, impenetrable psychic circle around it by limiting the number of people who know and refusing to allow its name to become a part of your mind and your vocabulary, so that, without nourishment, it inevitably withers and dies. Obviously it's imperative to seek out the best medical specialists available and follow their advice to the letter. But success also requires that we not "overcome" it but actually deprive it of the opportunity to exist in the first place.

An added incentive to delay sharing this news with my family until the last possible moment was an exciting event on the calendar for my son Corbin that I wasn't about to ruin for him. He'd directed his first film, *Carpool Guy*, and the cast and press screening and party were being held a week before my surgery. *Carpool Guy* was a labor of love for him, a comedy cast with a spectacular array of soap

actors—Anthony Geary, Lauralee Bell, Rick Hearst, Kristoff St. John, Sean Kanan, Sharon Case, and yours truly, to name a few— as Corbin's way of showcasing the unmined versatility to be found among daytime stars. He was justifiably proud of it, I was justifiably proud of him, and I was determined to make sure the *Carpool Guy* screening was about him, not his mother's upcoming surgery. And it was exactly as successful an evening as he deserved.

Inevitably, though, the time came when my family had to know. So five nights before I checked into the hospital, my daughter, Caren; Corbin's wife, Amanda; and I met for an early dinner, with Lindsay along for moral support. Caren and Amanda were as wonderful as I knew they'd be, deeply concerned but calm, falling right into their usual take-care-of-business mode, well aware of what I already knew—Corbin and Collin were going to be much more hysterical about this than all of us women put together. Caren was given the assignment of telling Collin, and Amanda took on the challenge of telling Corbin. How, what, and when to tell the grand-children was left to each of them.

Thanks to perfect, sensitive handling on Caren's and Amanda's parts, Collin and Corbin were able to have their meltdowns and recover before talking to me, so that at no time did I feel as if I needed to get them through my upcoming procedure. Corbin had to be out of town for work the day before I left for the hospital. He was coming to say good-bye on his way to the airport when Caren announced, "Mom, you look like hell. Do something or, you know Corbin, he'll never get on that plane." If anyone knows about hair, makeup, and artificially applied health it's a soap actress, so believe me, by the time my older son arrived, I was fabulous and he was reassured enough, just barely, to leave for his business trip.

Collin and Caren were with me when I checked into the hos-pital. They were with me right up to the moment I was wheeled

into the operating room and handed one of the nurses a plastic bag in which I'd placed a medallion engraved with the Lord's Prayer, the one thing I wanted with me during surgery. They were at my bedside when I opened my eyes after the procedure was over—a simple, noninvasive forty-five minutes, thanks to Dr. Fuller, that involved a small incision, a tiny camera, and a couple of small holes in my side and my arm. They stayed with me, taking turns rubbing my feet, Collin even spending the night in my room while Caren went home to her husband and daughters for a few much-needed hours of sleep before rushing right back to the hospital first thing the next morning. Corbin came straight from the airport to my bedside at home when he got back to Los Angeles. I fully recovered with no chemo, no radiation, and a clean bill of health, and I was back to work right on time with no one at *Y&R* or the soap media knowing a thing about how I'd spent my two-week "vacation."

Thanks to an unspoken agreement to keep that "circle" intact, my family and I have never spoken of it again.

All of which is to say, between my brilliant surgeon, early detection, a lot of faith, and the most loving, devoted children anyone could hope for, I am one blessed, grateful, and healthy woman.

～～～

Two years later, in the summer of 2007, I decided to treat my whole family to a three-day trip to Las Vegas for a Fourth of July celebration. And by my whole family, I mean my children, their spouses, and my eight grandchildren—Corbin and Amanda and their four sons, Oliver, Angus, Henry, and Finley; Collin and his two sons, Harrison and Weston; and Caren, her husband, John, and their daughters, Sarah and Grace. It was perfect. We saw shows, we watched the fireworks displays, we relaxed by the

pool, and we just enjoyed ourselves and one another in general, luxuriating in what a close, fun, playful family we are.

I will always believe that Caren spent that weekend hiding something she knew, probably from self-examination, seeming to participate with all her heart while watching it from a distance, exactly as I'd handled the Linda Dano party.

Immediately after we returned from Las Vegas, she went to see her doctor and then headed straight to Dr. Fuller's office.

He strongly recommended a double mastectomy, sooner rather than later, and he assured her that his wife, who's also a doctor, would make that same choice if faced with Caren's test and X-ray results.

Her trust in him was so unconditional after my surgery that she agreed without a moment of hesitation.

And every one of you who are parents know how literally I mean this: I would have given anything and everything I have in this world to trade places with her and let it be me instead.

Since that wasn't an option, all I could do was try my damned-est to emulate the extraordinary grace, courage, and determination with which my incredible daughter tackled the biggest, toughest fight of her life.

She was in the brilliant hands of Dr. David Fermelia for the double mastectomy. She went through what seemed like more than her share of chemotherapy and radiation before proceeding with reconstructive surgery by Dr. David Kulber. She had occasional bouts of disheartenment and depression, and frankly, I would have worried if she hadn't—I had firsthand experience that those are an inevitable part of the process. But not once did I see her breathe life into that fear circle or waver from her underlying approach: "If that's what needs to be done, let's do it."

She also wasn't about to let chemotherapy decide when her hair

would start falling out—she cut it off all by herself at *her* convenience, thank you. Her husband and daughters announced one day that they'd decided to shave their heads too, to let her know that as far as they were concerned, they were all in this together. Her response: "I love you for offering, and I appreciate the gesture. But I'm the one with breast cancer, not the three of you, so put that thought right out of your heads."

Caren also refused to wear a wig. She didn't want to deal with the inconvenience, and she thought she would look and feel silly in them. She was right. In an ongoing effort to do something, *anything*, to help her, I bought several wigs for her in case she changed her mind. One day we sat down together in front of a mirror so that she could try on her new wig wardrobe. I'm not sure either of us has ever laughed harder. And no one will ever convince me that the old cliché isn't true: there really is no greater medicine than laughter.

The one thing I never, ever wanted to do was let Caren see how worried and sad and frightened I was, and to put her in the position of having to comfort me through her health crisis. I believe—I hope—I held up beautifully when we were together, and I reserved any meltdowns for the studio. Only a handful of my castmates and crew knew what I was going through on Caren's behalf. One of them, thank God, was our amazing costume designer Jennifer Johns.

Jennifer had known me for a long, long time, and she knew me well enough to know not to escalate the drama by making a fuss or trying to talk me through it with a lot of clichés and platitudes. Instead, she did the most perfect thing for me that she could possibly have done: she saw to it that every day a dahlia from her garden would be waiting for me in my dressing room. I've never seen dahlias like them, before or since, and she tells me she's never grown more amazing dahlias, before or since. They were strong, exquisite, thriving, so vibrant with color and life that they took my breath

away. All I had to do was pass by them, or sit near them, and I swear the strength and energy I got from them, with blues and purples so deep you could lose yourself in them, acted as a silent, constant reminder to focus on life and hope and good health rather than on the dark fear that kept trying to pull me under.

~~~~~~

In chapter six I talked about the special night of the AMEES in March 2009. I don't remember much about my acceptance speech, other than a lot of heartfelt thanks for the honor and for the warm, gracious, perfect evening. I finished what I had to say and took a few steps away from the microphone. As I paused to acknowledge the applause, I happened to spot Caren at her table near the stage. She looked so beautiful, so strong, and so happy, her hair adorably short and growing back, her face glowing with renewal. It overwhelmed me how blessed I was to have her there with me that night, how heroically she'd fought and won the toughest fight of her life, and how full my heart was from loving her.

I stepped back to the microphone and interrupted the continuing applause with an unapologetic "Excuse me, just one more thing . . ."

Without belaboring it, I explained that my daughter was in the audience and why her presence among us was such an extraordinary, joyful victory.

"With all the respect in the world for my fellow honorees," I concluded, "I don't think there's a greater lifetime achievement in this room tonight than the one accomplished by that woman right over there, *my* greatest achievement, Caren Bernsen."

My daughter, who's not exactly a spotlight hog, modestly stood to identify herself and then promptly sat down again. I wish you

could have seen the awestruck look on her face when the thunderous applause started and every person in that huge ballroom, from Smokey Robinson to Berry Gordy Jr. to Vin Scully to hundreds of invited guests to past and present members of the *Y&R* cast to Caren's very proud, adoring brothers, gave her the longest, loudest standing ovation of the whole wonderful night.

My daughter and I are both in perfect health today. I hope with all my heart that you are too. But in case you're not, please don't lose sight of the power you have—to surround yourself with faith, love, positive thoughts, and the most gifted experts at your disposal, and to starve your fear and your illness out of existence by surrounding it with a small, impenetrable psychic circle that prevents it from ever, ever becoming a part of who you are.

Oh, and to resist the temptation to dwell on it, which explains the deliberate brevity of this chapter.

CHAPTER EIGHT

# *Costars and Other Playmates*

And now, the chapter some of my castmates have been dreading (and most of them will turn to first) since I announced I was writing my memoirs. Where they get the idea that I might shoot my mouth off and be brutally honest I can't imagine—it's typically all anyone can do to drag an opinion out of me, but I'm going to give this my best shot if it kills me. (Please tell me none of you read this paragraph with a straight face.)

But first, I feel compelled to clear up a story about me that's been repeated in the press and all over the Internet for some time now. Apparently it's been widely publicized that I've developed a reputation on the *Y&R* set, particularly among such younger male members of the cast as Greg Rikaart, Josh Morrow, Billy Miller, and Michael Graziadei, that I'm a serial pincher. That no butt or groin area is safe during a scene with me. That I lurk in all my Katherine Chancellor splendor and dignity, waiting for exactly the right, least-expected moment and then strike, on-camera, daring my victim not to react with, let's say, an involuntary grin or snicker.

It's time to set the record straight once and for all about this insidious pinching rumor: every word of it is absolutely true.

Frankly, it amuses the hell out of me to sneak in a playful pinch, as my way of saying, "I don't care how dark or lighthearted this scene is, let's not forget to enjoy it." I'm also very selective about who gets pinched. If I'm not enormously fond of someone, as I am of the boys I mentioned (and at my age, "boys" refers to anyone under sixty), you couldn't pay me to pinch him. It's a gesture strictly reserved for my favorites on the set and those to whom I'm close enough to know they'll take it in the spirit of fun and fondness in which it's intended.

To his eternal credit, Josh Morrow goes out of his way to move close to me during our all-too-rare scenes together, daring me to get in one good surprise pinch, so I make it a point to let time pass between assaults, to lull him into a sense of false security. Billy Miller and Michael Graziadei are so loose on-camera that their reactions invariably fit right into whatever's going on around them. Greg Rikaart, on the other hand, if I plan it properly, has to struggle to keep a straight face, which I guess makes him the most ideal target.

Greg had grown accustomed to my occasional pinches on his butt, so I'm sure he felt safe from me when he was seated in the backyard of the Chancellor estate with his butt protected by a chair during the wedding of Katherine and Murphy. But what can I say? I can't resist a challenge. So as I walked up the aisle, with cameras rolling, I unexpectedly paused to say hello to Greg (Kevin), ran my hand down his tie while complimenting him on it, and got in a good quick pinch to his groin before heading on up the aisle to my waiting groom.

I'm told there are fans who make a game of seeing if they can catch Katherine pinching someone in the course of a scene. If this

is the first you're hearing of this, please, by all means, feel free to start watching for it too. Not only am I not giving up the game anytime soon, but I'm just getting started.

And for those of you who are wondering, by the way, yes, I did, on one occasion, branch out from the young ones. It was during an especially tedious scene in which I was frankly bored and knew he was too, and suddenly it became impossible to resist giving one sound, meaningful pinch to one of my oldest friends in the cast, the inimitable . . .

## Eric Braeden

If you know *The Young and the Restless*, you know that one of the strongest, most enduring friendships in Genoa City is the friendship between Katherine Chancellor and Victor Newman, brilliantly portrayed by Eric Braeden since 1980. Katherine met Victor through her close friend Nikki Newman, who is the great star-crossed love of his life. He was a self-made man who rose from his childhood in an orphanage to become a successful businessman. Katherine was impressed enough to make him the new head of Chancellor Industries, essentially telling him, "Make as much money as you want, just be sure I make every bit as much as you do." They don't just know each other; they understand each other very, very well, more alike in their strong-willed determination to succeed and in their private vulnerabilities than they might care to admit. They deeply love each other, flaws and all. They're loyal to each other, they pull no punches when it comes to the honesty between them, they unconditionally have each other's back, and no matter how exasperated they might get with each other from time to time, the foundation of their friendship

is strong enough that they can disagree without judgment and move on when the argument's over.

Which, come to think of it, except for the part about being billionaires, is a pretty good description of the friendship between Eric and me. If only Victor Newman had Eric Braeden's sense of humor.

I know. The word "hilarious" doesn't exactly leap to mind when you think of Eric. But there's a well-disguised playful streak in him that can make working with him feel like an exercise in the arts of improvisation and self-control.

Eric doesn't look at a script until the day he's shooting it, and if there's dialogue he finds inane or out of character for Victor Newman, he changes it or cuts it completely. He's good at it too. He's as protective of Victor, his character, and his relationships in Genoa City as I am of Katherine. But playing a scene with someone who's changed or cut his lines with no warning often means your dialogue makes no sense at all, which, especially in these days of "shoot it and move on no matter what," leaves you no choice but to pay attention, think on your feet, and start improvising, trying as best as you can to keep the purpose of the scene intact. It may drive writers, directors, and other actors crazy, but he and I trust each other enough to get a kick out of it. And to be perfectly honest, it's not unusual for our improvisation to make more sense, and be more true to our characters, than the dialogue we were given.

Close-ups in a scene with Eric are a whole other challenge. He thinks nothing of waiting until he knows the camera is focused solely on you and then, looking deeply into your eyes, letting drool come out one side of his mouth, or putting on an animated little dance with his eyebrows. In the unlikely event that I give up my hobby of Pinching by Ambush, I might even start complaining about it.

There's also an ongoing battle between me and Eric that I'm

ready and willing to expose: Eric insists on making sure that Victor Newman has the last word in any scene, whether it's written that way or not, and it's my position that every once in a while, his bene-factress, Katherine Chancellor, deserves it just as much.

Even when my line indicates finality, something like "I'm going to put an end to it, Victor, and I'm going to do it *today*," or "I don't care what it takes or who tries to get in our way, we *will* get back Jabot Cosmetics," he'll pause long enough to give me a glimmer of hope and then, just before the director yells, "Cut!" he'll murmur some gratuitous line, like "I'm sure you will," or "That will be won-derful, Katherine."

One day, as if we were playing a game of who could be the last to cross the finish line, I decided that if he was going to keep talking, so was I, so I said, "Well, I'm not sure 'wonderful' is quite the right word, Victor. It could get very unpleasant." He responded, "But it will be worth it." My turn again. "I certainly hope so." I smelled victory. But no. "Count on it," he said, immediately followed by the director's "Cut!"

I didn't move a muscle, I just kept staring at him, and the instant the cameras were off I said, "Eric, do you think it would be okay if I have the last word in a scene just once?"

He simply smiled and said, "No."

Which, of course, made me more determined than ever.

Months later we were doing a scene in Gloworm—a name that, as you may have noticed, Katherine deliberately refuses to memorize, so that it might come out "Glow . . . Thing" or "Glow Whatever-It-Is." Victor and Katherine were seated at a table having a very intense conversation, and at least according to the script, the scene was to end with my line: "That, my friend, remains to be seen." Knowing that Eric considers lines like that to be the perfect open-ing for a classic Victor Newman response, I delivered it as written

and then, before he had a chance to even take a breath, leapt up and practically sprinted out the door. He didn't know I could move that fast. *I* didn't know I could move that fast. But rather than deliver a comeback to an empty chair, he simply sat there in silence, and let me tell you, I was ecstatic when I heard the word "Cut!" In fact, I admit it, I gloated for the rest of the day over my one and only "win." I know I'll pay the price—he'll be making it even more of a challenge from now on, but take my word for it, I've beaten him once, and I'll do it again.

The bottom line is, personally and professionally, I cherish this man. I cherish the fondness and respect between us. I cherish our phone calls to check on each other when one of us is going through a health crisis of some kind. I cherish the talks we've had about what a bitch this aging process is, but how it sure as hell beats the alternative. I cherish our thirty-plus years of laughter and tears and personal struggles and on-screen storylines, from the exciting to the preposterous. I even cherish our occasional frustration with each other, because it's always accompanied by the luxury of being able to work through it. I can't in my wildest dreams imagine another Victor Newman, and I wish we had another thirty-plus years together to look forward to.

All of which can be summed up perfectly, I guess, with four simple words:

God bless Eric Braeden.

# Ed and Melody Thomas Scott

From the moment Melody Thomas arrived on the set of *Y&R* in 1979 to take over the role of Nikki Newman (née Reed), I was enchanted with her. She was gorgeous, sexy, adorable, and already a

skilled, experienced actress who'd been working since she was three years old. Our on-screen relationship was as unlikely as it was beautifully conceived: Katherine, the insanely wealthy businesswoman, and Nikki, the stripper, became as close as if they were mother and daughter, with the added bonus of being best friends. They shared a common battle with alcohol addiction, highly dubious track records with the men in their lives, an intense loyalty to the people they loved, and bigger, more vulnerable hearts than they could sometimes handle.

Off-screen, we were every bit as close. My God, I loved her, and my God, did we have fun, working together and playing together. She was the first person other than my own children who called me "Mother," and I wore that badge proudly.

In 1976 *The Young and the Restless* had hired a very smart, very gifted young associate producer named Ed Scott. He and I quickly developed a friendship I cherished. I admired him, I admired his talent, and when Bill Bell called me one night at two A.M. to tell me he was thinking about elevating Ed from associate producer to producer and to ask me what I thought, I gave him a resounding "Yes! Do it! You won't regret it, that's for sure."

I couldn't have been happier for Ed, or more proud, when, in 1978, he became a full-fledged *Y&R* producer, already in place for a year when the stunning twenty-three-year-old Melody Thomas entered the building. I was working closely with two of my dearest friends, and life was good.

I can't say exactly when Ed and Melody started seeing each other and fell in love. I can say that somewhere along the line, as we reached the mid-1980s, things slowly began to change between the three of us, and I wasn't quick to catch on.

When Melody had mononucleosis and wasn't able to work, I called her one morning on a day off to suggest I come over to see

her and take care of her for a few hours. There was a long, deafening silence before she finally said, "Uh, no, today wouldn't be good." I didn't think a whole lot about it, but I did have an uneasy feeling that something wasn't quite right.

Something wasn't. For the next two years after that phone call, Melody didn't speak a single word to me. Not so much as a simple hello. Nikki kept right on speaking to her dearest friend Katherine, of course. But the minute a rehearsal or a scene ended, Melody turned her back and walked away. There was no explanation, there was no willingness to discuss it, there was just, all of a sudden, nothing. I was shocked, I was devastated, and I had no idea what I'd done or what to do about it.

By then Ed and Melody had become a serious couple. In fact, they were married in 1985. And the air had decidedly cooled between Ed and me as well. Obviously it wasn't a coincidence, and it hurt. It hurt even more when, as time went on, I felt like Ed Scott, whom I'd cared deeply about and cheered for and supported, was trying to wipe both me and Katherine Chancellor right off the *Y&R* canvas. No matter what you do for a living, if you've ever found yourself working closely with a former friend who clearly doesn't want you there anymore, you know the cycle of emptiness and anger in the pit of your stomach that became my constant companion.

It was a tough couple of years on the set. I missed Melody. I missed the days when Katherine Chancellor was a force in Genoa City rather than an occasional part of the background. I missed looking forward to going to work. And all the while our days were getting longer and longer as Ed would repeatedly demand forty-five minute breaks to relight Melody in a scene or have her hair redone. Inevitable as it may have been, I hated it that some of my

resentment toward Ed was spilling over onto Melody, but in my heart of hearts I kept hoping that someday—although I had no idea when or how—she and I would find our way back to each other.

I still don't know what brought this on, but I know I'll never forget it. One day, after two years of silence, Melody and I were preparing to shoot a scene together. Ed must have spent half an hour lighting and relighting Melody until he was satisfied with how his wife looked on-camera. At the same time, he was so obviously ignoring me that, I swear to you, I was left standing there in the dark. He was walking away, ready to shoot, when Melody's eyes met mine and out of nowhere I saw a flicker of love and recognition, of my old friend reconnecting as if she'd just awakened after a bout of amnesia, followed by, "Ed, wait. What about Mother?" As suddenly as she'd gone away, she came back, and slowly but surely and a bit tentatively, what do you know, we managed to pick up where we left off.

In fact, not long after our "reunion," Melody provided me with a memory I still treasure to this day. She and her then-one-year-old daughter, Alexandra, had picked me up for a trip to the park to cheer on our team at a *Young and the Restless* versus *The Bold and the Beautiful* softball game. We were starving, so she did what I'm sure was the most natural thing in the world: she pulled into a Jack in the Box drive-thru and asked, "What would you like?"

To her incredulity, I was completely lost. As far as I was concerned, she'd just pulled off of a perfectly normal street into *The Twilight Zone*, and I answered accordingly. "I don't know," I said. "Where are we? What are we doing?"

She couldn't stop gaping at me. "Are you telling me you've never been to a fast-food drive-thru before?"

"Yes," I said, "that's exactly what I'm telling you."

When she finally recovered from that revelation, she ordered for both of us, since I didn't have a clue how to do that or how to go about retrieving our food without leaving the car. We headed on to the park, spread out a blanket, and had the loveliest afternoon, watching the game while having a picnic of the most convenient hamburgers and French fries I'd ever eaten. I loved them too, almost as much as I loved the sheer magic of this newfangled phenomenon called a "drive-thru," which I would never have discovered without Melody.

A seemingly trivial event, I know, but it makes me smile as if it happened yesterday instead of twenty-some years earlier. I never pass a drive-thru to this day without remembering that sweet afternoon with my new old friend, and I can now say after a great deal of personal follow-up research that my preferences are In-N-Out hamburgers and McDonald's French fries.

Which reminds me, what's this I hear about something called an ATM machine?

I do insist on memorializing this in print: it's obscene that Melody Thomas Scott doesn't have an Emmy in every room in her house. She has my greatest admiration as an actress and as an extraordinary mother to her three beautiful daughters, and it's a joy to work with her and count her among my friends again.

As for Ed Scott, he left *Y&R* in 2007. He's now literally across the hall from us at CBS producing *The Bold and the Beautiful*, and his marriage to Melody is still going strong after twenty-six years. It's taken me a while, but I'm finally over it—all the "it" that went on between him and me for much too long. I believe in karma, after all, and I'm referring to my karma, not his. His karma is none of my business. Mine, on the other hand, demands that I say, and mean from the bottom of my heart, that I wish him nothing but happiness and success.

# Kate Linder

In 1982 I finally convinced Bill Bell that Katherine Chancellor needed a replacement for her original maid, Emma, who'd passed away a year earlier. Katherine lived in a vast three-story mansion, and she had no doorbell in those days, just a heavy door knocker. The audience was seemingly being asked to believe that even from the farthest corner of her mansion, Katherine could hear that door knocker and manage to answer it quickly enough that her visitor didn't assume she wasn't home and leave. And why on earth was this insanely wealthy woman answering her own door in the first place?

Bill cooperated. Halfheartedly, but it was a start. A young actress named Kate Linder was recruited to hover around the Chancellor mansion in the old-school maid's uniform I knew Katherine would demand—black dress, lacy white hat, white apron, and occasional feather duster. She had no lines, limiting her to nothing but a lot of smiling and head bobbing. She also had no name, referred to in scripts only as "Woman Maid." So when she began serving tea to Katherine, Nikki, and friends, I suggested we call her Esther, as opposed to "Hey, you!" or "Thank you, that will be all . . . whoever you are." I started taking delight in yelling orders offstage to Esther whether she happened to be working that day or not, and in looking at her as I still look at her today—as if I appreciate her as part of the household and part of the family, but I can't quite put my finger on what planet she's from.

Before long the writers made the transition from "Woman Maid" to "Esther," bestowed her with the last name of "Valentine," started giving her dialogue, and put Kate Linder under contract, and no doubt about it, she's become the most iconic maid in daytime.

A few weeks after Kate joined *The Young and the Restless* I boarded

a United Airlines flight from New York to Los Angeles, settled into my first-class seat, and, shortly after we'd taken off, heard a voice say, "Mrs. C.! Hi!"

And there stood Kate Linder—not a fellow passenger, it turned out, but one of the flight attendants. She sat down beside me and said very quietly, "Please don't tell anyone at work about this. I don't want them to think I'm not serious about my acting career."

"Are you kidding? Why keep it a secret?" I asked her. "It's part of who you are and what you do and how you earn a living. I would let everyone know if I were you, and be proud of it."

It's still true, and it's become common knowledge: Kate Linder, thirty years later, still balances her duties as Esther Valentine with her job as a United Airlines flight attendant. She is also involved in more charities than anyone else I've ever known, is incredibly gifted at promoting herself to the point where she has her own star on the Hollywood Walk of Fame, and has created a whole cottage industry out of being the actress who plays Katherine Chancellor's maid on *The Young and the Restless.* My hat's off to her for every bit of it too, with the one possible exception she's always denied.

It was the mid-1980s, a few years after Esther Valentine officially joined the cast, when I got a phone call out of nowhere from one of our production assistants. "I just wanted to give you a heads-up about something," she said. "A rumor might work its way back to you that Katherine Chancellor is going to be killed off and you'll be out of a job. Don't believe a word of it. I promise you, it's not going to happen."

I thanked her, hung up in shock, and immediately started asking around to find out what the hell could have prompted that call. The story that finally got back to me, and that I don't mind telling you threw me into a rage, was that Kate had arranged a lunch with Bill and Lee Bell in New York at which she pitched what she thought

was a great idea, based on a scene we'd already shot in which Katherine Chancellor told Esther she was including her and her newborn daughter in her will. Katherine Chancellor, Kate decided, after leaving Esther her mansion and a vast amount of money, could die, and Esther could become the mistress of the mansion, a zany, madcap, eccentric former maid who runs around Genoa City using her newfound wealth to help the needy.

It hit me like a punch in the stomach to think of any castmate, let alone Kate, being so ambitious that they would dream up a storyline in which a close castmate dies. It goes without saying that I confronted her about it, and she completely denied it, as she does to this day. Mind you, it was during this same period of time that I was sure Ed Scott wanted me gone. How does the saying go—"It's not paranoia if they really are out to get you"?

It was a difficult time, when the studio that I'd thought of for so long as my safe haven became a place where, for a while, I was never quite sure who or what to believe. I'm so thankful that those days are behind us and that Esther's still around, in uniform, as devoted to Mrs. C. as Mrs. C. is devoted to and perpetually mystified by her. All the best to you, Kate, with all my heart.

## Terry Lester

Terry Lester, who came roaring on-screen in 1980 as *Y&R*'s original Jack Abbott and played him for nine unforgettable years, passed away in 2003. Not a day has gone by when I haven't missed his friendship and wished I could pick up the phone, call him, and solve a vast majority of the world's problems.

Terry was a brilliant man, a concert-level pianist and singer, who was generous and playful, with an occasional dark side that

kept him from letting too many people get close. He wore his best and his worst just beneath the surface, which made him a fascinating man and an equally fascinating Jack Abbott. That I was one of the few people he let in was a real source of joy in my life.

It was Terry, for example, who leapt at my idea, and split the cost with me, to rent a party bus for twenty cast members who joined us on a silly, hilarious one-hour trip to see our friend and castmate Marla Adams (Dina Abbott) in a production of *A Little Night Music*.

It was Terry who joined me in hosting and paying for an annual party for our unparalleled *Y&R* crew.

It was Terry who could make me laugh and move me to tears in the same scene, Terry to whom I wanted to give a good swift kick in the butt when his dark side crept in, and Terry who always made me feel loved and supported on my best days and my worst ones.

It was Terry who, on hearing that I was going to Taos, New Mexico, for two weeks to shoot *Sweet Hostage*, a TV movie with Martin Sheen and Linda Blair, told me to look up a friend of his while I was there, which is how I met a man we lovingly called "that crazy Indian" (as if this Cherokee has a lot of room to talk).

His name was R. C. Gorman, and he was a spectacular Navajo artist. At Terry's insistence, I went to Gorman's gallery in Taos on my first afternoon off. The instant I walked in the door his friend and manager, Virginia Dooley, let out a gasp and said, "Oh, my God, it's Mrs. Chancellor."

After we properly introduced ourselves, I told her that Terry Lester had suggested I stop by to say hello to R. C. He wasn't there, Virginia told me, but he would be as soon as she called and told him who was looking for him.

A couple of hours later R. C. Gorman burst into the bar of my hotel where we'd agreed to meet. "Mrs. Chancellor!" he yelled

across the room, and he came over and hugged me as if we'd known each other for years. And thus began a great friendship that lasted until he passed away in 2005.

One of my fondest memories involved another trip to Taos a few years later. A parade to celebrate God knows what was being held, and R. C. invited Terry and me to join the festivities. Caren went with me, and the spectacular Jeffrey Jones, a friend of Terry's who was shooting a movie in Santa Fe, joined us too. (You'd know Jeffrey from *Ferris Bueller's Day Off, Amadeus, Beetlejuice, Deadwood,* and countless other projects.) I think the entire population of Taos was lining the streets as Jeffrey, Terry, R. C., and I drove slowly by in our respective convertibles, happily waving and having the time of our lives. Unfortunately, the weather decided not to cooperate. Early in the proceedings it began to drizzle. When it progressed to a light rain, Jeffrey, Terry, and R. C., unbeknownst to me, abandoned their convertibles and made a break for the sidelines. In a matter of minutes I was riding along in a steady downpour, still waving and drenched to the bone, only to hear Terry yelling and cheering and whistling from among the equally drenched crowd: "Look, everyone, it's Katherine Chancellor!!! Let's hear it for Mrs. Chancellor!!! [whistle, whistle, woo-hoo, whistle]" He was getting a huge kick out of himself, and as hard as I tried to fight it in my dripping wet, unsightly misery, so was I.

It was also Terry who saw to it that I met the "Bill Bell of *As the World Turns*," the extraordinary head writer Douglas Marland. Terry had left *The Young and the Restless* in 1989 for reasons too idiotic to go into, and after a brief stint on *Santa Barbara*, he'd signed on for a role on *As the World Turns*, which Douglas Marland had created just for him. When Terry introduced us at a party at his house, I said, and meant it, "It's an honor to meet you. I'm a huge fan of yours."

As luck would have it, he was a fan of mine too, and by the end of the conversation he told me he'd love to create a part for me as well, if I'd be willing to do it.

I wasn't about to say no to Douglas Marland, and frankly the thought of moving to New York, where I'd always dreamed of living, tackling a part written just for me by the likes of him, not to mention working with Terry again, sounded almost too good to be true.

"Doug," I said, "you write it and I'll be there."

After which Douglas Marland flew back to New York and promptly died of a heart attack. The loss to daytime television was and is incalculable . . . and once the shock wore off, I couldn't help but selfishly feel a little robbed and wonder what could have happened.

<center>～ ～ ～</center>

IT'S AN UNDERSTATEMENT TO say that my life, onstage and off, is infinitely richer for having known, loved, and been loved by Terry Lester. Rest in peace, my dear, dear friend.

And before I leave the subject of the late, great Douglas Marland behind, I can't resist sharing something he once wrote, which I firmly believe every soap opera writer and producer should be required to memorize and adhere to religiously. I wonder how many treasured soaps could have been saved . . .

## How Not to Ruin a Soap

- Watch the show.
- Learn the history of the show. You would be surprised at the ideas that you can get from the backstory of your characters.

- Read the fan mail. The very characters that are not thrilling to you may be the audience's favorites.
- Be objective. When I came in to *ATWT*, the first thing I said was, "What is pleasing the audience?" You have to put your own personal likes and dislikes aside and develop the characters that the audience wants to see.
- Talk to everyone, writers and actors especially. There may be something in a character's history that will work beautifully for you, and who would know better than the actor who has been playing the role?
- Don't change a core character. You can certainly give them edges they didn't have before, or give them a logical reason to change their behavior. But when the audience says, "He would never do that," then you have failed.
- Build new characters slowly. Everyone knows that it takes six months to a year for an audience to care about a new character. Tie them in to existing characters. Don't shove them down the viewers' throats.
- If you feel staff changes are in order, look within the organization first. P&G [Procter & Gamble] does a lot of promoting from within. Almost all of our producers worked their way up from staff positions, and that means they know the show.
- Don't fire anyone for six months. I feel very deeply that you should look at the show's canvas before you do anything.
- Good soap opera is good storytelling. It's very simple.

—Douglas Marland

# Peter Bergman

The relationship between Terry Lester and *The Young and the Restless* ended in 1989, and I promise you, based on a lot of long, emotional

phone conversations, he deeply regretted the bridges he'd burned along the way. Arriving to assume the role of Jack Abbott was a tall, handsome actor named Peter Bergman, with perfect military-class posture, an amazing shock of hair, and a soap following from his days as Dr. Cliff Warner on *All My Children*.

The transition from Terry to Peter was an interesting one for us actors, let me tell you. Terry wore Jack Abbott's imperfections on his sleeve. From the very beginning Peter kept them well hidden, pulling them out only on an as-needed basis when he saw no other choice. Terry's Jack Abbott was likely at any given moment to be a loose, silly, playful womanizer who happened to be an executive in the family business. Peter's was and is, first and foremost, an executive in the family business who happens to have a somewhat flawed personal life and an all-encompassing love of family. Just like in real life, you couldn't imagine Terry Lester or his Jack Abbott settled down with a wife and children, while you couldn't imagine Peter any other way, or doubt that his Jack Abbott wanted to settle down, no matter how misguided his efforts might be toward that goal. But the bottom line was, incredibly different as they were as people and as actors, both Terry and Peter brought great talent and depth to a complex role Bill Bell meticulously created when he decided *Y&R* needed a new core family named Abbott in Genoa City in 1980.

On Peter's first day we were all privately sizing up "the new kid," involuntarily thinking, "That's not how Terry would have played that scene." Several of us, including Peter, were sitting around discussing God knows what—I admit it, I was a little preoccupied with missing my pal and not paying much attention. When they called us to the set, I started to stand up as I'd been routinely doing with ease for about fifty years and suddenly discovered I could no

longer hop to my feet from a cross-legged sitting position on the floor. I kept trying and failing as discreetly as possible, not wanting to call attention to myself, when I looked up to see Peter standing there, smiling and extending his hand to me.

I felt a little self-conscious, but I was grateful for the help and took his hand. "I've always been able to do this," I explained as he pulled me to my feet.

"As long as I'm here, you'll always have a hand up," he told me. He's kept that promise ever since, and I hope that, in my way, I've done the same for him.

His children, Connor and Clare, were babies when Peter and I first met. They're in college now, and I've had the pleasure of watching then grow up and marveling at what great parents he and his wife, Mariellen, are. He's such a class act and such a pro, always focused and prepared and never bringing his personal baggage to the studio. On any given day you'll find Peter and me in my dressing room trying to figure out how to solve the show's problems when no one wants to listen, or sometimes just deciding how to play a scene that sounds like nothing either Jack or Katherine would ever say or do. His instincts are as impeccable as his performances, and no one has cheered more loudly than I have for his sixteen Emmy nominations and his three Outstanding Lead Actor Daytime Emmy Awards.

It's an ongoing source of fascination to me that two actors so personally different from each other, taking such different approaches to their performances, can be so successful at playing exactly the same character . . . and that I can miss Terry Lester every single day, on-screen and off, while being just as grateful every single day, on-screen and off, that Peter Bergman is a part of my life.

# Christian LeBlanc

It was April Fool's Day 2009 when the announcement hit the news that the longest-running soap in history, the CBS classic *Guiding Light*, had been canceled. It was shocking and heartbreaking and infuriating and a whole lot of other adjectives I'm sure many of you felt too. Including its days as a popular radio serial, *Guiding Light* had been around for seventy-two years. It made its television debut in 1952. One school of thought, I suppose, is that it had outlived its usefulness. But as far as I'm concerned, you don't discard an institution if it's got problems; you fix it. It's the TV equivalent of finding cracks in the Lincoln Memorial and replacing it with a strip mall.

The decision had been made, though, and I was pretty sure that a good stern scolding from me wasn't going to change anyone's mind. Instead, I decided that, since every soap actor in the business owes *Guiding Light* a huge debt of gratitude, I wanted to find a proper way to say good-bye and thank you. I immediately called Barbara Bloom, who was then the head of CBS Daytime, and ran my idea past her: I wanted to make an appearance on the show during its final week. I didn't want any dialogue. I didn't want to say a word. Just put me in the background on a park bench, or have me stroll past and nod at a cast member or two, and I'd consider it an honor. Barbara Bloom talked to *Guiding Light* producer Ellen Wheeler, who responded with a resounding "Yes!"

I was excited and told my castmates about it, and the words were barely out of my mouth before Christian LeBlanc, aka multiple Emmy winner Michael Baldwin, leapt up and chimed in, "I want to go too!"

Think of your ten most high-energy friends fueled by a generous supply of chocolate-covered coffee beans. Put them all together into one person and that person would be named Christian

LeBlanc. He's tireless, he's generous, he's a spectacular actor and artist, he's the life of every party, and he's *everywhere*. "I want to go too!" should be his motto if it isn't already. I explained the part about no dialogue, just background in some scene or other, and he didn't care. He wanted in. I was happy to have a pal to go with me and *Guiding Light* was delighted.

So delighted, in fact, that by the time we arrived on the set in rural New Jersey, the writers had actually scripted brief cameo roles for us. I was a wealthy dowager, and Christian was my Italian (I think—I know he played it with an accent of some kind) boy toy with his shirt unbuttoned to his navel. It was an amazing experience, being welcomed by so many treasured, talented friends under such sad and incredibly unfair circumstances, knowing that all those people in the cast and crew were going to be unemployed soon through no fault of their own. What an honor to have been part of it, even if it was just for one day, and be given a chance to tell everyone in person how appreciated they were by the whole daytime community and how much they'll be missed. In case I didn't say it often enough while we were there: to all of you involved with *Guiding Light*, thank you so much for having us.

Then, at Christian's invitation, he and I were off to Tennessee to pay a visit to St. Jude Children's Research Hospital in Memphis. I'd never been, and I was looking forward to it, but I wasn't prepared for how completely blown away I was by the whole experience. It's a magnificent facility, the staff is extraordinary, and the children were brave and sweet and utterly inspiring. In the hours we spent with them I saw that side of Christian that's so gentle, playful, compassionate, comforting, and full of hope, with that rare gift of making every child he talked to feel like the most important person in the whole world. And every bit as touching to me was the fact that throughout our entire visit, there wasn't a single

photographer or reporter in the place. Believe me, I appreciate the importance of publicizing worthy charities. But I also appreciate discovering quietly generous friends and colleagues in this business who don't look at every charity as a potential photo op. God bless you, Christian, for being one of them and for including me in those few extraordinary hours I'll never forget.

(I wasn't kidding about the chocolate-covered coffee beans, by the way. When you happen to think of it, send him some. He loves them, and chances are, whatever day he receives them, he's done something to deserve them.)

# David Hasselhoff

It was 1975 when a tall, wildly handsome twenty-three-year-old boy named David Hasselhoff arrived at the studio to replace William Gray Espy in the role of Snapper Foster, who was a medical student at the time and (ostensibly) Jill Foster Abbott's brother. (Of course, Jill later found out she wasn't a Foster at all and was then thought to be Katherine Chancellor's daughter for a while, until she was finally revealed to be Lauren Fenmore's sister.) David's was a classic Hollywood "discovery" story—he was spotted by super-manager/casting director Joyce Selznick while he was waiting tables in a restaurant in Marina del Rey. She quickly signed him to a management contract and aimed him straight toward daytime, knowing he was as green at acting as he was great-looking and that the training and discipline of a soap could give him the kind of career building he needed.

Bill Bell loved David's chemistry with the rest of the cast, and John Conboy was excited about this brand-new potential young heartthrob. One of John's first long talks with David still makes me

chuckle. Trying to be as diplomatic as possible without offending him, John asked David if he would have any objection to changing his name for career purposes. David, earnest and unoffended as could be, said no, he wouldn't mind that at all . . . as long as he could keep the name Hasselhoff.

What David lacked in skill and experience he more than made up for with his work ethic, his love of the work itself, and his genuine desire to learn the craft. Bill Bell asked if I would take on the challenge of being his coach, and it was precisely because David was so earnest and so eager to become a good, respected actor that I agreed. We became close, as castmates, as mentor/student, and, eventually, as a woman who'd fought her own demons and wasn't about to sit by and watch him give in to his without some long, private, loving, painfully honest talks. Even after he moved on to prime time in 1982 and became a star on *Knight Rider*, and later on *Baywatch*, he knew and still knows I'm pulling for him to find the peace of mind I know he's capable of.

In 2007 I went to see David in a Las Vegas production of the Mel Brooks classic *The Producers*. His reviews will back me up on this—he lived up to every bit of his potential, and he was spectacular. I was so proud of him, and so touched when he introduced me to the cast backstage with a sweet, heartfelt "This is my friend Jeanne Cooper. I want you to know that everything I've achieved as an actor I owe to her."

David was back on *The Young and the Restless* for a few episodes in 2010. His two daughters were with him, and it was a joy to watch him with them and see how much he adores them. Hamburger video, colossal public screwups, tabloid stories, and all, don't ever, ever doubt that.

I have a lot of love in my heart for that earnest, excited boy I met in 1975 and will never stop believing he's still in there, waiting for

those demons to get out of the way. No one dares to speak badly of David Hasselhoff around me, that's for sure, and no matter how many times he manages to shoot himself in the foot, I'll be praying he finds a way to grow another one.

# Nancy Grahn

No, Nancy Grahn isn't one of my castmates. She plays Alexis Davis on *General Hospital*. She's a superb actress, as most of you know, and she also happens to be a passionate, hilarious woman and an incredible mother to her daughter, Kate. This is one of my favorite stories, the story of how, if a certain evening had gone a little differently, Nancy might have joined the cast of *The Young and the Restless*. It's never appeared in print before, and I'm telling it with the permission of the two people directly involved: Nancy and my collaborator, Lindsay Harrison.

Beginning in 1985, Nancy brilliantly played the role of Julia Wainwright Capwell on the NBC soap *Santa Barbara*. When the show was canceled in 1993, Nancy took a little time off and then began the process of auditioning for prime-time series. And believe me, it can be infuriating. With rare exceptions, prime-time producers tend to be very dismissive of daytime actors. It's not uncommon for them to say at an audition while they glance through an actor's résumé, "I see you've been on a soap opera for the last eight years, but have you actually *done* anything?" Nancy was going through more than her fair share of that nonsense, and it was beginning to get on her nerves. Then just when she thought she couldn't be made to feel more estranged from her career, she received a formal invitation to the Soap Opera Digest Awards.

"Just what I need," she told Lindsay, "an evening with hundreds of people I know, all of whom are working and all of whom know I'm not. That should be a real confidence builder."

"You're going, right?" Lindsay asked.

"Are you insane?" she shot back. "I'd rather shave my head. It's too awkward and too embarrassing."

Lindsay wasn't having it. "Are *you* insane? Of course you're going. You said it yourself—hundreds of people will be there, all of whom know you and respect your work and many of whom are in a position to hire you. You're going to go, you're going to look like a million dollars, and you're going to be the friendliest, most outgoing person in the room, if you know what I mean."

"No, I don't know what you mean, and I'm not sure I want to," Nancy said, voice dripping with skepticism. "Friendly and outgoing like what?"

"Like, in addition to all the friends you'll run into, who'll be happy to see you by the way, you're going to walk up and introduce yourself to people you admire but have never worked with. Bill Bell, for example."

"You're kidding. You know how terrible I am at things like that. You really think I'm going to just stroll up to Bill Bell, and say what, exactly?"

Lindsay's enthusiasm was building, despite the fact that Nancy's wasn't. "Think about it. This will be perfect. It's the Soap Opera Digest Awards. Every show has its own designated tables. So once everyone's seated at the *Y&R* tables, you'll walk up to Bill Bell, extend your hand, and say, 'I'm sorry to bother you, but I can't believe we've both been in the business for this many years without meeting. I'm a huge fan, and I just wanted to introduce myself. I'm Nancy Grahn.'" After a series of barfing and gagging noises on Nancy's end, Lindsay

added, "I know you can do this, and we both know it's exactly the right thing for you to do, especially since there's nothing dishonest or insincere about it. So come on, let me hear it, you're going to walk up to Bill Bell once he's seated at the table and you're going to say . . . ?"

In her best patronizing, singsongy voice, Nancy recited, "I'm sorry to bother you, but I can't believe we've both been in the business for this many years without meeting. I'm a huge fan, and I just wanted to introduce myself. I'm Nancy Grahn."

Several days of arguments and protests followed that first conversation, but at the end of each one of them Nancy reluctantly agreed to go to the awards and, if she could work up the nerve, approach Bill Bell. There were countless rehearsals of her brief monologue so that, if nothing else, she could get through the encounter without getting tongue-tied, and Lindsay helpfully recited it with her: "I'm sorry to bother you, but I can't believe we've both been in the business for this many years without meeting. I'm a huge fan, and I just wanted to introduce myself. I'm Nancy Grahn."

Lindsay was a nervous wreck on Nancy's behalf on the night of the Soap Opera Digest Awards, dying to hear how it went. She didn't have to wait long. Nancy called her at six the next morning.

"Damn it!" she began, not even bothering with hello. "What a disaster! I can't believe I let you talk me into that!"

It was the last thing Lindsay expected to hear. "Why? What happened?"

"It started out okay," Nancy told her. "I got there, I looked fine, I did get to say hi to a lot of people, and they all seemed supportive and happy to see me. But I kept one eye on the *Y&R* tables, and when everyone was seated I took a nice deep breath, walked up, extended my hand, and said, just like I was supposed to, 'I'm sorry to bother you, but I can't believe we've both been in the business for

this many years without meeting. I'm a huge fan, and I just wanted to introduce myself. I'm Nancy Grahn.'"

"And . . . ?"

"And he stood up, very courtly and gracious, took my hand in both of his, and said, 'How do you do, Nancy? I'm Jerry Douglas.'"

Unfortunately, Lindsay was laughing too hard to be as sympathetic as she should have been, especially when Nancy added, "Two seconds later, I glanced over and saw that Bill Bell was sitting just two chairs away, and of course he'd heard the whole thing, so I couldn't even say it again, I just told Jerry Douglas it was nice meeting him and headed straight to my car."

<center>〜 〜 〜</center>

Now, TO BE FAIR, Jerry Douglas, aka John Abbott, patriarch of the Abbott family on *The Young and the Restless*, did bear a resemblance to Bill Bell. It was a relatively understandable mistake. But I think we'll always wonder what would have happened if Nancy had actually approached the right man that night. The happy ending is that in 1996 *General Hospital* was smart enough to sign her; she was back to work where she most definitely belonged and she's still there today.

As for my castmate Jerry Douglas, he came to *Y&R* as John Abbott in 1982, a true family man and founder of Jabot Cosmetics, the epitome of honesty and integrity and one of Katherine Chancellor's dearest friends. It was always a common assumption, in fact, that Katherine and John were lovers when they were young, and she's been a constant treasured presence in the lives of the Abbott children, Jack, Ashley, Traci, and Billy. It hit both Katherine and me very hard when the insane decision was made to have John die of a stroke in 2006. Bill Bell was gone by then, but I could hear his

voice as clearly as if he were standing there beside me when the news hit: "You do *not* kill off your core characters, and you do *not* let your core families disintegrate!"

I couldn't agree more. And believe me, if a vote were taken on the set today among the actors who've been on *Y&R* for any length of time at all, the Abbott family would be sitting down to breakfast at their long-lost dining room table again right this very minute.

## The Backbone of *The Young and the Restless*

When all is said and done, there's only one real star of *Y&R*, and that's the show itself. We members of the cast are simply there to contribute our light to that star. As I look around and look back, I marvel at the long, amazing journey of a show that's developed a persona of its own and at some of the actors who have formed the backbone of that persona. So many of us have been through one another's off-screen marriages and divorces and births and deaths and illnesses and crises and celebrations, and whether we're still part of *Y&R* or have moved on, I have to at least mention a few more of those castmates who've left indelible impressions on the show and on my heart.

Lauralee Bell: Five years old when I first met her, now a happily married mother of two beautiful children. Fifteen years old when she joined the cast of *Y&R* as supermodel Christine "Cricket" Blair, and so gracefully tolerated the inevitable, undeserved nepotism accusations from being Bill and Lee Bell's daughter despite working every bit as hard as the rest of us without ever, on-screen or off, feeling entitled. She's as "normal" and grounded a woman as you'd ever meet, and comes back on *Y&R* from time to time even with a busy, well-rounded life as a producer, businesswoman, and

completely devoted wife, mother, and daughter. I still say to this day what I've said to Bill and Lee a thousand times over the years: I'd proudly adopt her in a heartbeat.

Tricia Cast: My housemate when she flies in to work from her home in a small town near Nashville, Tennessee, where she lives with her husband, singer-songwriter Bat McGrath. She started acting at the age of twelve and already had an impressive list of credentials when she joined *Y&R* in 1986 as Nina Webster and became Christine's best friend and Jill's daughter-in-law. She's always been one of my favorite actresses on the show, with a well-deserved Emmy and another recent nomination to her credit, and it's an ongoing source of amusement for us that Nina lives with Katherine when she comes to Genoa City while Tricia lives with me when she comes to Los Angeles. There are few people to whom I'm closer and of whom I'm more proud.

Tracey Bregman: An integral member of the cast as Lauren Baldwin (née Fenmore) since 1983, with a few gaps in between. I've known her as a single woman, a married woman, a devoted mother, and a divorcee, from huge hair to the gorgeous mane she has now, and not once, maybe because of her show business background thanks to her musician/composer father, Buddy Bregman, have I ever seen an "off" day or a less than utterly professional, right-on-the-money performance. She also manages to get more beautiful with every passing year, by the way, which I would find annoying if she weren't such a loyal, generous friend. Now if Lauren Baldwin would just repay Katherine Chancellor the $50,000 she borrowed in the 1980s to make an album . . .

Doug Davidson: He was a major heartthrob when he joined the *Y&R* cast in 1978 as the private detective Paul Williams, and he's still a major heartthrob of mine all these decades later. He's as fine a husband and a father as he is an actor and a man, a perfect mixture

of laughter and sensitivity. Give him any storyline, no matter how emotionally difficult, and he'll make it soar. He's earned three Emmy nominations, but I would personally add a Most Hilarious Off-screen Comedy Team nomination for him and his most notorious partner in crime . . .

Don Diamont: Doug Davidson and Don Diamont, our ridiculously handsome Brad Carlton from 1985 until 2009, never let a day go by without finding a way to burst into some form of much-needed silliness to loosen up their castmates. Off-screen, Don is a natural born father and caretaker, someone who'd be there for you at three in the morning if you needed him. As Brad Carlton, he started as the Abbott family gardener and ended up marrying not one but both of the Abbott sisters while becoming a shrewd, formidable businessman. It literally felt like a punch in the stomach when Don stopped me at the elevators one day in 2009 to tell me he'd just been fired from *Y&R*, killed off, mind you, after an utterly insipid storyline that painted Brad, and Don, right into a corner. He's right across the hall now, finding all the success he deserves as Bill Spencer Jr. on *The Bold and the Beautiful*, and as much as we miss him, he's got a loud, enthusiastic fan club cheering him on from our side of the hall. Thank you, Bradley Bell, for being smart enough and loyal enough to at least keep Don in the building where he belongs.

And speaking of the Abbott sisters . . .

Eileen Davidson and Beth Maitland: Also known as Ashley and Traci Abbott, both of whom joined *Y&R* in 1982. Two spectacular actresses and two of the finest women I've ever met. Eileen left us for a while to play five roles on *Days of Our Lives* and to go across the hall, thanks again to Bradley Bell, to appear on *The Bold and the Beautiful*, but thank God we've got her back. She's come into her own, happily married with a precious son and a successful career as an author when she's not at the studio. I've always wished our

writers would capitalize on a facet of Ashley and Katherine's relationship that's never been explored: Ashley grew up thinking John Abbott was her father, but in fact her father was a tennis pro with whom Katherine had an affair and then introduced to Ashley's mother, which it would seem to me Ashley might resent.

As for Beth Maitland, our first Emmy Award–winning actress, I swear that woman is lit from within, and with John Abbott gone, we need her back full-time as the heart and the moral compass of the Abbott family, the true reincarnation of her father. It thrills us all when Beth comes to work, and what a joy to see her blossom offstage as well, as a happily married woman with a gorgeous sixteen-year-old daughter, four horses (including a miniature horse), four dogs, two miniature burros, and a hilarious goat.

And then there's the original Winters family: Kristoff St. John, Victoria Rowell, Shemar Moore, and Tonya Lee Williams. Each of them sensationally gifted and all of them essential to the foundation of *Y&R*. Kristoff, aka Neil Winters, a former child actor (I have a framed photo of him and Tricia Cast in my bedroom, from their days together on *The Bad News Bears* TV series when they were about twelve years old) and a two-time Emmy winner, joined the show in 1991 and is still with us as, until very recently, the CEO of Katherine's multibillion-dollar corporation, and here's hoping he will be again. He's a wonderful dad and a devoted activist for his beloved charities.

Victoria joined *Y&R* in 1990 and, with a few interruptions, was with us until 2007. The talent, energy, and spirit she brought to the show were incredible and irreplaceable—she somehow managed to juggle her essential role as Drucilla Winters with a regular prime-time job on Dick Van Dyke's *Diagnosis Murder* while also maintaining her passions as a ballerina, an advocate for foster children (having been a foster child herself), a bestselling author, a wife, and a mother.

Shemar, one of the most gorgeous men in the history of daytime, arrived in 1994 as Neil's brother, Malcolm, with a swagger, a flair, an intensity, and a playfulness that made him incredibly exciting to work with. He left in 2005 for a leading role on the CBS hit series *Criminal Minds*, and I couldn't be happier for him while selfishly missing that irresistible smile.

Tonya, aka Dr. Olivia Barber Williams, arrived in 1990 and, despite a lot of protests, including mine, left in 2005, with only rare and all-too-brief appearances ever since. She was the perfect grounded, logical, well-educated counterpart to her sister, Victoria Rowell's Drucilla, solid as a rock and a joy on the set. She's gone on to become a producer, a director, and a writer, and no one is more deserving of all the success that's coming her way.

Patty Weaver: In 1982 an adorable blonde named Patty Weaver came on board as Gina Roma, restaurant owner and sister of Genoa City's own rock star Danny Romalotti (Michael Damien). Gina made the best lasagna in town, and Gina's Place was one of the town's hottest hangouts, kind of the 1980s version of Crimson Lights, until Kevin Fisher burned it down in an attempt to kill Brad and Traci Abbott Carlton's daughter, Colleen. (Not to worry, we all got over it.) Gina was one of our most beloved characters, and Patty was one of our most beloved colleagues, with a singing voice like an angel. (Between Patty Weaver and Beth Maitland, *Y&R* has been blessed with two of the most beautiful voices you'll ever hear.) I'm told there's something called "YouTube" on something called "the Internet" on something called "a computer." (I admit it, I'm technologically challenged, and furthermore, I don't care.) If any of this sounds familiar to you, please do go on YouTube and look for footage called "Gina Sings to *The Young and the Restless* Theme." It's from 1983, a bit grainy and scratchy, but you'll never hear our theme song sung more gorgeously. Patty's last appearance on *Y&R*

was in 2009. She married one of our late, great writers, Jerry Birn, and has retired from acting. We get together with Lee Bell several times a year, and I'll keep nagging Patty to become the voice teacher I'm convinced she's meant to be—if she can teach me to sing "What I Did for Love" at a fan event, she's as good as it gets.

And even though I've talked about her in other chapters, I have to give one more verbal hug to Jess Walton, my sidekick Jill Foster Abbott, the bane of Katherine Chancellor's existence and my divinely neurotic friend. I don't say it often enough to her, but Jess, throughout all these years, on-screen and off, what on earth would I have done without you?

~ ~ ~

IF THIS CHAPTER SOUNDS like a very long love letter to some of the coworkers who have helped form the core of daytime's number-one soap opera since 1988, it's only because that's exactly what it is, and I make no apologies for it. I know and love these people, and I want you to know and love them too, whether you're new to *The Young and the Restless*, have watched for years, or have never seen a single episode. I have faith in the future of *Y&R* because I have faith in its past and the goldmine Bill Bell created with an embarrassment of riches still waiting to be explored. Soap operas have outlived their usefulness? I don't think so. No one's going to convince me that great actors playing great characters involved in great storylines will ever be outdated, and I'll believe in this show and this unique, historic genre until the day I walk out the doors of the CBS studio for the last time.

# Where Are They Now?

Every veteran soap actor appreciates wrapping up storylines. We don't leave murders unsolved (even when they drag on so long that nobody remembers or cares who the victim was, or if the victim shows up again alive and well and claiming to be an identical twin we've never heard of), we don't leave falsified paternity tests unexposed (even when they come from as inept a facility as the Genoa City DNA lab), and we almost never let an established character wander off into nowhere without some explanation about where he or she might have gone (an explanation that, in real life, would probably involve the words "budget cuts").

Since I am nothing if not a veteran soap actor, I feel compelled to wrap up some of the storylines in my life, especially since it will give me a perfect opportunity to indulge in a lot of bragging about my children and grandchildren later in this chapter.

~~~~~~

THERE'S A FAMOUS EPISODE of the classic *Mary Tyler Moore* series of the 1970s called "Chuckles Bites the Dust" in which Mary, to her horror, begins uncontrollably laughing at the funeral of Chuckles the Clown. If you've never seen it, I can't urge you enough to get a copy of it. It's hilarious.

It's also an unfortunate glimpse of what I went through on the day we gathered to say a formal good-bye to my father.

Daddy and I had grown further and further apart after he left for the Canadian oil fields while I was still in high school. I remember seeing him at my high school graduation, but our visits from then on were very few and far between, although I did see to it that he met Corbin, Collin, and Caren so that they'd be real to each other rather than just nebulous concepts of "grandfather" and "grandchildren."

For the most part, though, except for occasional phone calls, Daddy went on with his life and I went on with mine, which seemed to make us both comfortable. He met and married a woman named Judy in Canada, and the two of them moved to Alaska when his business in the oil fields took him there. I'm not sure I'd ever realized how young Daddy was when Mother died until it occurred to me that Daddy and Judy were married longer than he and my mother were. I think—I *hope*—that their marriage was a solid, happy one.

Daddy was in his eighties when Judy passed away. He went to live with my sister, Evelyn, and her husband for a while, and with my brother as well. I invited him to move in with me, but he wasn't interested. I don't doubt for a moment that we loved and respected each other. I just think we had so little in common at that point in our lives that we weren't sure how to even start connecting, so if he

had stayed with me, he would have been very well cared for while sharing a house with a familiar-looking stranger who happened to be his daughter.

A point came when he needed full-time care, for which he was moved to a nursing home in Taft. I went to visit. We smiled and talked quietly to each other. I remember realizing that I loved him, and I treasure those parts of him that *are* me, but I didn't really know him. I wonder if anyone did.

Daddy died on April 11, 1986. Corbin and I drove to Taft the day before the funeral—a service, I was told, that Daddy, a man who had no use for organized religion, had prearranged. The family, including lots of aunts, had already gathered in the viewing room when Corbin and I arrived at the funeral home. I mean no disrespect to anyone else's beliefs when I say that not for a moment, as I stood there beside that open casket, did I feel it was Daddy lying there in an alpaca sweater and glasses. It was nothing but a body, the vehicle he'd traveled in while he was here, a vehicle he'd happily abandoned and moved on from. He was no more in that body than I was, as far as I was concerned, but I did lean in close to him, in case he was hanging around eavesdropping on all of us, and recite the bedtime poem with which I used to tuck my children into bed:

Now I lay me down to sleep.
I pray the Lord my soul to keep.
Guide me through the starry night
And wake me when the sun shines bright.

(For the record, I know those aren't the most common last two lines of that poem, but no way would I send my children off to sleep with the cheerful suggestion "If I should die before I wake" unless I were trying to raise a houseful of insomniacs.)

An impressive crowd of family members and Taft residents assembled in the funeral home chapel the next day to say a final farewell to Daddy. Again, remember, every part of the service was supposedly at his personal request, which, if the results were any indication, must have started like this: "I want a pastor who wouldn't know me or my immediate family from a herd of cattle to officiate the ceremony with the help of a boom box."

So sure enough, up the aisle came Reverend Somebody-or-Other, carrying a boom box the size of Michigan, which he set up on the podium and solemnly hit the Play button, treating us to a tinny, badly played organ solo of a hymn I'd never heard before in my life.

When the prerecorded music mercifully ended, Reverend Somebody clicked the Off button and launched into a somber, heartfelt stream of descriptive words and phrases about the "dearly departed." It was a lovely tribute. Unfortunately, not a word of it even remotely applied to Daddy. For all I know, it might have been left over from a funeral the day before, and, pressed for time, Reverend Somebody simply decided it was such a hit that he'd just use it again.

Not that there wasn't a personal moment or two. The reverend did acknowledge Daddy's pride in his son, Jack, and nodded in the vague direction of my brother. Then, of course, there was Daddy's "beloved daughter Evelyn," on which he pointed to someone a good twenty feet away from my sister, prompting our entire row of Coopers, including Evelyn, to lean forward and crane our necks for a glimpse of the designated "beloved daughter."

And sometime during the synchronized scanning for the new Evelyn, the boom box, and the sermon by a total stranger tenderly describing Daddy as everything from a professional tap dancer to an avid needlepoint enthusiast, I began to laugh so hard that I had

to hide my face in my hands, so hard that I didn't even notice Reverend Somebody's failure to mention a word about Daddy's third child, his beloved daughter Wilma Jeanne. If you've ever tried unsuccessfully to make yourself stop laughing, you know how excruciating it is, and I would feel guilty about it if it hadn't been so involuntary.

When the service finally ended—with one more ear-grating selection from the "Barbie's First Organ" tape on the boom box—we all trooped off to the cemetery, half of which is populated with my relatives, to bury Daddy beside my stepmother, Judy, at his request. I paused at Mother's grave to pay my respects, and I couldn't resist adding under my breath, "Thank God you're already dead, because what we just sat through would have killed you."

I didn't cry over Daddy's death. Not then, not to this day. I think of him and smile, and I thank him, with love, for giving me life and countless qualities I'm sure he genetically passed along, from his extroverted fearlessness to his sense of adventure to his reverence for this earth and all living things with which we share it. It might also be true that I inherited from him the very lack of sentimentality that kept me from crying when he died.

I did send a huge, beautiful wreath to the cemetery a few days later. There was no card, no indication at all of who sent it. It wasn't for Daddy's grave. It was for Mother's, to say out loud that I thank her too, and always will.

~ ~ ~

I swear that silly funeral made a lasting impression on all of us, including my brother, Jack, who, when he passed away in 2004, made it very clear that he wanted to be cremated. (For the record, I've specified the same thing.)

The six-year age difference between me and Jack prevented us from being very close when we were growing up. I loved camping and hiking and doing "boy" things with him, and I was proud of him for being a football hero and a great athlete in general. But when he left home at eighteen to get married, I was only twelve. And while we didn't ever become especially close as adults, I can't say enough about what a wonderful man he turned out to be. His marriage to Edith was a true love story, lasting more than sixty years, until she passed away a few years before he did. He was fun and funny, with a great, infectious laugh, and he was a devoted father who outlived three of his four children. He and Edith lived in Alaska for forty years, where Jack was a consultant in the oil business.

We saw each other at a long-ago family reunion, and I went to Jack and Edith's fiftieth wedding anniversary celebration. The many miles between us kept us more separate than we meant to be, I'm sure, and frankly, so did Harry Bernsen—Jack, like the rest of my family, found Harry unbearable, and Harry made it apparent that my family was of no interest to him whatsoever. In fact, Jack and Edith would only come to visit on the condition that Harry wasn't around. (Why didn't *I* think of that?)

When Edith passed away, Jack went to live with his son and daughter-in-law, Chris and Dianne, in Stallion Springs, California, in their beautiful house by a golf course. Chris and Dianne took wonderful care of him, and the three of them loved traveling together until Jack began struggling with a nasty recurring staph infection. He was back and forth to the hospital God knows how many times. Finally one day, when his doctor wanted to check him in yet again, Jack said, "No more. I'm done. I'm staying right here." He was eighty-three when he quietly, peacefully passed away at home.

I love the arrangement he and Edith made in their last years

together: Edith was cremated when she died, and her ashes were set aside. When Jack died he was cremated as well, so that their ashes could be placed together on a rock beside the river in Oregon where they'd built a house, and the wind and the water could take them away, setting their spirits free to soar.

≈ ≈ ≈

AND THEN THERE'S MY sister, Evelyn, now eighty-seven years old. I hardly know where to start.

Evelyn is, without a doubt, one of the most fascinating people I've ever met. She and her husband lived all over the world, and when she was widowed five years ago, she began living part of the year with her son, Roy, and his wife and part of the year with me. (She's a self-described nomad, so staying with either of us full-time makes her feel too confined.) It makes me laugh to think of the incredulity on our parents' faces if they knew the two of us were spending months at a time in the same house together, and they wouldn't be wrong. We drive each other crazy. We also adore each other. We would take a bullet for each other, although Evelyn would demand an explanation first.

We were born and raised in the same household, and all my life I've wondered if one of us might be adopted. If it weren't such ancient history, I would tell you about how she used to get me in trouble when we were little girls and forced to take baths together; every single time she would suddenly yell, "Jeanne! Stop hitting me!" when I hadn't laid a hand on her, so that I would get punished for no reason . . . or how she could be counted on to get a convenient stomachache when there were chores to be done. To be fair, when I remind her of those incidents today she looks at me with

Oscar-worthy innocence and says, "Jeanne, I don't know where you get these stories." Maybe I just made them up. And maybe there's life on Uranus.

Where Evelyn's Oklahoma twang came from I'll never understand, since I never had a trace of an accent. Nor can I make any sense of some of the nicknames she comes up with for friends of ours. Calling Peter Bergman "Mr. Military Man" I get, inspired as it was by his perfect posture, his perfect diction, and his impeccable manners. But one night, suddenly blanking on Lindsay's first name, she came out with, "You know. *Spinelli*." To this day she has no idea what brought it on, and to this day Lindsay happily answers to "Spinelli" when she's talking to Evelyn, probably because she loves her, as do all my colleagues. In fact, at *Y&R* parties, everyone used to greet me with some version of "Jeanne! There you are! Come sit with us!" Since they met my sister, what I now hear is "Jeanne! Where's Evelyn?"

She's stubborn (I don't know where she gets that), she spoils my dogs rotten (unlike me, who would never dream of such a thing), and she always has to be right . . . which, of course, is ridiculous, since I'm the one who's always right.

She also doesn't have a trace of phoniness or pretense in her, loves simplicity, and would much rather read a book or watch a football game on TV than go to a party, and during my recent viral infection that kept me in bed for two months (and God bless you, Michael Learned, for filling in for me so beautifully on *Y&R* until I was back on my feet), she was the best sister, friend, drill sergeant, message service, protector, and caretaker anyone could ever hope for.

She happens to be traveling with her son and daughter-in-law for a few weeks at the moment. I'm telling you, the woman exasperates to my wit's end . . . and I miss her terribly and can't wait for her to come home.

Evelyn, I love you with all my heart, and I wouldn't trade you for any other sister on earth. But let's not talk it to death.

≈ ~ ≈

ON MAY 31, 2008, Harry Bernsen died of pneumonia at the age of eighty-two. His health had been failing for a couple of years, and he'd finally checked in to a Motion Picture & Television Fund health center several months before he passed away.

It's an understatement to say we weren't close then. We certainly weren't friends. We saw each other rarely, when family functions dictated. It would be hypocritical for me to say that his death saddened me, but he was my children's father, and I was proud of them for taking such good, loving care of him right to the end.

Harry asked that his body be cremated and that there be no public memorial service. Instead, there was a very nice private gathering at Corbin's house for family, close friends, and a handful of Harry's former clients. A podium was set up in the backyard with a life-sized, full-length cardboard photo of Harry placed a short distance away, facing the crowd, as if he were supervising the several speakers who stepped up to say a few words. And I must say, those who spoke managed to be both kind and honest, acknowledging that there were areas in which Harry was certainly talented, and revealing that (to my surprise) he'd been very attentive toward contemporaries of his who were retired and in failing health, checking up on them and visiting them when he could. Who knew? Good for him.

Then it was my turn.

I'm sure there were a few cringes among my children as I walked to the podium, but I'd already promised myself that I was going to say what I had to say without insincerity but also without (deliberately) embarrassing Corbin, Collin, and Caren.

I started by pointing out that my knowledge of Harry had been unique, that I'd known him differently and more intimately than anyone else, for better or worse, so while yes, there had been some good times—I came up with a few—and yes, I would be eternally grateful to him for the three children no other man on this earth could have given me, I had to admit that, for the most part, I'd found him to be pretty unbearable.

Suddenly, a breeze swept through Corbin's backyard during one of my less-than-flattering stories (I'm not sure which). But in the middle of the story that breeze blew Cardboard Harry over on top of me, bonking me right in the back of the head. During the inevitable laughter I turned and said, "Harry, you know perfectly well I'm not making this up, now leave me alone."

Corbin stood Harry back up again, but I lost track of the number of times he blew into me again during my "tribute." I swear to you, he didn't fall over on anyone else but me that entire afternoon. Coincidence? I highly doubt it.

Harry's ashes were divided evenly among Corbin, Collin, and Caren to be scattered in places he'd specifically requested. Wherever they are, and wherever he is, thank you one more time, Harry, for these magnificent children, and . . . I'll just leave it at that.

~~~~

THE BIGGEST HOLE IN my heart was left by Bill Bell's death on April 29, 2005. It was an incalculable loss to daytime television, but it was a deeply personal loss to me as well. He was my boss, my friend, my favorite sparring partner. He saved my life, tough-loved me into sobriety, and refused to settle for anything less than my best, sometimes giving me a "nudge" at the top of his lungs (and mine). I couldn't imagine saying good-bye, so in a way I never have—to this

day, when I have a tough storyline and difficult scenes to tackle, I tap into that depth he demanded and sail through them. Sometimes it's all I can do, when the director yells, "Cut!" not to take a moment to glance upward and say, "How'd you like that one, pal?"

Bill had actually left *The Young and the Restless* in 1998 when he felt his health was declining enough to compromise the quality of his work. My great friend Kay Alden, who'd been writing for the show at Bill's direction since 1974, took over as head writer while Bill slowly, surely, and tragically slipped into the cruel abyss of Alzheimer's disease. I think we all started grieving for him years before he passed away, when that obscene illness took his mind, his memory, and his essence from us. Lee, Bill Jr., Lauralee, and Bradley handled it with their usual devotion and grace, and as you know if you've ever known and loved an Alzheimer's victim, it's impossible not to be happy for them when their body finally gives out and sets them free.

The flags at CBS flew at half-mast in Bill's honor and production shut down on both of his shows, *The Young and the Restless* and *The Bold and the Beautiful*, so that we could all attend the funeral at the Church of the Good Shepherd in Beverly Hills and then head on to the Beverly Hills Hotel for a beautiful reception. It was exactly what it should have been—a celebration of his life, his love, and his legacy, with equal parts tears and laughter. And what finer tribute is there to anyone than the fact that all these years later Bill Bell is still an inspiration to everyone who knew him?

The older I get, the more true it becomes that the word "family" isn't limited to a shared bloodline, so I'm not just speaking figuratively when I say that I continue to treasure the Bells as part of my family. Lee in particular never ceases to amaze me. She still comes to the office a few days a week with her constant companion Joy, a cinnamon-colored miniature poodle who pretty much owns CBS

and everyone who works there. She loves to travel and entertain, and she completely outdid herself for my eightieth birthday party. Seventy of us gathered at her house for a perfect evening of friendship, dinner, live music by my pal, singer-songwriter Billy Vera (including his classic "At This Moment"), and a cake that thankfully did *not* have eighty lit candles on it. I remember at one point looking over at Lee's three children and my three as well, all of whom have children of their own now, and marveling at how far she and I have come since we first met in 1973—I was the newly signed cast member of *Y&R*, and she was the toast of Chicago, the Emmy-winning hostess of *The Lee Phillip Show*. We've both been through a whole lot of joy, a whole lot of crises, and a whole lot of sadness over all these years, and I'm so very grateful that we've been through it together with, God willing, a long way still to go.

~~~

FOR A WOMAN WHO didn't form many especially deep family attachments as a child, I'm blessed with more than my fair share of them now. My children and grandchildren and I live within about ten minutes of one another. We're all very close and very involved in one another's lives. When something happens to one of us, good or bad, it happens to all of us, and we see it through together.

I know this arrangement wouldn't work well for every family. In fact, I'm sure I just saw some of you shudder at the mere thought of it. But it works for us, thank God, and not a day goes by when I don't marvel at it, not only on my own behalf but also on behalf of my grandchildren. The cousins couldn't be closer if they were brothers and sisters, which is a tribute to them and to their parents, who've always embraced one another's children as if they were their

own. And I like to think that my heartfelt desire to really know each and every one of them and invite them to really know me had something to do with it.

My family is typically described in the press as "three children and eight grandchildren"—perfectly factual, but it reduces them to a bunch of stick figures. That's not nearly good enough for my book, not for the eleven amazing people who make up the core of my life.

So please indulge me while I do some blatant, unapologetic bragging.

~ ~ ~

THERE'S NO DOUBT ABOUT it, Corbin is the busiest member of the family. I can't keep up with him. I've long since stopped trying.

At the heart of his life are his wife, Amanda Pays, and their four sons (you'll be hearing about them shortly). Corbin and Amanda will be celebrating their twenty-fifth wedding anniversary in 2013, and there are no finer, more hands-on and devoted parents. Theirs is a happy home full of laughter and creativity and a whole lot of mutual involvement and support.

Corbin's "day job" is his role as Henry Spencer on the USA Network series *Psych*, which is shooting its sixth season in Vancouver. But in his "spare time" (I'm kidding), he's making great use of his bachelor's degree in theater arts and his master's degree in playwriting, both from UCLA, by writing, directing, producing, and often acting in a series of independent films, not just to exercise his considerable talent but also to express the fact that, personally and professionally, he's, if you'll pardon the cliché, come of age. He's always been an overachiever, but he's finding peace now, in his spiritual center, in the quiet pleasure of simplicity and in his desire to give back as a way of expressing his gratitude for all he's been given.

His films have nothing to do with sex and violence, and everything to do with making changes through personal involvement and taking responsibility for the course of our own lives. They celebrate basic values and the power of a united community. They acknowledge how essential hope is to the human spirit. They're respectful, they're decent, and they're contagiously inspiring.

Rust, for example, which was released in 2010, was inspired by Harry's death and the journey it triggered in Corbin to explore his relationship with God and Christ—as he puts it, not a relationship he'd abandoned but more like a muscle he hadn't flexed in a while. He dramatized that journey in the film, which is the story of a pastor in his midfifties who has a "midlife crisis of faith," and it's been thrilling to watch him go through the rediscovery of that faith both on-screen and off.

And then there's *25 Hill*, which Corbin wrote and directed to help revive the All-American Soap Box Derby when he learned that this great national tradition was in financial trouble and in danger of becoming extinct. The title is a tribute to the former soap box racing hill in Taft, California, where I used to take him as a child. He shot this wonderful movie in Taft, Akron, and Cleveland, using mostly local talent, for release on DVD in 2011. Its theme is about parents and children, and whole communities, creating something positive together for themselves and for one another. To put his money where his mouth is, Corbin's production company, Team Cherokee Productions, has infused the soap box derby with about $150,000 as well as 10 percent of the film's proceeds, and he'll be doing a lot of traveling, especially to cities where derby races are held, to promote *25 Hill* and the derby itself. He's excited about the movie and even more excited about the fact that instead of just talking about it at industry cocktail parties, he saw a family- and community-oriented treasure in need of help,

committed himself to doing something about it, accomplished it, and made a difference.

Yes, I admit it, I'm Corbin Bernsen's biggest fan as a writer, a director, and an actor. In fact, it delights me when, for example, someone spots him, recognizes him as the iconic Arnie Becker on *L.A. Law*, and excitedly yells, "Hey, Arnie!" no less than it delights me when someone spots me and excitedly yells, "Mrs. Chancellor!" But what a gratifying joy to be able to say, of much more importance, that I also happen to be his biggest fan as a husband, a father, a provider, a son, and a man.

～～～

IF COLLIN WEREN'T MY son, I would seek him out as a friend.

He had more options than most:

He's tall, blond, and very handsome. When Corbin was living in New York doing the soap opera *Ryan's Hope* in the mid-1980s, he was also a model. One day Collin stopped by the modeling agency with Corbin on their way to dinner and the agency recruited him on the spot. "The Bernsen Brothers," as they were known at Beverly Hills High School, traveled all over the world for modeling jobs, and Collin picked up his share of acting work along the way.

He's a natural-born athlete, and had a few NFL scouts keeping an eye on him from as early as eighth grade.

He's extremely bright, so much so that, with his parents' permission, he was going to be observed as a possible candidate for a Rhodes Scholarship. (I signed the paperwork. Harry didn't. Don't get me started.)

He's artistically gifted with everything from wood to metal to stone to ceramics. He's created some of the most beautiful furniture, pottery, houses, and sculptures you've ever seen. His uncle set

him up in the contracting business, with only one reservation when Collin took exception to the idea of padding his fees: "I'm afraid you'll never make any real money as a contractor, Collin. You're too honest." Collin became an honest contractor and has built a lot of multimillion-dollar homes without getting rich, and even when money is tight he never wishes he'd done it any other way. He's one of those refreshing people to whom status means nothing—if a choice has to be made, he'd much rather be happy than rich.

And happiness comes as naturally to him as breathing, which may be the reason that he attracts so many friends of both sexes. It speaks volumes that many of the closest, most active friends in his life date back to elementary school, and that he's his nieces' and nephews' favorite uncle. He's got a playful streak in him that he's never outgrown, and trips to the beach or the bowling alley or just plain dinner with Uncle Collin are the most fun there is to be had, for both the kids and for him. Frankly, the rest of us grown-ups have given up even trying to compete.

He's also a caretaker, through and through. When he and his wife, Cheryl, were divorced in the early 1990s, Collin became a single parent to their two infant sons, and did it happily and magnificently. On one hand, he's been a great buddy to them, surfing with them and playing sports with them and taking them on some spectacular father-son trips. On the other hand, he's demanded that they be responsible, hardworking students, that they live up to their full potential, and that they never forget the importance of family or take for granted the many advantages they've been given. The boys have taken more than one trip to downtown L.A. with their father not just to give to the homeless but to talk to them, get to know them, and hear their stories. In fact, it's become a Thanksgiving tradition for Collin to package up all our leftovers and drive them straight to Skid Row to make sure a few people don't go to

sleep hungry that night. When Harry's health was declining, Collin was right by his side. When I'm sick, Collin sleeps here at the house, and during my few brief hospital stays over the years, Collin simply pulled a couple of chairs together and spent the night in my room. On the rare occasions when I need full-time care, Collin doesn't just make the arrangements; he creates a new bedroom if he has to so the caretaker will have a comfortable, private space of her own.

In 2011 Collin's art pieces began attracting attention, almost by accident, and they've started selling very handsomely, to his pleasant surprise. It's my completely nonobjective opinion that much of what makes them so irresistible is their expression of his pure creative talent and passion, with no thought of "I wonder how much I can charge for this one." He's also getting ready to market an invention of his called the Stud Buddy—not the pornographic implement you might be picturing, but a device that will help builders locate studs and other structural details hidden behind walls.

All this because I didn't want Corbin to grow up an only child.

~ ~ ~

ONCE I'D FALLEN IN love with being a mother, i.e., from the moment I became pregnant with Corbin, I had a deep yearning for a daughter, and as you know, the third time around, I got one. If I'd designed one myself, from the ground up and the inside out, I would never have had the nerve or the creativity to fashion the one I got.

Caren, my steel magnolia, was raised with two older brothers who thought she was the most precious thing they'd ever seen, a mother who couldn't get enough of her, and a father who had no idea how to appropriately bond with a daughter. She gamely played sports with Corbin and Collin when they invited her, but rather than grow up in the shadow of the Bernsen Brothers, she began

very early in life to establish her own very smart, very strong, very independent, very feminine, very compassionate, somewhat intro-verted identity.

After graduating from Lake Forest College near Chicago toward her goal of becoming a clinical psychologist, she began an intern-ship with the Kennedy Foundation, counseling children. What she discovered, to her surprise, was that, as much as she loved her work and the children, she was unable to separate herself from their problems and their pain every night when she got home. It was no way to live and no way to be effective at her job, so she went to New York for a year to work in retail sales and regroup before coming back to Los Angeles to start a new career.

She traveled with me for a few years, helping me with personal appearances and merchandising. In fact, she met her husband, Jon Wilson, through a mutual friend when she accompanied me to a charity chili cook-off I was judging in Reno, and they're now the extraordinary, involved parents of two daughters—Jon coaches their sports teams, and both Caren and Jon go out of their way to get to know every one of the girls' teachers and participate in every aspect of their schooling, from homework to extracurricular activi-ties. Caren's especially sensitive to the fact that Grace's and Sarah's public schools can't always afford all the necessary supplies for their students, so every year she adopts a class to help provide whatever's needed, eliminating the necessity for teachers to spend their own money on materials they're rarely able to afford.

She's been with a company called Pacific Studios for the past eighteen years, a business she now manages that creates, rents, and sells backdrops for television and film projects. She's a tough, smart, fair businesswoman, incredibly hardworking and trustwor-thy, approaching her career with the same integrity with which she approaches being a wife and mother.

Caren also happens to be my best friend and my favorite traveling companion. A few times a year she and I take off to Las Vegas for a girls' weekend. We get pampered with facials and massages, we meet friends for dinner, and we lose ourselves for a few hours at a time at the slots and poker machines. Most of all, we laugh. When I look back on the longest, hardest, most convulsive laughs of my life, every one of them is with Caren—sometimes over pure silliness and sometimes over situations in which we knew better than to even glance at each other until we were alone together later.

She's also a great pal to her brothers, adoring them and their children and running interference between them during their rare, inevitable skirmishes. When the need arises, she's the "bridge" among us, the peacemaker and the voice of reason with the mind of a psychologist and both feet on the ground—qualities that this family does not necessarily uphold every minute of every day of the year.

There's an old saying that goes "Crisis doesn't build character, it reveals it." What was revealed in my daughter through the crisis of surviving (in fact, beating the hell out of) cancer came as no surprise to me: the courage of a lioness, the compassion to carry as much of the emotional weight of it as she could for the benefit of all of us who love her, and the clarity to tell us what she needed when she needed it.

In other words, she's my hero, and it's nothing less than an honor to be her mother.

～ ～ ～

CORBIN AND AMANDA HAVE four sons. They're an incredibly close family who genuinely enjoy one another's company, and the six of them have traveled all over the world together, giving the

boys great memories, familiarity with other cultures, and a sense of being part of a vast global community with unlimited possibilities.

Oliver, their firstborn, went to the University of Connecticut for a year on a football scholarship after graduating from high school, but then came to the realization that he really had no desire to play football, and that he couldn't start taking the filmmaking courses that were his passion until his junior year. So he's moved back to Los Angeles to attend film school, has worked as an art director on several projects including his father's, and has made several short films of his own. He's a warm, friendly, down-to-earth young man with a wonderful sense of humor who also happens to be an incredible artist and cartoonist.

The fraternal twins, Henry and Angus, headed straight from high school to New York University. Henry's in his sophomore year and dreams of being a professor at an Ivy League school. Angus decided it was a waste of his father's money to continue paying tuition for a lot of classes in which Angus had absolutely no interest, so he's seeking out a more specialized education in his area of passion, which also happens to be filmmaking. Henry and Angus share an apartment in New York, have a wide variety of friends, and are earning a living working at a Ralph Lauren store and following in their father's and uncle's footsteps by taking some modeling jobs. They're genuinely interesting and interested boys, well rounded, well traveled, and well informed, although probably the most private of all of us, with that special connection and way of communicating that only twins can truly understand.

Finley is the youngest of Corbin and Amanda's sons, born fourteen years after the twins while the family was living in England. I would say this even if he weren't my grandson: he's one of the funniest people I've ever met and has been since he was a baby. He's also one of the most adaptable—when he's told that the family's

headed off on yet another trip to Canada, New Mexico, France, England, New York, wherever, or that they're moving to a new house (Corbin and Amanda love buying and remodeling houses), Finley's invariable response is a simple "Okay" before he heads off to his room to start packing. He's a good student and a popular one, about to enter high school. He wants to be an actor, and mark my words, he'll be one.

~ ~ ~

COLLIN'S TWO SONS, WESTON and Harrison, were very young when their parents divorced. Their mother moved to Europe for several years, and Collin and the boys lived with me during much of that time, which was a joy for me and gave us a chance to be especially close.

Weston will be graduating from the University of Colorado at Boulder in 2012 with a business degree. He's got a special talent for marketing and, among other ventures, is going into business with his father to promote some of Collin's inventions. Their dream is for those inventions to become popular enough to require mass production and be made exclusively in America to help create as many new jobs as possible. Weston's fairly introverted but loves to laugh, and he also loves anything involving the outdoors, from surfing to camping to hiking to skiing. He's a hard worker with a great sense of responsibility and is very devoted to his family. He also, by the way, has manners that would make any grandmother proud.

His younger brother, Harrison, inherited his father's brains and brawn, an excellent student who was also the captain and quarterback of his Calabasas high school team. (His football career came to a sudden, unfortunate end during a game when his leg was broken so badly in several places that it took him six months to recover.)

Another similarity to his father that fascinates me is that Harrison is as devoted to Weston as Collin has always been to Corbin, to the point where, in both cases, the brothers belong as much to each other as they do to their parents. Harrison is currently in his second year at the University of California at Santa Barbara, working in an emergency room three shifts a week as part of an internship toward his goal of becoming a pediatrician.

~~~ ~~~ ~~~

CAREN AND JON CONTRIBUTED the two girls to the group, much adored by their six male cousins and able to hold their own in any and every situation. Finley and the girls, being the youngest and closest in age, spend at least one night a month at my house. If they don't, I go into serious withdrawal.

Grace, the tall, blond, blue-eyed older sister, graduated from eighth grade with honors, at the top of her class, and is taking several accelerated courses at Notre Dame High School. She excels at everything she does, from academics to dance to sports to the short stories she's been writing since she was a little girl. In fact, she decided when she was twelve years old that she wanted to run in the 26.2-mile L.A. Marathon and finished it in six hours and twenty-three minutes. She's sweet, she's generous, she's very family oriented, and she's incredibly empathetic, first in line to get involved in any cause aimed at helping disadvantaged children. While she's bright, gifted, and versatile enough to pretty much take her pick of careers to pursue, at the moment she's determined to become—forgive the predictability, and say it right along with me if you want—a forensic paleontologist. (I know. The first time I heard it I had exactly the same expression on my face that you do.)

Her younger sister, Sarah, intends to be an actress, although

when she announced this news to me she added, "I just don't want anyone to watch me." (I think I'm making some headway in convincing her that earning a living as an actress nobody watches may be more of a challenge than she's anticipating.) It's worth mentioning that one of Corbin's favorite activities at family gatherings is to direct Finley, Grace, and Sarah in an improvisational performance, and he's amazed at Sarah's talent and her focus at such a young age. She adores her sister, but she gets discouraged following in the footsteps of a girl who can seemingly do anything and everything and do it with ease. But she's starting to appreciate her own talents, her own interests, and her own identity. She's fiercely independent, fearless about expressing her opinions, and doesn't believe in "gray areas"—in Sarah's world, something is either right or it's wrong, it's either fair or it's unfair, and when it's unfair, either on her own behalf or on behalf of someone she loves, you can bet everyone within earshot is going to hear about it. She is, in other words, a little force of nature, and, like all eight of them, I wouldn't have missed her for anything.

CHAPTER TEN

*Paying It Forward*

I was driving along Sunset Boulevard one day with Caren and Collin when a terrible car crash happened right in front of us. It was obvious that there might be injuries, and I immediately pulled over.

Caren, who was nine years old at the time and very frightened, yelled, "Mom, no, keep going, let's get out of here!"

I explained that we couldn't keep going if someone needed our help.

At that moment she didn't care. All she knew was that she was scared. "There are lots of other people around to help them, Mom. Why do we have to do it?"

Collin, age eleven, looked at her and said, "Because we have no choice."

"WE HAVE NO CHOICE" is exactly what I believe about our responsibility as citizens of this planet. We're all caretakers here.

We're all custodians, nothing more, nothing less, and we're all interconnected. Every hungry child, every abused or neglected human or animal, every living thing in need of simple kindness diminishes every one of us, and I don't want the karma of knowing I could have helped but didn't.

I got an early start at paying attention to those around me who were struggling. As a high school student I belonged to the Junior League, which focuses on education and volunteerism, and I was a candy striper, visiting hospital patients to read to them, bring them their mail, and generally make sure they knew someone cared about them and what they had to say.

I was also a child of the Depression. That meant giving thought to every dime we spent and not even imagining buying what we couldn't afford. It also meant watching a lot of people lose every-thing, through no fault of their own, that they'd worked for all their lives, teaching me the lifelong lesson to never take money or a pay-check for granted.

Believe it or not, until I was well into my twenties or maybe even my early thirties, plain old household credit cards didn't exist. I'm sure there are those of you to whom that sounds like hell on earth, which is exactly why, from the moment I first laid eyes on them, they scared me to death. I'm no financial genius, but I knew entrapment when I saw it. What better way for banks and other corporations to entice people into spending money they didn't have and then make a fortune charging interest on that debt as people tried to dig themselves out of these seductive new holes? And owing money you don't have, plus interest, to a multimillion-dollar corporation that could make your life a living nightmare if you didn't pay sounded a lot like slavery, which has never appealed to me.

Of course, before we all knew what hit us, it was raining credit cards across the United States. Those credit cards were apparently

interpreted as gift certificates by many of those who received them, since even the most intelligent, well-meaning people—especially those in the middle class—began drowning in debt, selling their souls for designer wear, meals at expensive restaurants, and the very latest in electronic devices while the banks got richer and richer and richer.

So when a debt solutions organization called No2Debt approached me about doing a commercial for it, I leapt at the opportunity. I'd met its founder, Virginia Swanson, by chance one night at the House of Blues in Hollywood. The devastating Northridge earthquake of 1994 had just happened, and a group of us had gathered to share our earthquake recovery stories. In my case, I'd found myself on the receiving end of an insurance scam in the process of trying to get the cracks in my house and pool repaired. Virginia, whom I'd never met before that night, offered to help—she'd been in the insurance business for years and knew her way through all that mystifying, infuriating red tape. She was smart, she was thorough, she was effective, and she cared. In fact, it turned out, few things outraged her more than people being scammed, tricked, or seduced out of their hard-earned money by Big Business.

No2Debt was Virginia's way of fighting back, and I've personally witnessed what a fierce, honest, skillful fighter she is. I didn't stop at making just that one commercial. For several years I enjoyed being a No2Debt spokeswoman, traveling around the country helping to inspire people to cut up their credit cards and liberate themselves from the slavery—and believe me, that's exactly what it is—of indebtedness. Suze Orman was and still is *my* inspiration when it comes to personal finances, and I was honored to be one of the standard-bearers following her mission of keeping the middle class financially healthy.

Of course, times have changed in the past few years. The

economy is in trouble, which understandably creates fear, and when people are afraid they'll do almost anything to escape their fear, if only for a few moments—they'll resort to one of those obscene payday loans that amount to legalized loan-sharking, charging interest rates of 300 percent or more, or they'll blow their rent money on an iPad or an Xbox because everyone else has one. I can't tell you how much it saddens me.

I'm not qualified to give financial advice, but my gratifying years with No2Debt taught me so much about refusing to sell my soul to banks, corporations, and *things*. I won't be owned by a closetful of designer shoes and handbags, or the latest cell phone, or the most fabulous luxury car on the road. That lesson I learned as a young girl is just as relevant today as it was during the Depression: if you can't afford it, don't buy it. There's no shame in living within your means—in fact, it should be a source of pride to be smart enough to choose peace of mind over fear. What more incredible gift than that could you possibly give yourself and your family?

I can't recommend strongly enough that you take a look at www. no2debt.com and, for that matter, www.suzeorman.com if you're struggling these days, or even if you're not. Let's face it, the better informed you are the more power you have, and I don't want you to be afraid anymore.

~~~~~

SEVERAL YEARS AGO THERE was an awards luncheon for some of our local CBS newswomen to honor their charitable work, and several of us CBS actors were invited to attend. It was at that luncheon that I was introduced to a dynamic woman named Carol Williams, the executive director of Interval House Crisis Shelters and Centers. She and her community education director, Janine Limas, and

I talked many times over the following few weeks, and the more I learned about the work they were doing, the more impressed I was, the more I wanted to be involved, and the more Interval House became one of my passions.

Interval House, founded in 1979, is dedicated to helping victims of domestic, sexual, and dating violence. One of the many unique facets of its program is that the staff members specialize in African-American and immigrant cultures within our society, providing services in more than seventy languages, and the vast majority of employees are ethnically diverse and have been through Interval House interventions and education themselves. They embrace women and children from abusive homes, feeding, clothing, and housing them while giving them hope and teaching them to become self-sufficient. There are also programs dealing with elder abuse, substance abuse, and victims of stalkers and human trafficking.

It was a perfect opportunity for me to answer a long-standing prayer inspired a few years earlier by a visit to a children's shelter in San Diego for at-risk children from the very young through teenage years. During the tour I noticed a tiny boy who was sitting all by himself in a chair in a corner of the room. He had on a little hat, and he was holding his head in his hands, as lost and alone as anyone I'd ever seen in my life. I asked about him and discovered that he was there because his mother was in jail on drug charges and for mercilessly beating him. He broke my heart, and I couldn't get the image of him, and of someone laying a hand on him in anger, let alone beating such a helpless, precious child, out of my mind. That image was the inspiration for countless prayers: "Please, God, let me find an active, meaningful way to help as many precious children as I can who are as lost and helpless as that tiny little boy."

So along came Carol Williams and Interval House, the answer

to all those prayers. They were about to have their annual banquet and charity auction, and I wouldn't have missed it for anything in the world. The Ritz-Carlton hotel donated accommodations for us out-of-town guests. Helen Reddy, Beverly Garland, Shirley Jones, and Marcia Clark were part of the festivities. It was a spectacular event, one of those amazing evenings when every single person in the room was there not out of some sense of obligation or as a meaningless publicity ploy, but simply because of a shared commitment to a truly inspired and inspiring cause.

My treasured relationship with Interval House continues to this day, and I hope you'll read more about the organization on its website, www.intervalhouse.org. And if you or a loved one needs help, please keep its hotline numbers on hand: (562) 594-4555 and (714) 891-8121.

I HAVE COPIES OF one of my favorite quotes hanging in three separate places in my house so that I can't take more than a few steps in any direction without being reminded:

I hold that the more helpless a creature, the more entitled it is to protection by man from the cruelty of man.
—MAHATMA GANDHI

In the first chapter I told you about my father surprising me with a puppy that woke me out of a sound sleep with a million nose kisses. I named my puppy Patrick, and my God, did I adore that little guy.

When I was nine years old, our neighbor showed up at the door with Patrick in her arms. It seems my puppy had found his way to

their yard, and her husband had kicked him hard enough to break a couple of his ribs and cause internal bleeding. There wasn't much our veterinarian could do for Patrick, so I simply stayed with him every second, including pitching a tent and sleeping with him every night, until he passed away three days later.

I'm not sure which was more overwhelming—my badly broken heart, or my rage and horror at the neighbor, or anyone, who could be cruel to a puppy, or to any other living thing. I still feel the same heartbreak, rage, and horror when I look back on it, and I vividly remember thinking, "I'm not always going to be nine years old. Someday when I have a voice I'll find a way to do for other animals what I couldn't do for Patrick."

Well, I'm not nine years old anymore, and I sure as hell have a voice now, which I've devoted to many animal causes, most notably Humane Society International. A portion of the group's mission statement reads, "We work to reduce suffering and to create meaningful social change for animals by advocating for sensible public policies, investigating cruelty and working to enforce existing laws, educating the public about animal issues, joining with corporations on behalf of animal-friendly policies, and conducting hands-on programs that make ours a more humane world. We are a leading disaster relief agency for animals, and we provide direct care for thousands of animals at our sanctuaries and rescue facilities, wildlife rehabilitation centers, and mobile veterinary clinics." As if that wasn't enough to inspire me to become one of the Humane Society's spokeswomen and continue to be an advocate to this day, I also love another part of its mission: "extolling the human-animal bond."

That promise manifests itself in a way that touches me deeply, that I hope will spread throughout the world, and it's such a simple solution to a lot of loneliness. Thanks to the efforts of the Humane

Society, senior citizens in many assisted-living homes in Canada are allowed to have pets. I've personally witnessed extraordinary transformations in so many people when they were able to wake up every morning with a little soul to care for and love and be unconditionally loved by, when they had purpose to their days again, when they weren't alone anymore. It made a difference that was nothing short of miraculous, and God only knows how many animals have been rescued and given loving homes thanks to this beautiful program.

And for the record, yes, I do speak from experience, by the way. I live with and treasure three dogs of my own—Daisy, Bishop, and Crackerjack. They bring me more joy and laughter and love and devotion than I can ever repay, and I literally can't imagine how empty my life would be without them.

Please visit the Humane Society's website, www.humanesociety. org, and help if you can. Believe me, every dime of every donation makes a difference to a precious soul that has no voice of its own.

~~~

IN 1975 I WENT to New Orleans for Mardi Gras with my friend Colbert "Bud" Baker. We had a spectacular time, during which Bud introduced me to his son, Tim. We talked, we laughed, we enjoyed the fabulous French Quarter, and I flew home without a clue that I'd just met a man who would become an important part of my life more than three decades later.

Tim Baker moved to Midland, Texas, in the 1980s, and in the process of making it his home he found himself compelled to get involved in the area's "recovery community"—friends and neighbors whose lives were being ripped apart by drug and alcohol addictions. Many of them, even the most committed ones, had tried to

overcome those addictions and failed, which inspired Tim to start exploring treatment methods that would maximize the odds of success. The result was an office in downtown Midland that housed a not-for-profit facility, founded by Tim and named the Springboard Center, devoted to treating chemical dependency.

Several years, grants, and private donations later, Tim was able to realize his ultimate dream for the Springboard Center: to house it in a new state-of-the-art treatment and recovery complex. He called one day to tell me about it, and the more he talked, the more excited I got. So when he asked if I would consider being the center's national spokesperson, I answered with an immediate, emphatic, "Yes!"

I may never have been to Midland, Texas, before, but God knows I'd been a substance abuser in need of help. I knew what those clients were going through and what it would take for them to recover and be whole again, and everything Tim had described sounded like exactly what I knew to be true and workable. What a perfect way for me to honor all those people who'd been there for me during my addiction and recovery, a perfect way to "pay it forward."

So off I went to the groundbreaking ceremony for the new facility in May 2008, surrounded by the rolling plains and endless skies of Midland. I was back in November to tour the thirteen-thousand-square-foot building as it neared completion, and in May 2009 I proudly attended the Springboard Center's grand opening.

This eighteen-bed facility is unique among rehab and treatment programs. The focus is on restoring health and dignity to clients and their families through diet and nutrition; emotional, mental, and spiritual development; exercise; education; and the development of self-sufficiency skills. A unique treatment plan is created for each individual client, since everyone arrives with their own history and their own set of problems and circumstances. The brilliantly trained staff of doctors, nurses, counselors, and therapists is

on duty every hour of every day of the year. And incredibly, there's nothing exclusive, elitist, or cost-prohibitive about the Springboard Center. It's not reserved for the wealthy and privileged. The cost is based on the client's ability to pay, so no one is turned away based on a lack of funds or insurance. The center really is truly available to anyone who needs help—more than six thousand souls and their families so far, in fact.

Plans are currently under way for a new wing that will expand the facility to twenty-four beds, and for stables and a riding ring to capitalize on the almost magical connection between recovering clients and the magnificent strength and beauty of horses. I've been back to Midland several times for fund-raising events, and I'll be back whenever Tim and the center need me. Every time I visit I'm even more touched, more inspired, more energized, and more committed to this amazing nonprofit cause, which, as far as I'm concerned, should be used as a template for other substance abuse treatment and recovery centers throughout the country.

If I sound passionate about the Springboard Center, it's only because I am. I saw it rise out of the Texas soil into a complex any community would be proud to call its own, and I've also personally talked to dozens of clean, sober, grateful clients who'd failed at other facilities and almost given up any hope of recovery until they found their way to Midland.

Please visit the Springboard Center's website, www.springboard center.com, to read more about the extraordinary work my friend Tim Baker and his colleagues are doing there. Whether or not you can help, whether or not you or a loved one needs help, I'm excited for you to know where a big part of my heart is invested these days.

No matter who you are, no matter where you are, no matter what your circumstances, you can change the life of a soul who needs you right this minute. It's the quickest cure for loneliness,

boredom, and depression you'll ever find. Isn't it thrilling to know that you can wake up tomorrow morning and, before the day is over, make a difference? That you can matter to someone, even if you're just doing it for your own sense of self-worth?

Not because you have to, but because you want to.

Because it's right.

Because you'll get back everything you give and more.

Because we can all use some hope right now in these tough times.

Because we have no choice.

# Afterword

I admit it, I didn't exactly leap at the idea of writing my memoirs, and not because I was reluctant to tell you my secrets. In fact, I think I'd be one of the hardest people on earth to blackmail—threaten to expose some "dirt" about me and I'll be on the phone with the press in a heartbeat to expose it myself. I just wasn't sure I was ready to dredge up some of my more painful memories and feel them all over again.

But the truth is, I've enjoyed every minute of it, even the hard parts. It's been cathartic. It's been liberating. It may have even saved me thousands of dollars in therapy bills. And it gave me a chance to relive the impossibly happy times and feel those all over again too, and be reminded that they far overshadow the occasional darkness.

I thank you for walking through these pages with me and for caring enough to take that walk. It's because of each of you that I have so much joy to share and look back on and look forward to, and if you only take away one truth from this book, I hope it's this:

I'm living proof that you can overcome mistakes, substance abuse, and plenty of bad choices, and as long as you fight hard to keep your heart in the right place and full of gratitude, you can wake up one morning and realize that you really are a blessed, purposeful, exhilarated eighty-three-year-old.

And now, if you'll excuse me, I've got a seven A.M. hair and makeup call.

# Acknowledgments

I'm overwhelmed trying to think of everyone who's more than earned my heartfelt thanks for their contributions to my life. The complete list would demand a book of its own. I pray that those of you I'm inadvertently forgetting know how much you mean to me, and that I'll never stop finding other ways to express my gratitude.

But for now . . .

To Tom Langan, my longtime producer and cherished friend to this very day.

To John Conboy, the creator and master of the "new look" of television in the 1970s, who taught me the elegance of Katherine Chancellor.

To Josh O'Connell, associate producer of *The Young and the Restless*, who quietly, and often without nearly enough thanks, makes everything happen.

To each and every member of the *Y&R* crew, the true unsung heroes of our show. It's an honor to know you and work shoulder to shoulder with you.

To Lindsay Harrison, for convincing me to tell my story, for being the animal lover she is, and for epitomizing the word "friend."

To Michael Gregory, the Greek in my life.

To Dr. James Todd, the young dentist who wanted to meet Katherine Chancellor, did, and became, along with his wife, Susan, my "active friend" for thirty-eight long years.

To my amazing, loyal, generous Canadians, for your love and friendship over all these decades, every bit of which is reciprocated, and for the spectacular celebrations honoring my fifty years in show business. I haven't forgotten, and I never will.

To Marilyn and Conrad Welle—"Viva Las Vegas!"

To Virginia Swanson, the intrepid PI of scams.

To our literary agent, Jennifer DeChiara, and to Lisa Sharkey and Amy Bendell, without whom this book wouldn't have happened.

And to every single one of you who's ever watched and supported Katherine Chancellor and *The Young and the Restless*. We, every one of us, owe it all to you.

# *About the Author*

J eanne Cooper was born in 1928 as the youngest child of part-Cherokee parents. She has been working in show business for the past seven decades. She has earned the love of soap-opera fans for her long-running role as the wealthy, tough-as-nails but generally good-hearted Katherine Chancellor on CBS's *The Young and the Restless*. She is the only actor who has been with the show since its premiere. For her work on the series, she received back-to-back Daytime Emmy Award nominations as Outstanding Leading Actress in a Drama Series in 1989, 1990, and 1991. In 1993, she was awarded a star on the Hollywood Walk of Fame, in recognition of her many years in show business.